NEXUS NETWORK JOURNAL Architecture and Mathematics

Aims and Scope

Founded in 1999, the *Nexus Network Journal* (NNJ) is a peer-reviewed journal for researchers, professionals and students engaged in the study of the application of mathematical principles to architectural design. Its goal is to present the broadest possible consideration of all aspects of the relationships between architecture and mathematics, including landscape architecture and urban design.

Editorial Office

Editor-in-Chief
Kim Williams
Corso Regina Margherita, 72
10153 Turin (Torino), Italy
E-mail: kwb@kimwilliamsbooks.com

Contributing Editors
The Geometer's Angle
Rachel Fletcher
113 Division St.
Great Barrington
MA 01230, USA
E-mail: rfletch@bcn.net

Book Reviews
Sylvie Duvernoy
Via Benozzo Gozzoli, 26
50124 Firenze, Italy
E-mail: syld@kimwilliamsbooks.com

Corresponding Editors
Alessandra Capanna
Via della Bufalotta 67
00139 Roma, Italy
E-mail: alessandra.capanna@uniroma1.it

Ahmed Ali Elkhateeb
King Abdulaziz University
Department of Architecture
Faculty of Environmental Design
21589 Jeddah, Saudi Arabia
E-mail: aelkhateeb@kau.edu.sa

Tomás García Salgado
Palacio de Versalles # 200
Col. Lomas Reforma, c.p. 11930
México D.F., Mexico
E-mail: tgsalgado@perspectivegeometry.com

Ivan Tafteberg Jakobsen
St. Blichers Vej 20
DK-8230, Aabyhoj
Denmark
E-mail: Ivan.Tafteberg@skolekom.dk

Robert Kirkbride
studio 'patafisico
12 West 29 #2
New York
NY 10001, USA
E-mail: kirkbrir@newschool.edu

Andrew I-Kang Li
Initia Senju Akebonocho 1313
Senju Akebonocho 40-1
Adachi-ku
Tokyo 120-0023, Japan
E-mail: i@andrew.li

Cover
"Together" (November 2008) by Reza Sarhangi

Jesper Matthiasen
Silkeborg Vej 130, 1.tv
DK-8000, Aarhus C, Denmark
E-mail: Jesper.Matthiasen@skolekom.dk

Michael J. Ostwald
School of Architecture and Built Environment
Faculty of Engineering and Built Environment
University of Newcastle
New South Wales, Australia 2308
E-mail: michael.ostwald@newcastle.edu.au

Vera Spinadel
The Mathematics & Design Association
José M. Paz 1131 - Florida (1602), Buenos Aires, Argentina
E-mail: vspinade@fibertel.com.ar

Stephen R. Wassell
Department of Mathematical Sciences
Sweet Briar College, Sweet Briar, Virginia 24595, USA
E-mail: wassell@sbc.edu

João Pedro Xavier
Faculdade de Arquitectura da Universidade do Porto
Rua do Gólgota 215, 4150-755 Porto, Portugal
E-mail: jpx@arq.up.pt

Instructions for Authors

Authorship
Submission of a manuscript implies:
- that the work described has not been published before;
- that it is not under consideration for publication elsewhere;
- that its publication has been approved by all coauthors, if any, as well as by the responsible authorities at the institute where the work has been carried out;
- that, if and when the manuscript is accepted for publication, the authors agree to automatically transfer the copyright to the publisher; and
- that the manuscript will not be published elsewhere in any language without the consent of the copyright holder.

Exceptions of the above have to be discussed before the manuscript is processed. The manuscript should be written in English.

Submission of the Manuscript

Material should be sent to Kim Williams via e-mail to: kwb@kimwilliamsbooks.com or via regular mail to: Kim Williams Books, Corso Regina Margherita, 72, 10153 Turin (Torino), Italy

Please include a cover sheet with name of author(s), title or profession (if applicable), physical address, e-mail address, abstract, and key word list.

Contributions will be accepted for consideration to the following sections in the journal: research articles, didactics, viewpoints, book reviews, conference and exhibits reports.

Final PDF files
Authors receive a pdf file of their contribution in its final form. Orders for additional printed reprints must be placed with the Publisher when returning the corrected proofs. Delayed reprint orders are treated as special orders, for which charges are appreciably higher. Reprints are not to be sold.

Articles will be freely accessible on our online platform SpringerLink two years after the year of publication.

Nexus Network Journal

Persian Architecture and Mathematics

Reza Sarhangi, Guest Editor

Volume 14, Number 2
Autumn 2012

KIM WILLIAMS BOOKS

Nexus Network Journal

Persian Architecture and Mathematics

Reza Sarhangi, Guest Editor

Volume 14, Number 2
Autumn 2012

Nexus Network Journal
Vol. 14
No. 2
Pp. 195-406
ISSN 1590-5896

CONTENTS

Kim Williams

Kim Williams Books
Corso Regina Margherita, 72
10153 Turin (Torino) ITALY
kwb@kimwilliamsbooks.com

Letter from the Editor

Persian Architecture and Mathematics

Abstract. *NNJ* editor-in-chief Kim Williams introduces the papers in *NNJ* vol. 14, no. 2 (Autumn 2012).

For some years now, each issue of the *Nexus Network Journal* contains a group of articles focussing on a single topic, complemented by other research, book and article reviews and conference reports. This arrangement allows us to collect groups of related papers in order to constitute an anthology capable of becoming significant research resource for those pursuing a certain topic, and to allow the journal to function as journals usually do, publishing new research in the field of architecture and mathematics as a whole in a timely fashion so that new findings reach their intended readership.

This present issue of the *NNJ*, dedicated to Persian architecture and mathematics, grew out of a dialogue between Reza Sarhangi, director of the Bridges conferences for art and mathematics, and myself. I was particularly happy when Reza accepted my invitation to guest edit an issue of the *NNJ*, because he was the author of a paper on this topic that appeared in the very first issue of the journal, in 1999, so his participation represents a special kind of on-going collaboration. In his turn, Reza selected an Editorial Committee composed of a group of scholars familiar with Persian architecture and mathematics, which included Carol Bier, Lynn Bodner, Douglas Dunham, Mohammad Gharipour, and Hooman Koliji, who played an active and valuable role in reviewing and selecting the papers received as a result of the Call for Papers, and editing those selected for publication. I am very grateful to all of them for their gifts of time and effort.

Reza's Letter from the Guest Editor, entitled "Persian Architecture and Mathematics: An Overview" provides a helpful introduction to Persian architecture and mathematics, as well as a good outline of the group of papers that make up this issue, contributed by Alain Juhel; Mahsa Kharazmi, Reza Afhami and Mahmood Tavoosic; Carol Bier, Maryam Ashkan and Yahaya Ahmad; Hooman Koliji, B. Lynn Bodner, Carl Bovill, and Reza Sarhangi himself. Also included is a glossary of special terms that appear in the issue.

The issue is completed by a pair of other research papers which describe the geometry and proportions of important monuments in Italy and Iran built around the same period of time: the fifteenth century. Giampiero Mele has analyzed the urban fabric contained within the city walls of the town of Acaya, in Italy's Apulia region, an analysis made possible by a new integrated survey involving manual, topographical, photogrammetric and 3D laserscan techniques. His research has allowed him to shed new light on how the town was originally laid out and then changed over the ensuing centuries. In a similar vein, on the basis of his own careful survey, Mojtaba Pour Ahmadi has analyzed the mausoleum of Sheikh Zāhed-e Gīlāni in northern Iran in order to shed light on how the unusual dome of the building might have been designed. Although it will come as no surprise to readers of the *NNJ*, finding geometric techniques used to design works of architecture and urban design in very different cultures underlines the universality of geometry, and the intimate relationships between architecture and mathematics.

As I write this, we are very close to time for our biennial Nexus conference on architecture and mathematics: Nexus 2012: Relationships Between Architecture and

Nexus Netw J 14 (2012) 195–196
DOI 10.1007/s00004-012-0115-7; *published online* 12 June 2012
© 2012 Kim Williams Books, Turin

Mathematics, to take place in Milan, Italy, 11-14 June 2012. The next two issues of the *NNJ* will feature papers presented at the conference.

I hope you enjoy this very special issue of the *NNJ* as much as I did!

[signature: Kim Williams]

About the author

Kim Williams is the director of the conference series "Nexus: Relationships Between Architecture and Mathematics" and the founder of the *Nexus Network Journal*.

Reza Sarhangi

Department of Mathematics
Towson University
8000 York Road
Towson, MD 21252 USA
rsarhangi@towson.edu

Keywords: Persian architecture,
Persian mathematics

Letter from the Guest Editor

Persian Architecture and Mathematics: An Overview

Abstract. *NNJ* Guest Editor Reza Sarhangi introduces the Editorial Committee for this issue: Carol Bier, B. Lynn Bodner, Douglas Dunham, Mohammad Gharipour, and Hooman Koliji, and the papers dedicated to Persian Architecture and Mathematics in *NNJ* vol. 14, no. 2 (Autumn 2012).

1 Persian architecture and mathematics: an overview

Persian architecture has long been known as the embodiment of mathematical and geometrical premises. From remote history to recent times, edifices and landscapes were designed based on rules of mathematics; their implementation required skill in practical geometry. One could consider the mutual interaction between the disciplines of mathematics and architecture as divided into three major periods: ancient Mesopotamia, pre-Islamic Persian Empire, and the Islamic Era.

Extant buildings of pre-Achaemenid architecture are few, but the ruins that remain provide evidence for the dominance of geometry in conceiving architectural space. Informed by the Babylonian culture, ancient Persians used geometric shapes as ordering tools for their monumental buildings. The Chogha Zanbil ziggurat in southwestern Iran, a stepped pyramid temple, used concentric ascending square forms in its design. The use of mathematical computation was not, however, limited to architecture. In drainage and sewer systems, Persians employed advanced knowledge of mathematics. Sewer systems in Shahr-i Sukhteh ("Burnt City") in southeastern Iran (around 3200 B.C.), and Nari Qanat (about 3500 B.C.) demonstrate their builders' knowledge of geometry. Arts and crafts of this period represent ornamental motifs such as animals and flora in highly abstract geometric forms.

The second period, marked by the founding of the Achaemenid Empire (550-330 B.C.) by Cyrus the Great, left numerous marks on the civilizations and cultures in a large part of the world from North Africa to Europe, India, and China. Achaemenid Persia was a large empire that encompassed modern day Iran, Iraq, Armenia, Azerbaijan, Afghanistan, Tajikistan, large parts of Pakistan, Central Asia and India. Unifying diverse ancient cultures, the Achaemenids brought together scholars and scientists of all fields, including mathematicians and astronomers, from different parts of their own empire as well as their neighbors and rivals. As significant testimonies of the knowledge of mathematics of this period, one could refer to buildings, gardens and irrigation systems, bridge construction, and arts and crafts. Applied geometry was used as an ordering tool in conceiving building plans and façades. Roof structures of this period were built of both wood timbers (long spans) and stone (small chambers). Achaemenid building ornament, often related to political and cultural rituals, represented abstract portrayal of vegetal forms.

The Achaemenid Empire was succeeded by the Seleucid Empire (the Hellenistic conquerors who were influenced by Buddhism), Parthians (from the Eastern part of the Iranian plateau who were influenced by Hellenistic culture), and Sassanids (who

Nexus Netw J 14 (2012) 197–201
DOI 10.1007/s00004-012-0116-6; *published online* 5 June 2012
© 2012 Kim Williams Books, Turin

established Zoroastrianism as a state religion). The Sassanid dynasty ended with the Muslim Arab conquests (651 C.E.). The interchange of cultures and combinations of arts among nations living in a vast area conquered by Arabs created a type of art known as Islamic. Sassanids introduced domed structures into their buildings. The catenary arch of Ctesiphon (today in Iraq) demonstrates use of curvilinear geometric forms in space. The squinches of the dome in the palace of Sarvistan, Fars Providence, Iran, are late pre-Islamic examples of complex curved surfaces.

The flourishing of geometry and mathematics in the Islamic periods of Persia is found roughly between the tenth and eighteenth centuries. The Persians contributed to the flowering of knowledge in Abbasid Baghdad. Because of their background in art and architecture, Persians became very influential in lands governed by Islamic rulers. The Seljuk period exemplifies material exploration through geometry; brick structures demonstrate the dominance of geometric knowledge applied to construction at various scales, from ornaments to domes. Seljuk architecture showcased some of the purest and most sophisticated forms of geometric design. The Friday mosque of Isfahan is one of the most elegant monuments of this period. The monochromatic brick that was the dominant building material prior to the thirteenth century urged architects-engineers of the time to conceive highly elaborate and sophisticated geometric forms to enliven their architecture. These designs were later widely used in Iran and Central Asia. The Timurids' use of geometric patterns has been handed down to us through rare extant scroll drawings. Geometric interlocking patterns, such as *girih* (Persian, 'knot', geometric lines that form an interlaced strapwork), were widely used as a geometric grammar to order forms of two- and three-dimensional ornaments in architectural revetments and domed spaces.

Knowledge of mathematics resulted in the erection and embellishment of a variety of buildings and landscapes in Persia. This tradition culminated in the Safavid dynasty (1501-1736 C.E.), when the application of the knowledge of geometry can be found from the scale of urban design, garden design, architecture and building ornaments, to forms of arts and crafts. The Safavids redesigned their new capital, Isfahan, around a new urban core, today called Naghsh-i Jahan Square. As in other new developments, the new urban development of the capital embodied geometric forms on massive scales, articulated by small tectonic modules. The significant scale of landscape architecture not only required the extensive use of geometry in design and layout of gardens but also in the design of systems for their irrigation. This period also marks a physical and intellectual change in the use of geometry. The emergence of vegetal ornament, ordered by underlying geometric forms, became increasingly popular among architect-engineers, introducing a new era of Islamic architectural ornament. The realistic vegetal and abstract geometric forms alluded to the spiritual attributes of architecture.

2 Mathematics: an intellectual and practical vehicle

Since early times, Persians regarded mathematics as an area of knowledge essential for thinking as well as for very pragmatic reasons. The use of symbolic Mandala forms in the architecture of the time alludes to metaphysical and intellectual attributes of geometry. The Islamic era, as evidenced by Abbasid Baghdad (the cultural and scientific capital of the Islamic world at the time) embraced mathematics, along with the philosophies of the Alexandrian and Persian schools. These two key realms of thought highly influenced Islamic art and architecture. Gundeshapur, the Sassanid intellectual center for the study of philosophy, sciences, theology, and medicine, along with the School of Alexandria,

served as intellectual resources for the Islamic court. With the establishment of the House of Wisdom (Bayt al-Hikma) in Abbasid Baghdad, a scientific institution, and the movement to translate Greek and Persian texts, scholars were able to paraphrase and develop earlier knowledge and disseminate it throughout all Islamic lands. The early Abbasid court, benefiting from Sabians' knowledge of mathematics and astronomy, developed the knowledge of mathematics and its applications on many fronts. The Sabian mathematician Thabit ibn Qurra's contribution with Banu Musa in translating Euclid's *Elements* is an example in this regard. Euclid's *Elements* were long used by Islamic and Persian scholars in early Islamic centuries, until the fourteenth century when prominent Persian polymath Nasir al-Din Tusi's edition of Euclid's *Elements* became widely accepted as a major mathematical resource.

Mathematicians became responsible for disseminating mathematical knowledge to the artisans and craftsmen. Treatises on practical geometry assisted architect-engineers in their conceiving of buildings and structures. Mainly addressing issues concerning *ilm al-hiyal* (a subcategory of practical geometry), practical geometry provided craftsmen and architects with essential "know-how" for working with geometric shapes and figures. The treatises were simplified forms of theoretical geometry explained in a practical manner to be used in the real world. One surviving example is *Kitāb fīmā yahtā ju ilayhi al-sāni' min a'māl al-handasa* (*A book on those geometric constructions which are necessary for a craftsman*) by Abū'l-Wafā Muhammad al-Būzjānī (940-998 C.E.), a Persian polymath, mathematician and astronomer of the tenth century, who lived most of his life in Abbasid Baghdad.

An anonymously-authored attachment to one of the copies of al-Būzjānī's treatise provides a glimpse into the depth of investigations of geometric patterns in the eleventh to thirteenth centuries. Most likely added to al-Būzjānī's treatise in the twelfth century, the *Fi tadakhul al-ashkal al-mutashabiha aw al-mutawafiqa* (On Interlocking Similar or Congruent Figures) introduces about 110 various *girih* patterns. Al-Bayhaqi (1100-1169 C.E.), a Persian historiographer and biographer, cited the astronomer and mathematician al-Isfizari (1123 C.E.), who regarded the science of geometry as the foundation that "architects and bricklayers had to follow." Another entry about the geometer al-Hakim Abu Muhammad al-'Adli al-Qajini "establishes a hierarchy based on the differing levels of geometric knowledge required by the designing architect and the mason executing his designs; the architect with his practical knowledge of geometry follows after the theoretical geometrician, and the bricklaying mason comes last." In this sense geometry and mathematics provided a connection between the very practical stages of building construction and the associated conceptual and transcendental ideas. Mathematics was regarded as an intellectual tool capable not only of providing answers to abstract mathematical problems, but also of penetrating the spiritual realm. Concurrently, mathematics was a tool available to engineers and artisans for everyday practice in making edifices, tools, or objects.

3 The scope of this issue

The present issue of the *Nexus Network Journal* is an attempt to offer a variety of approaches and interpretations of the presence and use of mathematics and geometry in Persian architecture. The papers are conceptually arranged. A chronological order provides the reader with a historical understanding of the subject matter. Papers with similar themes are ordered in a way that physical and tectonic descriptions come first and more interpretive and conceptual themes follow.

This issue begins with Alain Juhel's "Touring Persia with a Guide Named ... Hermann Weyl," an overview of the presence of mathematics in Persian architecture using an approach similar to that taken by Herman Weyl's book *Symmetry*. Next, in "A Study of Practical Geometry in Sassanid Stucco Ornament in Ancient Persia," Mahsa Kharazmi, Reza Afhami and Mahmood Tavoosic examine pre-Islamic ornaments of the Sassanid period in regards to geometric frieze -patterns. This article contains drawn analyses of various types of patterns that in repetition create groups of associated forms.

"Along the Lines of Mathematical Thought: The Decagonal Tomb Tower at Maragha" by Carol Bier is a critical study of overlapping polygons and radial symmetries, which includes analyses of the geometric patterns that appear on the tympanum at Gonbad-e Surkh in Maragha and on the western tomb tower at Kharraqan. In "Significance of Conical and Polyhedral Domes in Persia and Surrounding Areas: Morphology, Typologies and Geometric Characteristics" Maryam Ashkan and Yahaya Ahmad introduce typologies of dome structures and their tectonics by examining a variety of dome structures across history. This is followed by a semantic discussion of the role of geometry in the construction of domical structures: Hooman Koliji's "Revisiting the Squinch: From Squaring the Circle to Circling the Square", which takes an interpretive approach to the intellectual role of geometry in vault structures, and, in particular, the case of the Friday Mosque in Isfahan. B. Lynn Bodner's "From Soltaniyeh to *Tashkent Scrolls*: Euclidean Constructions of Two Nine- and Twelve-Pointed Interlocking Star Polygon Designs" is an analysis of two star polygon *girih* patterns used from the fourteenth to the seventeenth centuries, both of which are considered to be of Persian origin. Carl Bovill looks into the geometric patterns of Mirza Akbar, an architect of late-eighteenth-century Qajar, Iran. "Using Christopher Alexander's Fifteen Properties of Art and Nature to Visually Compare and Contrast the Tessellations of Mirza Akbar" is a discussion of the use of tessellations in pre-modern Iranian ornament. Finally, in "Interlocking Star Polygons in Persian Architecture: The Special Case of the Decagram in Mosaic Designs," Reza Sarhangi studies a series of Persian mosaic designs that have been illustrated in scrolls or decorated the surfaces of old structures.

As the reader will notice, this issue, while including a wide historical, tectonic, and conceptual spectrum of Persian architecture, is by no means an exhaustive representation of the rich tradition of Persian architecture as it pertains to mathematics. We have attempted to include a variety of papers that represent diverse attributes of Persian architecture and mathematics. However, the review process was rigorous and did not allow an ideal diversity of papers to be included in this issue. The Call for Papers announced in September 2010 for this special issue was widely answered by scholars from different fields. In addition to a thorough review by the editor, each paper underwent blind peer-review by two reviewers. Finalists received comments from the reviewers and revised their papers accordingly. At this stage, a group of scholars comprising academic mathematicians, architectural historians, and architects was invited by the editor to serve on an editorial committee. This group, which included Carol Bier, B. Lynn Bodner, Douglas Dunham, Mohammad Gharipour, and Hooman Koliji, was responsible for making final reviews of the papers and cross-reviews among all papers. In this second stage, further comments were shared with authors and final revised papers were resubmitted to the editorial committee. The committee oversaw overall integration and connections among final papers in terms of content and form.

I thank the authors for their contributions, Kim Williams for giving us this unique opportunity, and the editorial committee for their hard work.

4 Glossary

Because it was also found that most papers used terminologies specific to Persian architecture, which may be foreign to Western readers, the board decided to provide the following brief glossary.

Azaj: Cradle Vault, Barrel Vault

Girih: Literally meaning knot in Persian. In architecture, it refers to the interlocking geometric patterns found in two-dimensional revetments or three-dimensional vaults or structures.

Gunbad: Dome

Handasa: Geometry

Iwan: Vaulted hall or space, walled on three sides, with one end entirely open.

Kar-Bandi, Rasmi-Bandi: Technical terms used by masons and architects as an act of making interlocking patterns in construction.

Madrasa: Islamic academy, where not only theology, but also literature, poetry and sciences were taught.

Mashrabiyah: A type of window enclosed with carved wood latticework.

Mihrab: A niche space in the wall of a mosque indicating the direction towards *Qibla* (direction to Mecca). In plan, *mihrab* is often found in semicircular or half-octagonal forms.

Minar: Minaret, a cylindrical structure of the mosque used as a visual landmark for the mosque and a means to deliver *adhan* to the public as a call for prayer.

Minbar: Pulpit; often a wooden structure similar to a pulpit for the *imam* or the clergy to deliver sermons.

Muqrnas: Stalactite-like structures built and hung under vaults or half-vaults. These structures were built out of plaster of paris in horizontal layers and vertical faces and were often covered with glazed tiles, colored glasses, and mirrors.

Pishtaq: Portal projecting from the facade of a building, usually decorated with glazed tile-work, mixing calligraphy and geometric designs.

Shabistan: A vaulted space adjacent to the mosque's courtyard. The plan of *shabistan* is a checkered-grid of columns.

Taq: Vault

About the guest editor

Reza Sarhangi is a professor of mathematics at Towson University, Maryland, USA. He teaches graduate courses in the study of patterns and mathematical designs, and supervises student research projects in this field. He is the founder and president of the Bridges Organization, which oversees the annual international conference series "Bridges: Mathematical Connections in Art, Music, and Science" (www.BridgesMathArt.Org). Sarhangi was a mathematics educator, graphic art designer, drama teacher, playwright, theater director, and scene designer in Iran before moving to the US in 1986. After completing a doctoral degree in mathematics he taught at Southwestern College in Winfield, Kansas (1994-2000), before moving to Towson University. In addition to writing many articles in mathematics and design, Sarhangi is the editor/coeditor of fourteen Bridges peer-reviewed proceedings books. He is an associate editor of the *Journal of Mathematics and the Arts*, published by Taylor & Francis in London.

Alain Juhel

Lycée Faidherbe
9, rue Armand Carrel
59034 Lille FRANCE
ajuhel@nordnet.fr

Keywords: Hermann Weyl,
geometry, symmetry, symmetry
groups, tessellations, tilings,
ornament, Persia

Research

Touring Persia with a Guide Named ... Hermann Weyl

Abstract. A journey across the lands that were part of Persia long ago offers a friendly introduction to symmetry and symmetry groups, as presented in Hermann Weyl's seminal and popular book, *Symmetry* (1952). Weyl's intent was to show how geometrical transformations first, then mathematical structures, could be better understood from a cultural point of view through art and architecture. Our intent is to provide a complementary set of selected pictures of Persian monuments to illustrate Weyl's ideas. Following the master, we have focused on different kinds of symmetries, starting from the simplest and oldest to those that are more complex, disregarding chronology or geography within the lands of Persia.

Introduction

Just before he retired from the Institute for Advanced Study in Princeton, New Jersey, Hermann Weyl (1885-1955) gave four "semi-popular" lectures on symmetry. These were gathered in a book simply entitled *Symmetry*, first published in 1952, "a masterful and fascinating survey of symmetry in sculpture, painting, architecture, ornament and design," according to *Scientific American*. At the time it was and still remains the kind of book that professional mathematicians seldom write: Weyl planned to demonstrate to people who were not acquainted with mathematics how familiar the mathematical concepts of symmetries and groups had been, from the dawn of civilization to the then brand new advances in physics, such as relativity and quantum mechanics. He explained in the foreword :

> I aim at two things: on the one hand to display the great variety of applications of the principle of symmetry in the arts, in inorganic and organic nature, on the other hand to clarify step by step the philosophico-mathematical significance of the idea of symmetry. As readers of this book I had a wider circle in mind than that of learned specialists [Weyl 1952: preface (not numbered)].

Consequently, his book surprises some readers: one will not find mathematical proofs nor even a bibliography. Definitions are precise, but the text runs along without pausing to introduce them. Although organized very carefully, dealing with symmetry from its common meaning to sophisticated achievements in contemporary mathematics and physics, this small book offers a stroll through places and time with unexpected jumps and backtracks. The backbone of the book demonstrates the growing complexity of geometrical and algebraic concepts; it must be kept in mind that the idea of *symmetry* is one of the oldest in mankind's development, while the concept of *group* is one of the newest, having emerged in the first half of the nineteenth century, although it was not applied to geometry until the second half of the century.

It seems evident that Weyl mostly journeyed virtually through libraries to locate relevant pictures and, as a result of then contemporary standards, the book contained only black and white snapshots. Half a century later, however, there is place for a work to

Nexus Netw J 14 (2012) 203–226
DOI 10.1007/s00004-012-0107-7; *published online* 2 June 2012
© 2012 Kim Williams Books, Turin

combine new techniques and to extend the area of investigation geographically. Even given greater facilities for traveling, this was nonetheless challenging in two directions at least:

– Attempting to obtain a representative collection of illustrations not restricted to European or ancient Mediterranean civilizations (I have undertaken this on my website, and it is a work in progress; see [Juhel]);

– Choosing a geographic region that seemed underrated in Weyl's book – not due to the author's taste or insufficient knowledge, but perhaps to a lack of images – and devising an itinerary through it that is parallel to that of Weyl. From this point of view, Persia was an ideal and quite evident choice.

Persia has had such a long and varied history and has covered such a large territory over time that it can be considered living testimony to Weyl's ideas about symmetry. It offers all kinds of examples to illustrate his points. Roughly speaking, from the time of Darius and the Achemenids (550-330 BCE) to Shah Abbas and the Safavids (1501-1736 CE), Middle Eastern and Central Asian countries comprised different parts of an empire, the extent of which varied through time, but always included a broad zone from Anatolia to the Indus. We shall choose our examples as widely as possible in this area, approximately corresponding to the extent of the Sasanian Empire (224-651 BCE) (fig. 1), keeping in mind that the borders of past civilizations are often quite different from political and contemporary boundaries. In our selection we also include a few monuments that attest to Persian influence in eastern China and northern India.

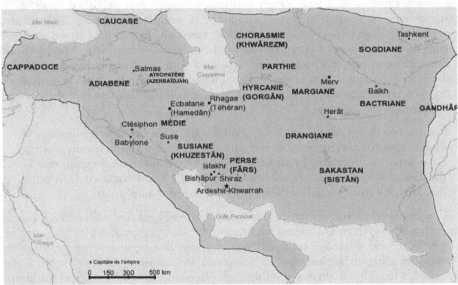

Fig. 1. The Sasanian Empire (about 500 CE). Map by F. Dany

We follow the plan of Weyl's book and classify examples according to the symmetries involved rather than by geographical or chronological considerations.

From harmony to symmetry

At the beginning of his book, Weyl points out an older common meaning of the word *symmetry* as a general feeling of harmony and balance. Even someone who is not a

mathematician or architect will experience the symmetry of Naqsh-e-Jahan Square in Isfahan or Registan Square in Samarkand as harmony and balance. But Weyl turns at once to the precise meaning of a geometric transformation and starts studying the simplest kind, a reflection across a line or a plane. It is the very first geometric transformation that artists used after having observed that human or animal bodies are invariant through it, so it is found in the oldest representation of idols: no fidelity to reality forced sculptors to carve two figures facing one another, each the reflected image of the other. One of two examples of Persian art in Weyl's book is taken from Darius's palace in Susa (490 BCE). The selected picture did not show the Mazdean winged sun above, but, as our image shows, its own reflection invariance respects this general symmetry, too (fig. 2).

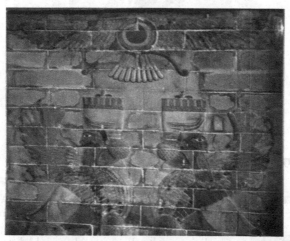

Fig 2. Susa Relief, glazed bricks (Teheran Museum)

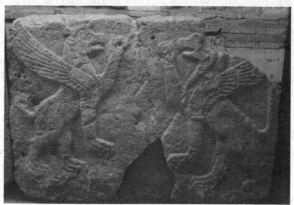

Fig 3. Hittite Relief from Gaziantep (Ankara Museum)

It is well known that Persian art was nourished by, and later incorporated, many previous elements from all the peoples in the Achemenid Empire. Reliefs with similar symmetry also existed in the Babylonian Empire, and in the Hittite world (fig. 3). Symmetry remained a key feature in the plans and elevations of palaces and places of worship after the Arab conquests. The elaborately decorated and enlarged portals of

mosques (fig. 4), called *pishtaqs,* celebrate reflection at the highest degree, where symmetry exists with respect to an axial plane, no longer a straight line.

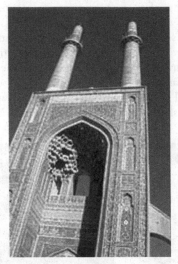

Fig. 4. Pishtaq of the Friday Mosque, Yazd (Iran)

Perfect symmetry or not?

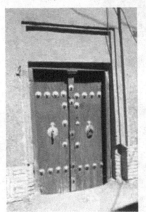

Sometimes symmetry seems to be perfect at first glance, then some infringement may appear upon a more careful inspection. There must be a higher reason, and in Persia more than elsewhere it is always a revealing sign of a social or religious order. First consider an old door in Yazd (fig. 5): in order not to violate symmetry, it has two knockers! But take a closer look: although the placement of the knockers preserves symmetry, their shapes don't. In addition, they do not produce the same sound, a feature designed to make it possible to know whether a man or a woman was knocking, so that the door would be opened by a person of same gender!

Fig. 5. Traditional door, Yazd (Iran)

The Shah Mosque (1611-1629), on the south side of Naghsh-e Jahan Square, Isfahan, may be considered in connection with symmetry and adjustments to symmetry in at least two ways. First, the entrance *pishtaq* is carefully aligned with the axis of the rectangular square, but the domed sanctuary is not similarly aligned (fig. 6a). The reason for this is the requirement that the building be oriented toward Mecca, which clearly was of the highest priority. The architect solved the problem in a very elegant way by building two successive *pishtaqs,* one along the side facing Naghsh-e Jahan Square, and a second one facing the courtyard, perpendicular to the Mecca direction. Between the two *pishtaqs* lies the magnificent blue-tiled courtyard. In this manner, symmetries are preserved both in the square and within the mosque. Visitors reorient their steps towards Mecca in the covered passage between the first *pishtaq* and the courtyard, leaving one symmetry behind and entering another. The same device has been used in the Sheikh Lotfollah Mosque on the eastern side of Naghsh-e Jahan Square.

Fig. 6a. Shah Mosque, Isfahan (Iran)

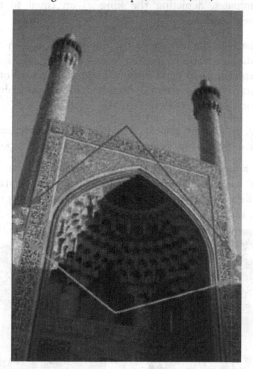

Fig. 6b. Entrance detail

Secondly, it is often said that barely perceptible changes were made in the ornamentation as a mark of respect for God: pure symmetry would mean that man is capable of the same perfection (fig. 6b). Weyl reports a similar legend regarding ancient temples. In figure 6b, arrows point to a pattern that has not been symmetrized; it is the name "Ali" (the Prophet Muhammad's son-in-law, who is highly regarded in Shi'ah Islam).

Our third example goes back to the foundation of the Sasanian Empire: in 226 CE, when Ardashir I became king. A stone relief, sculpted a few years later, tells the story [Bier 1993] as if it were a legend: King Ardashir takes a ring from the Persian sky god Ahura-Mazda (fig. 7).

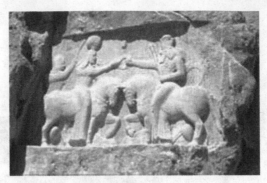

Fig. 7. Ahura Mazda (right) and Ardashir I (left), Naqsh-e Rustam (Iran)

Symmetry predominates, depicting the king as an equal to the God; but this geometrical rule was bent twice:

- first, in contrast with the forelegs of the horses, seen as if in a mirror (the raised left leg on Ardashir's horse facing the raised right leg on Ahura-Mazda's horse), the ring is given from right hand to right hand, the strength of the symbol having a higher priority. Weyl discusses this "mathematical philosophy of left and right," as he calls it, for a few pages [1952:20-25];

- second, a more subtle sign appears on closer scrutiny: the emperor is actually a little smaller than Ahura-Mazda, as a sign of respect. This is politically very clever!

Let us go back to a theoretical kind of perfect symmetry, the one generated by water as a mirror. Nobody has mastered this concept better than Persian architects! Their influence cannot be denied in the most perfect example in the world, the Taj Mahal, built in 1632 in Agra, India.

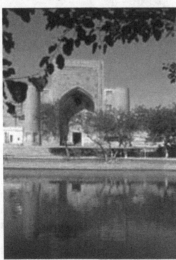

Fig. 8. Nadir Diwan Beg mosque, Bukhara (Uzbekistan)

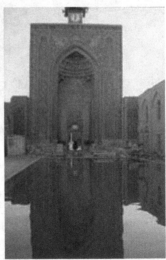

Fig. 9. Friday mosque, Kerman (Iran)

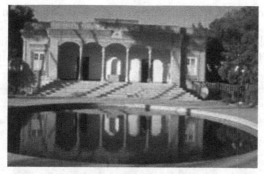

Fig. 10. Ateshkadeh Zoroastrian Temple, near Yazd (Iran)

In semi-desert zones, the scarcity of water gives even higher value to this daring plan. We can also notice that it is a friendly introduction to polygonal symmetries considered below, for in all these cases the resulting two orthogonal line-reflections generate a four element group (a so-called Klein Four-Group $K = R_2 \times R_2$; see the Appendix for precise definition of a group, and a Cayley's table of the Klein Four-Group) which preserves the frontal view through all its transformations (figs. 8, 9, 10). In Isfahan, the Chehel Sutun Palace (completed in 1647 under Shāh Abbas II, see fig. 19a below) got its nickname "40 columns Palace" from this symmetry property, as it has only 20 columns with a mirror reflection in the reflecting pool at the front!. What other trick could give us an opportunity to see this group act on the front elevation of a building?

Translations and rotations

Translations are the simplest geometric transformations after reflections, so Weyl examines this next. As an example of a figure that is invariant under a translation and its iterations, he refers to Darius's Palace in Susa [Weyl 1952: 49, fig. 25], but he could have chosen Persepolis as well: the Apadana stairways offer various examples, from the most basic one (fig. 11a, horizontal repetition of a single form) to the most unusual one, in which the direction of the translating vector is neither horizontal nor vertical (fig. 11b)!

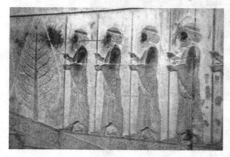
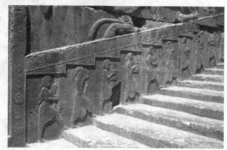

Fig. 11a, b. Stairways at Persepolis (Iran)

In fig. 11b, the pattern is not quite identical, of course, because the tributaries are carrying various gifts for the Great King.

In the relief at Susa, Weyl presents the case of a "fundamental" pattern (i.e., the smallest unit that generates the whole drawing through the iterations of one translation) made of two soldiers, differentiated by their garments. We can find a new implementation of this pattern of symmetry in the Apadana, where Persian soldiers

holding shields alternate with Median warriors (fig. 12a). This pattern of symmetry may also be seen in fig. 11b if we take the length of garments and the shape of caps into consideration. An older but more complex example was found in Susa at the time of Elamite civilization (thirteenth century BCE), where the pattern unit consists of three standing figures (fig. 12b).

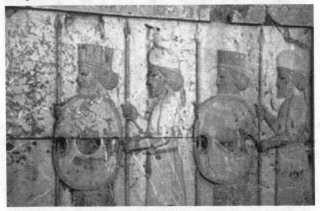

ig. 12a. Persepolis (Iran), Apadana, Achemenid period

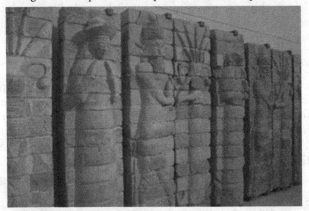

Fig. 12b. Susa (Iran), Apadana, Elamite period (Louvre Museum, Paris)

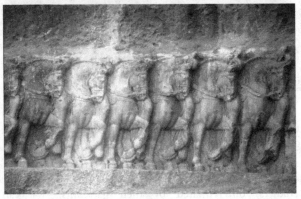

Fig. 13. Sasanian Relief, Bishapur (Iran)

Reliefs with similar patterns of symmetry were created centuries earlier by peoples who lived in areas that would later become parts of the Hittite Empire. The reliefs of the Hittites in central Anatolia, those of their successors in the eastern part of what is now Turkey, and the reliefs of Assyrians in Mesopotamia were among the sources for Persian art of the Achaemenid Empire, which assimilated the artistic traditions of its forerunners. Further along the time axis, we find beautiful translated horses among the Sasanian reliefs of Bishapur (fig.13).

However, the art of perfectly translated designs goes much farther back in time to Mesopotomian civilizations: translations are the natural outcome of rolling a cylinder-seal, whose function was to impress an authentic signature on a clay document. Median and Persian cylinder seals used symmetry similarly. From a geometric point of view, a single complete turn prints the pattern and each successive rotation prints translations. Fig. 14 shows an example with monstrous lions.

Fig.14. Cylinder Seal (4000 to 3000 BCE) from Uruk, Iraq (Louvre Museum, Paris)

This example shows a blend of line-reflection and translation, for the fundamental pattern has its own vertical line-symmetry: as this symmetry cannot be handled by rotation of the seal, the carving has been designed to include two animals facing one another with their necks interlocking.

Polygonal symmetries

In fact, Weyl proceeds in the opposite direction. Starting with a picture of translated patterns, each of length a, he imagines the result of applying it to a cylinder whose circumference is a multiple of a, say na, to introduce the finite groups R_n and D_n. The first one is a cyclic group of n elements, Id, r, r^2, ...r^{n-1} (r being a rotation such that $r^n = Id$); the second one is the dihedral group, that is, the group of all symmetries leaving an n-sided polygonal invariant: it has $2n$ elements, the n rotations in R_n and n line-reflections whose axes pass through the fixed point of the rotations. Weyl credits Leonardo da Vinci for discovering the fact that these are the only finite symmetry groups in the plane [1952: 66] while studying the symmetries in churches. Weyl adds, "In architecture the symmetry of 4 prevails" [1952: 65].

On second thought, this may be surprising: there are many more monuments based on a rectangular than there are based on a square. But of course, it must be understood as "among the regular polygons". Square monuments are found in nearly all civilizations, even those that are totally unrelated, but Central Asia offers two gems of this type: the

ziggurat at Chogha Zambil, near Susa in Iran (fig. 15) and the Samanid Mausoleum, which is the tomb of Ismaïl I and his successors in Bukhara, Uzbekistan (fig. 16). Chogha Zambil was built by the Elamites about 1250 BCE, and the tomb in Bukhara was built in 905 CE; both feature the D_4 symmetry group.

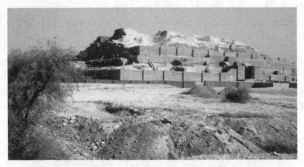

Fig. 15. Chogha Zambil, near Susa, (Iran)

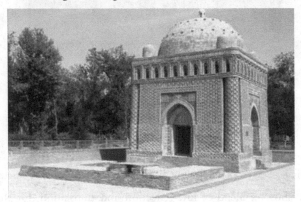

Fig, 16. The mausoleum of Ismaïl Samani, Bukhara (Uzbekistan)

Other occurrences of D_n may be found, provided we restrict ourselves to the study of the ornamentation rather than the general shape of the buildings. The D_6 group, for instance, is encountered in the ceiling of the famous mausoleum of Oljeitu in Soltaniyeh, Iran, which was built in 1312 CE (fig. 17).

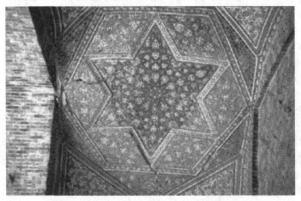

Fig. 17. Oljeitu's Mausoleum, Soltaniyeh (Iran)

We can also observe a D_{12}-invariant pattern at the center of the six-pointed star: the artist implicitly uses the fact that D_{12} is a subgroup of the D_6 group! The mausoleum itself is based on a D_8-invariant octagon, perhaps the regular polygon most frequently used by architects after the square; a beautiful example of D_8 is the base of the Burana tower (fig. 18) in the Tien-Shan mountains of the Kyrgyz Republic. Erected at the end of the ninth century, part of a minaret half-destroyed by an earthqake, it shows how far to the east the influence of Persian architecture spread.

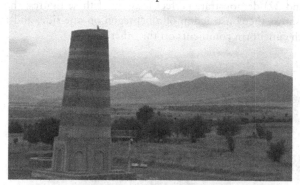

Fig. 18. Burana tower (Kyrgyz Republic)

As Weyl says, occurrences of an odd n are far more scarce, which seems a bit strange, as the means of constructing a pentagon were well known from both the Greek tradition and in medieval Persia. Pentagons and decagons appear relatively frequently as ornamental patterns on the ceilings and walls of civilian and religious monuments. Fig. 19a shows an example from the ceiling of the Chehel Sutun Palace in Isfahan (completed in 1647 under Shāh Abbas II).

Fig. 19. a, left) Chehel Sutun Palace, Isfahan (Iran); b, right) City Palace, Jaïpur (India)

This pattern with pentagons and decagons is indeed classical; it is documented from Turkey in the west to Xinkiang, China in the east. It is known in India, as shown in this *jali* (a type of window with carved wood or stone lattice openwork called *mashrabiyah* in North Africa and the Middle East) (fig. 19b). This is a blend of D_{10}-invariant patterns (the large ten-pointed stars) and D_5-stars, cleverly completed with quadrilaterals (tiling the plane with pentagons being impossible).

An *iwan*, a kind of vaulted hall in an Islamic monument, of the Friday Mosque in Yazd, Iran, shows several seven-pointed stars (Fig 20). The walls themselves are ornamented with a D_{10} pattern, but the trick was to insert the D_7 pattern inside the roof, just where the space is reduced so a ten-sided pattern could no longer be inserted. Hardly anyone — maybe only a mathematician? — would observe this "minor" change; rather, they percieve a perfect tiling. We might wonder why heptagons or seven-pointed stars are so rare, for approximate constructions were certainly known. The two early examples below (figs. 21 and 22) demonstrate perfect mastery of these figures: the piece from the Louvre (fig. 21) shows the construction of a heptagon on one side, and the construction of a hexagon, with cuneiform comments on the other side.

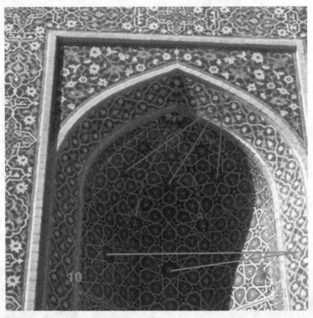

Fig. 20. Friday Mosque, Yazd (Iran) with several seven-pointed stars above and ten-pointed stars below as indicated

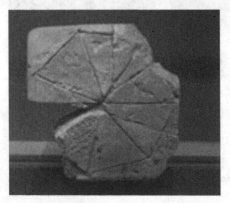
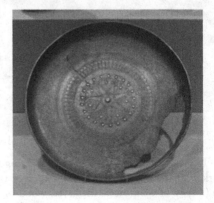

Fig. 21 (left). Constructing the heptagon, Susa clay tablet (Louvre, Paris).
Fig. 22 (right). Bronze Bowl, Nimrud, Neo-Assyrian period, ninth-eighth century BCE (Metropolitan Museum of Art, New York)

Rotation without reflection

Chasing R_n means going one step further in scarcity. However, patterns R_n but not D_n-invariant have fascinated people since the dawn of humanity: "It seems that the origin of the magic power ascribed to these patterns lies in their startling incomplete symmetry—rotations without reflections" [Weyl 1952: 67].

When you enter Yazd, you often hear a boast from natives: there are no mosques anywhere like the ones in Yazd. From our geometrical point of view, this is certainly true: we found an R_6-invariant pattern on the mihrab of the Friday Mosque (fig. 23a), and, located similarly in the spandrel above the arch, on the impressive *pishtaq* of the Amir Chakhmagh Mosque (fig. 23b).

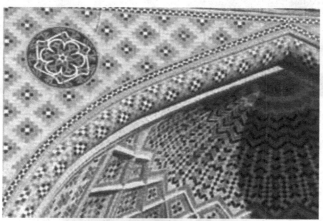

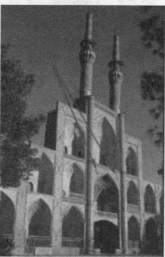

Fig. 23. a, above) Friday Mosque, detail of the mihrab, Yazd (Iran); b, right) Amir Chakhmagh Mosque, Yazd (Iran)

In the same monument, we can find the most frequent R_n-invariant patterns, with $n = 4$ (fig. 24). Another nice one appears in the corridor between the two *pishtaqs* of the Shah Mosque in Isfahan (fig 25).

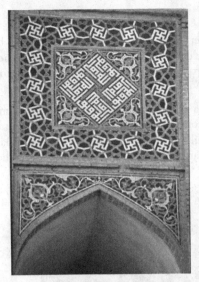

Fig. 24 (left). Amir Chakhmagh Mosque, Yazd (Iran) Fig. 25 (right). Shah Mosque, Isfahan (Iran)

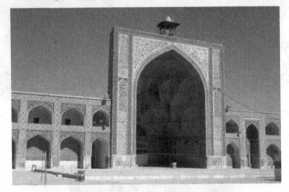

Fig. 26a. Friday Mosque, Isfahan (Iran)

Fig. 26b. Friday Mosque, Isfahan (Iran), detail of pattern in the western *iwan*

Of course, for a mathematician, the most fascinating pattern lies in the western *iwan* of the Friday Mosque in Isfahan (fig 26a): in addition to its inherent beauty, it offers a famous demonstration of the Pythagorean theorem (fig 26b) by Abu Al-Wafa (940-998). His celebrated book, *Geometrical Constructions useful to Craftmen* (*Kitab Fi Ma Yahtaju Al-Sani Min Al-a Mal Al-Handasiyya*), became so popular that it could have been used by an architect or craftsman without help from a professional mathematician, and it had been precisely intended for that purpose.

Ornamental symmetries

The combination of two-directional translations and the finite groups enumerated above gives rise to *wallpaper groups*; these are associated with the different ways of tiling a plane by repetition of a single design. If the tiles are regular polygons, they can only be equilateral triangles, squares or hexagons; the most beautiful example of the latter may be found in Ulugh Beg's Madrasa (a *madrasa* is an Islamic academy, where not only theology, but also literature, poetry and sciences were taught) in Samarkand, built in 1420 CE. The open-work brick balustrade (fig. 27) was indeed a revolutionary prince's idea, because it took the place of the usual high, solid wall that made it impossible to see in or out: its architectural function was to keep the scholars somehow isolated from the noisy marketplace, while keeping some symbolic social link between the elite and the people.

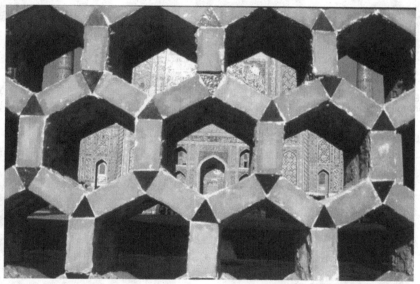

Fig. 27. Shir Dor Madrasa (built 1636 CE) as seen through the open brickwork of Ulugh Beg's Madrasa (built 1420 CE), Samarkand (Uzbekistan)

Do not think that this is the only item of geometrical interest in this madrasa: the artists who worked on the walls inside showed a deep understanding of ornamental geometry in creating arrangements of different regular shapes, none of which can be used to tile the plane by itself, but could do so when gathered together in a pattern that can be translated in two directions: this has already been observed in figs. 19a and 19b. We find a fine example on the interior wall of an *iwan* where the fundamental pattern is a combination of pentagons, hexagons and enneagons, with heptagons inside the enneagons (fig. 28b)!

Despite the fact that very sophisticated tilings were used in purely religious monuments, it would be hard to believe that these works had no connection with the Prince's deep appreciation of astronomy and mathematics: Ulugh Beg (1393-1449), a grandson of the warrior Timur-Leng, devoted his patronage to science, and, as a Viceroy of Samarkand from 1409 to 1447, he managed to obtain the funding for an observatory, schedule the building of the madrasa, and gather a research team of seventy astronomers to work in it! Among the distinguished scholars were the astronomer, Qadi-Zada-al-Rumi (1364-1436), and the mathematician Al-Kashi (1380–1450), who may be regarded as the father of the famous successive approximations method. He designed this to compute sin (1°) with an accuracy of ten sexagesimal places, about 200 years ahead of Kepler (1618). Six centuries later, this remains the standard method of computing roots of more or less intricate equations arising from astronomy!

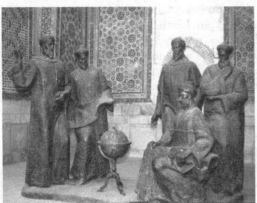

Fig. 28. a, above) Statues of Ulugh Beg and his astronomical team, Ulugh Beg Madrasa, Samarkand (Uzbekistan);
b, right) Detail of the tiling, inside wall of the *iwan*

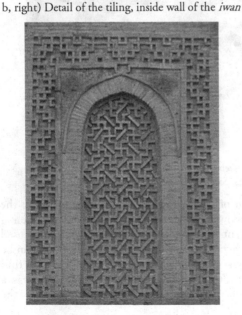

Fig. 29. a, left). Blind arch of the Burana Tower (Kyrgyz Republic);
b, above). Detail of brick ornament

A tiling may have an underlying lattice based on a square, but this does not mean that the subgroup of the transformations that fix one point must be the symmetry group of the square, namely, D_4. For example, in figs. 29 a, b the blind arches of the Burana tower (see fig. 18) show only rotation and translation invariance, without any reflection: if we consider the red dot in fig. 29b as a corner of the fundamental square, then the symmetries leaving it invariant are the R_4 group.

Though not located in Persia, the Burana tower exhibits brickwork typical of Islamic Central Asia around the year 1000 CE. The extent of Persian influence is evident when it is compared, for instance, to the brick patterns of the Samanid Mausoleum in Bukhara. The patterns of symmetry are not so far from the "mauresque" patterns of Weyl's fig. 66 [1952: 114], having the same invariance group, classically named *p4* in the theory of wallpaper groups (see [Frieze Groups] and [Groups] for notations and details).

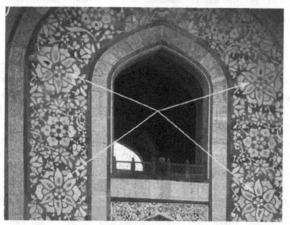

Fig. 30. Akbar Mausoleum in Sikandra, near Agra (India)

In a less severe style, many such combinations of patterns may be observed in Mughal monuments, for instance, in Akbar's Mausoleum (built 1613 CE) near Agra, where the Persian influence is easily recognized in both the general plan and in ornamentation (fig. 30). Here, the artist mixes a taste for geometry with a taste for nature and flowers. As Weyl points out [1952: 58], flowers frequently offer rotational symmetries of order 5 or 6! A careful inspection reveals, indeed, that local occurrences of D_5, D_6 and R_6 are present. Check the slight rotation of the petals! And notice the vertical invariance by translation.

Another example is offered by the world-famous Taj Mahal in Agra, which reflects the influence of Timurid mausoleums; its chief architect, Ustad Ahmad Lahauri, was said to be Persian.

A last example is the caravanserai of No-Gonbad (fig. 31), where we can see translations and symmetries and the winding of patterns around the corner towers. Note that the "arrows" at the top of the towers have been directed according to a plane reflection with respect to a (virtual) vertical plane through the main door.

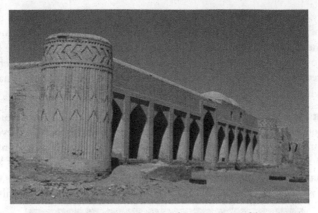

Fig. 31. No-Gonbad, on the road from Yazd to Isfahan (Iran)

Scale changes

When he turns to three-dimensional space and similarity groups, Hermann Weyl no longer refers to architecture, but to the works of nature, flowers and seashells. There are, however, examples from architecture: a wonderful example in brick is offered by the Emin minaret in Turfan (Xinkiang, China), built in 1778 CE (fig. 32). Its conical shape ensures its invariance by a continuous group of similarities (the common center of which is a virtual point, namely the apex of the cone; the tower is only a truncated part of it) and the brick protrusions trace conical helices on it. There seems to be a constant angle with the vertical axis of the tower, which the architect has taken care to maintain. This is the fundamental property of a helix, each family being invariant through a discrete subgroup of the group – one growing while turning right, the other while turning left.

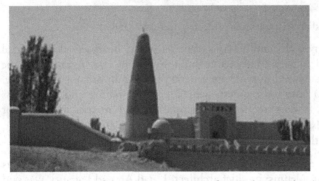

Fig. 32. Two views of the Emin minaret, Turfan, Xinkiang (China)

From geometry to abstract groups

Of course, we shall not find on the roads of old Persia any connection with one of the topics mentioned in the final chapter of Weyl's book, the use of group theory in relativity or quantum mechanics. Nor do we find the extraordinary development of group theory in itself, which occurred in the twentieth century. The struggle with the classification of finite groups ended more than thirty years after Weyl's death in 1955. Nonetheless, there is a spiritual link with Weyl's final topic, Galois theory, because it deals with the resolubility of algebraic equations: don't forget that in order to illustrate these symmetry groups in Persia, we have traveled in the native lands of algebra, the land of its father al-

Khwarizmi (780-850 CE) from Khwarizm, and the land of Omar Khayyam (1048-1131 CE), who came from Nishapur in Khorasan. Omar Khayyam was the first to make valuable attempts to solve cubic equations, that is, equations of the third degree.

But, as extraordinary as it may seem, we encounter in Persia a major and recent advance in the science of symmetries. Weyl's last chapter is entitled "Crystals. The General Idea of Symmetry". Thirty years after the publication of his book, quasicrystals were discovered in 1982, and in 2011, another three decades later, the Nobel Prize in Chemistry was awarded to Dan Shechtman for this discovery. The growth of quasicrystals can be modeled using Penrose tilings (1976), that is, structured tilings without any translation invariance. These tilings use a finite number of tile shapes, including pentagons and decagons. It is elementary to show that no regular tiling can use only this kind of tiles: just think of the sum of the angles at one vertex. Now comes the most astonishing fact: several researchers (first Makovicky [1992] and Bonner [2003], later Peter Lu and Peter Steinhardt [2007]) have found images of such tilings (with a few minor adjustments) in monuments of medieval Islamic architecture dating back to the Gonbad-e Kabud in Maragha (twelfth century); the most frequently cited is the later Darb-i-Imam shrine (fig. 33), Isfahan, Iran (1453)!

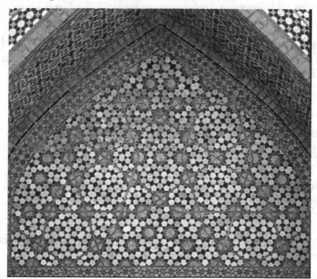

Fig. 33. Darb-i-Imam shrine, Isfahan (Iran).
Photo by K. Dudley and M. Elliff, reproduced by permission

Conclusion

Weyl's project was to show to his reader, who may not have been acquainted with mathematics, that there was a somehow secret but deep link between the history of civilizations and the more recent advances in science and the study of symmetry. In our times of highly specialized research and compartmentalized knowledge, interactions between scholars in science, on one hand, and history, art, and architecture, on the other, still remain a statistical exception; there is no doubt that not only does the general public not know them, but even selected audiences can hardly imagine them. Weyl was one of the very few who tried to bridge the gap between mathematicians and laymen and this mission must be carried on. A trip to Persia is a relaxed, pleasant way of staying in touch

with the spirit of Weyl's book, so let us hope that those who study group theory will want to discover Persian architecture and that tourists in Persia will yearn for a basic understanding of group theory!

Appendix: About groups
A (very) brief history of (the birth of) groups

Groups were introduced first by Lagrange (1770), Cauchy (1815) and Galois (1830). All were concerned with the solubility of algebraic equations of the fifth degree and higher. They were led to the study of *permutations* of the roots of a polynomial, and Galois was the first to link the existence of explicit formulas for solving this kind of equation to the study of *a group of permutations*. It is interesting to notice that, despite his brilliant, although tedious solution, Galois did not give a precise definition of the word *group*, which was not provided until Cayley (1854).

An other source for understanding group theory was the study of geometrical transformations, mainly undertaken by Klein (1870).

What is a (symmetry) group?

It turns out that all isometric transformations preserving a given figure – for instance, a polygon – have the following properties:

i. Applying two isometric transformations in succession, say r first, and then s, leads to a transformation sharing the preservation property; we denote it $s \circ r$, such that, M being an arbitrary point in the plane (or space),

$$s \circ r \, (M) = s(r(M));$$

ii. The identical transformation, *Id*, preserves the given figure;

iii. any transformation of this kind has a reciprocal one, that is, for any r there exists an s such that $r(M) = P$ is equivalent to $s(P) = M$; as $s \circ r = r \circ s = Id$, we write it $s = r^{-1}$;

iv. The order of "packing" when applying a third transformation t is irrelevant; one can apply first $s \circ r$ then t, or first r, then $t \circ s$.

$$t \circ (s \circ r) = (t \circ s) \circ r.$$

These four properties are Cayley's definition. A group ***does not have***, generally speaking, the property:

v. $s \circ r = r \circ s$ for any r, s.

If it does, it is said to be *commutative* or *Abelian*, but as we said, most transformation groups do not have this property.

Building Cayley's tables: the square group

It follows easily from the preservation of distances that a symmetry preserving a regular polygon may be regarded as a permutation of its vertices. This links geometric groups to permutations groups as studied by the pioneers, and it is of great help in computing $s \circ r$, as it is sufficient to look at what each vertex is transformed in.

For instance, here is Cayley's table for the square-preserving group: it has eight elements that act on the vertices *A, B, C, D* of a square as eight of the sixteen permutations on these four points. (Thus, it may also be considered as a subgroup of the group of all permutations on four elements as well). This group, denoted as D_4, is made

of four rotations Id, r (a 90° turn), $r^2 = r \circ r = -Id$, $r^3 = r \circ r^2$, (the R_4 subgroup, as can easily be seen on the table by checking property (i)) and four reflections s_H, s_V, s_1, s_2 with respective axes (H), (V), (Δ_1), (Δ_2).

It must be read in the following way: $a \circ b$ is computed from a in column and b in row. Notice that $s_H \circ r$ and $r \circ s_H$ are not equal, so one has to be careful in building and reading this table.

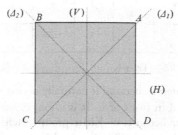

A square with four axes of symmetry

	Id	r	r^2	r^3	s_H	s_V	s_1	s_2
Id	Id	r	r^2	r^3	s_H	s_V	s_1	s_2
r	r	r^2	r^3	Id	s_1	s_2	s_V	s_H
r^2	r^2	r^3	Id	Ir	s_V	s_H	s_2	s_1
r^3	r^3	Id	r	r^2	s_2	s_1	s_H	s_V
s_H	s_H	s_2	s_V	s_1	Id	r^2	r	r^3
s_V	s_V	s_1	s_H	s_2	r^2	Id	r^3	r
s_1	s_1	s_H	s_2	s_V	r^3	r	Id	r^2
s_2	s_2	s_V	s_1	s_H	r	r^3	r^2	Id

Cayley's table for D_4, featuring R_4 in the top left corner

Building Cayley's tables: the rectangle group

A rectangle has fewer symmetries than a square: obviously (Δ_1), (Δ_2) are no longer axes of symmetry, (H), (V) are the only remaining ones. As for the rotations preserving it, there are just two, Id and $-Id$; $R_2 = \{Id, -Id\}$ is a group with two elements only.

	Id	$-Id$	S_H	S_V
Id	Id	$-Id$	S_H	S_V
$-Id$	$-Id$	Id	S_V	S_H
S_H	S_H	$-S_H$	Id	$-Id$
S_V	S_V	$-S_V$	$-Id$	Id

Cayley's table for Klein Four-Group, featuring R_2 in the top left corner.

This model is of some interest, because it naturally occurs when a symmetric facade is mirrored in a reflecting pond in front of it. It is a four element Abelian group, as R_4 is; however, they are different, because in Klein group, each element has the property $x \circ x = Id$, which is obviously false in R_4. An another way of looking at it is to think of $K = R_2 \times R_2$ with

$$(a , b) \circ (c , d) = (a \circ c , b \circ d).$$

When looking up how to build a four elements group from scratch (by writing down the different kind of tables), one can discover that these are the only existing four elements groups.

Polygonal symmetries and associated groups

Generalizing the case of the square, a regular n-sided polygon is preserved through the transformations of the *dihedral* group D_n, which has $2n$ elements, n axial symmetries and a subgroup of n rotations, the *cyclic* group R_n, (and, for this reason, called C_n by Weyl):

… we have the two following possibilities for finite groups of [symmetries] … : (1) the group consisting of the repetitions of a single proper rotation by an aliquot part $\alpha = 360°/n$ of $360°$; (2) the group of these rotations combined with the reflections in n axes forming angles $1/(2 \, \alpha)$. The first group is called the cyclic group C_n and the second the dihedral group D_n. Thus these are the only possible central symmetries in two-dimensions:

(1) $C_1, C_2, C_3, \cdots ; D_1, D_2, D_3, \cdots$.

… Leonardo da Vinci engaged in systematically determining the possible symmetries of a central building and how to attach chapels and niches without destroying the symmetry of the nucleus … [1952: 65].

As one may expect, the famous artist stated more than proved this property, and of course, he did not mention the group properties.

Acknowledgments

I am deeply grateful to Carol Bier for her careful editing and help in clarifying many points in this paper. All photographs are by the author unless otherwise noted.

References

The reader may be surprised by the lack of a bibliography in Weyl's book, but we must insist on the fact that it was not written for scholars in the field. In keeping with this idea, we offer only a limited selection of introductory works, together with a few references by the master himself. The interested reader will easily find further references to landmark papers by great mathematicians who contributed to the birth and evolution of group theory, such as Lagrange, Cauchy, Galois, Jordan, Klein, Lie, Cartan, and others.

ARMSTRONG, M.A. 1988. *Groups and Symmetry*. New York: Springer-Verlag.

BELL, John L. and KORTÉ, Herbert. 2011. Hermann Weyl. *The Stanford Encyclopedia of Philosophy* (Spring 2011 Edition), Edward N. Zalta, ed. http://plato.stanford.edu/archives/spr2011/ entries/weyl/.

BERGER, M. 1987. *Geometry I*. London, Berlin, Heidelberg: Springer-Verlag.

BIER, C. 1993. Piety and Power in Early Sasanian Art Pp. 171-194 in *Official Cult and Popular Religion in the Ancient Near East*, E. Masushima, ed. Heidelberg: Universitätsverlag C. Winter.

BONNER, J. 2003. Three Traditions of Self-similarity in Fourteenth and Fifteenth Century Islamic Geometric Ornament. Pp. 1-12 in *Proceedings ISAMA/Bridges: Mathematical Connections in Art, Music and Science*, R. Sarhangi and N. Friedman, eds. Granada.

BROUG, E. 2008. *Islamic Geometric Patterns*. London: Thames & Hudson.

COXETER, H. S. M. 1961. *Introduction to Geometry*. New York: John Wiley & Sons.

HAMMERMESH, M. 1989. *Group Theory and its Application to Physical Problems* (1962). Rpt. Mineola, NY: Dover Publications.

JOHNSON, D.L. 2001. *Symmetries*. London, Berlin, Heidelberg: Springer-Verlag.

JONES, O. 1987. *The Grammar of Ornament* (1865). Mineola, NY: Dover Publications.

LU, P. and P. STEINHARDT. 2007. Decagonal and Quasi-Crystalline Tilings in Medieval Islamic Architecture. *Science* 315, 5815 (February 2007): 1106-1110.

MAKOVICKY, E., 1992. *800-Year Old Pentagonal Tiling from Maragha, Iran, and the New Varieties of Aperiodic Tiling it Inspired* in *Fivefold Symmetry*, I. Hargittai, ed. Singapore: World Scientific.

ROTMAN, J. J. 1990. *Galois Theory*. New York: Springer-Verlag.

SENECHAL, M. 1990. *Crystalline Symmetries: An Informal Mathematical Introduction*. Bristol: Adam Hilger.

———. 1995. *Quasicrystals and Geometry*. Cambridge: Cambridge University Press.

SMITH, G. and O. TABACHNIKOVA. 2000. *Topics in Group Theory*. London, Berlin, Heidelberg: Springer-Verlag.

TIGNOL, J. P. 2001. *Galois Theory of Algebraic Equations*. Singapore: World Scientific Books 2001.

WEYL, H. 1939. *The Classical Groups: Their Invariants and Representations*. Princeton: Princeton University Press.

———. 1950. *The Theory of Groups and Quantum Mechanics* (1931). Mineola, NY: Dover Publications.

———. 1952. *Symmetry*. Princeton: Princeton University Press.

Internet references

[Frieze Groups]: http://en.wikipedia.org/wiki/Frieze_group.

[Groups]: http://en.wikipedia.org/wiki/Group_%28mathematics%29.

[JUHEL] "Art, Architecture et Symétrie". http://home.nordnet.fr/~ajuhel/Weyl/ weyl_intro.html (in French).

[Symmetry and Patterns]: The Art of Oriental Carpets:
http://mathforum.org/geometry/rugs/symmetry/.

[Wallpaper Groups]: http://en.wikipedia.org/wiki/Wallpaper_group#cite_ref-0

[Wallpaper Groups]: http://www.clarku.edu/~djoyce/wallpaper/index.html

About the author

Born in 1954, Alain Juhel is a former student at the École Normale Supérieure de Cachan, France. Since 1977, he has been training second-year undergraduate students for enrolment in the French Grandes Écoles (Science & Engineering Schools). His main interests are in arithmetic, geometry and trying to improve the status of mathematics as a popular science.

Mahsa Kharazmi[*]

*Corresponding author
kharazmi.mahsa@gmail.com

Reza Afhami
Afhami@modares.ac.ir

Mahmood Tavoosi
tavoosi@modares.ac.ir

Department of Art Studies
Faculty of Art and architecture
Tarbiat Modares University
PO Box: 14115-111
Tehran, IRAN

Keywords: Sassanid stucco,
Ancient Persia, practical
geometry, symmetry groups

Research

A Study of Practical Geometry in Sassanid Stucco Ornament in Ancient Persia

Abstract. This paper attempts to survey the use of practical geometry in Sassanid stucco ornament in Ancient Persia to understand the construction of geometrical structures and the progressive process of practical geometry. By use of geometrical analysis, we trace changes of ornament and extract the underlying geometrical structure; we also use symmetry groups, the seven frieze groups and the seventeen wallpaper groups, in order to arrive at a deeper understanding of practical geometry in Sassanid stucco ornament. These analyses will evince features of Sassanid stucco ornament such as: motifs as part of the whole; rotational symmetry and repetition of motifs in linear networks; application of complicated geometrical structures with rotational or reflection symmetry; the planning of whole decorative panels. Also, analyzing the Sassanid stucco panels allows us to discover their repetitive units, which are then classified according to frieze and wallpaper groups.

1 Introduction

In the ancient world, ornament was an inseparable part of architecture, so much so that Vitruvius, in his ten books on architecture [2009], advised architects to acquire extensive knowledge of history in order to realize underlying ideas through ornament as an expressive medium in architecture. The quadrivium of intellectual disciplines of classical education were arithmetic, geometry, music and astronomy. The practice of geometry served as an intellectual means to conceive the order of the universe [Lawler 1982]. For the Babylonians[1] and the Egyptians, it was a practical tool that was also essential in their everyday life [Sarhangi 1999].

In ancient Persia as well, ornament played a significant role in architecture and one can find the importance of ornament in the Achaemenid,[2] the Parthian[3] and the Sassanid[4] monuments, and then later in the Islamic period.

Sassanids, avoiding Greek forms, returned to the Achaemenid building design. Therefore, Sassanid art reflects individual dispositions and specific Persian innovations [Sammi 1984].

In this paper, we want to examine whether or not Sassanid stucco followed specific geometric rules. By analyzing Sassanid stucco ornament, we would also like to see the knowledge of geometry and mathematics possessed by ancient Persians. Existing research in the field of practical geometry relevant to architectural ornament mostly pertains to geometric patterns of Islamic architecture [Bonner 2003; Cromwell 2009; Lu and Steinhardt 2007; Özdural 2000]; scant research exists exploring the same subject in ancient Persian architecture and mathematics [Afhami and Tavoosi 2007; Baltrušaitis 1977; Roaf 1989]. This article aims to show the importance of geometry as an influential

component in the design process. The application of practical geometry in Sassanid stucco will be discussed and their geometrical analysis will be shown in order to arrive at a deep understanding of the connection between mathematics and art in ancient Persia.

2 Methods

Pre-Islamic stucco ornament from ancient Persia has been much studied [Kröger 1982; Herzfeld 1923; Ettinghausen 1979]. However, the uncertain dating of the styles and forms of works produced in stucco makes it impossible to establish an absolute chronology in the absence of precise archeological data. The same motifs continue to be repeated in essentially the same form for centuries. Roger Moorey [1978] and Jens Kröger [1982] argued that the stucco from Kīš[5] dates to the fifth century, while that from Ctesiphon[6] and Hisār[7] dates to the sixth or early seventh centuries. These opinions are based on the archeological evidence as well as on small variations in the vegetal and geometric patterns [Harper 1986]. Similarly, this present study views such issues in terms of the accuracy of dates of Sassanid stucco patterns as pending archeological investigation. For most buildings the date of the ornament is often the same as that of buildings' construction; however, in other cases the building ornaments were constructed in different epochs, making it very difficult to identify stucco ornament in a proper chronological context.

In section 4, Sassanid stuccos will be discussed based on their geometric structures and their figures and shapes will be ordered from simple to more complex designs. Two criteria were followed in the process of selecting case studies: First, examples should represent a typical ornament design; second, they can define a turning point or development in the application of practical geometry.

By using geometrical analysis (carried out by authors), we will show the latent geometric order in Sassanid stucco ornament and reveal the presence of practical geometry in the process of designing the stucco ornament in Sassanid era. This paper is also an attempt to find dominant organizations of Sassanid stucco motifs, basic modules and geometric rules for composing whole decorative panels. In the geometric analysis of the stucco, the following three aspects have been taken into consideration:

– Design of decorative motifs: study of the design method and geometrical organization of motifs;

– Pattern repetition: repetition of motifs in creating ornamental pattern as a major design principle;

– Pattern extension: extension of the decorative motifs in accordance with vectors of patterns extension and alternating rhythms, which shows an improvement in ornamental design.

In order to analyze the process, the seven frieze groups and seventeen wallpaper groups have been used to show the application of repeating units and symmetry. They will give us a better explanation for the creation of the Sassanid stucco patterns, and thus a better understanding of the ornament. These groups will be shown in section 4, Table 1 and Table 2.

3 Sassanid architecture and ornament

A collection of extant monuments, rock carvings, inscriptions, artifacts, and manuscripts have formed our present image of Sassanid history and culture. It was in the 1920s that the first archaeological excavation of a Sassanid site began at Ctesiphon in southern Mesopotamia [Mousavi 2008].[8] The Sassanid dynasty had its inception in a town situated near Persepolis,[9] Istakhr.[10] The office of chief priest of the sanctuary seems to have been linked with the secular administration of the region of Istakhr, and both functions seems to have been hereditary in a family which traced its origins to a legendary 'Sasan' a distant descendant of the Achaemenid dynasty. From this family came Ardashir.[11] He defeated Artaban, the last Parthian king, and firmly established the rule of the Sassanid by reorganizing the Persian Empire [Porada 1965]. With popular supporting, Ardashir I led a movement to restore Persian rule after several centuries of first Seleucid[12] Greek, and then Parthian rule. Under Ardashir and his successor, Sharpur I,[13] the Sassanid Empire re-expanded to include most of central Asia and areas of northern India [Feltham 2010]. Sassanid Kings made attempts to associate themselves with the Achaemenid lineages. They idolized Achaemenid art and benefited from the experiences gained through the Greek and Roman influences [Ghirshman 1962]. Unlike Achaemnids, Sassanid architects built their arch structures with bricks and relatively simple techniques, but they attempted to reach the grandeur and spectacular excellence of the Achaemenid palaces by adorning the buildings with abundant ornamentations [Godard 1965]. The convenience of the stucco technique accounts for its rapid growth. A pattern used in a given panel could be reproduced indefinitely by means of modules, and stucco workers started creating 'continuous motifs' that could proliferate endlessly in all directions [Ghirshman 1962].

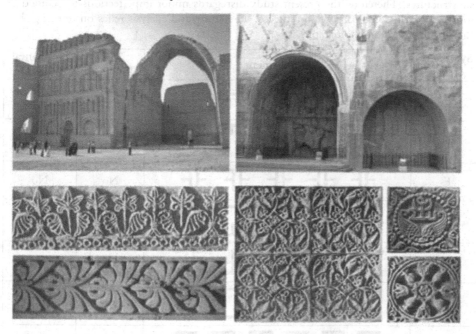

Fig. 1. Sassanid monuments and stucco

Sassanid stucco reliefs include a variety of subjects such as hunts, banquets, royal figures, and a great quantity of plant, animal, and geometric designs [Harper 1986]. Sassanid architect created appropriate contexts for developing the ornament. Palaces and ceremonial halls were designed to combine luxurious ornament with grandiose forms. Domes, vaults and ponderous walls provided large blank surfaces. The decoration completely covered imposts, friezes, dados, and walls, and the designs were used to enhance the effectiveness of the imposing masses. The ornament can be considered in three categories: purely architectural elements and frames; geometrical decoration consisting of abstract compositions of lines – curves, straight lines and angles–; and finally, plant ornament with leaf and floral motifs set into linear schemes; all these were, on occasion, executed in stucco [Baltrušaitis 1977]. Most of the stucco remnants of wall revetments comprise motifs combined to form continuous designs. Either the same or several motifs are repeated in a regular sequence, both vertically and horizontally. The preferred technique found in the revetments is stucco plaques of approximately one foot (30.48 cm) square. Therefore, these units could be multiplied and simply added one to another, similar to the tiling system of the Islamic architectural decoration. Indeed, these Sassanid stucco plaques can be considered as the antecedents of glazed tiles [Reuther 1977].

4 Geometrical analysis of Sassanid stucco

In this section we will analyze a selection of Sassanid stucco examples and study their hidden geometrical structure and regulating lines. The stuccos in this study contain some geometric imperfections, which could be due to the fact that they were handmade or possible minor distortions through time. However, we believe that they follow geometric substructures. Therefore, the present study disregards minor imperfections in geometric forms found in some parts of the stuccos. The study and analysis relies on drawings by the authors based on photographs.

Symmetry Group	Arrangement	180° Rotation	Horizontal Reflection
F₁		No	No
F₂		No	No
F₃		No	No
F₄		Yes	No
F₅		Yes	No
F₆		No	Yes
F₇		Yes	Yes

Table 1. Symmetries of the seven frieze patterns, after [Lui et al. 2004]

Table 1 shows the seven frieze groups that describe monochrome repetitive patterns along one direction [Liu et al. 2004]. We will use this theory of symmetry groups for periodic pattern perception.

4.1 Frieze groups

A frieze, or strip pattern, is a repeating pattern with translation symmetry in one direction. The repeating patterns may have rotational, reflection, or glide reflection symmetry. Frieze groups which has been standardized by crystallographers forms a system for naming repetitive patterns along one direction. Another naming system, suggested by mathematician John Conway [1992], is related to footsteps for each of the frieze groups.

Fig. 2 shows a section of Sassanid stucco frieze from Ctesiphon, preserved in the Metropolitan Museum of Art. This example shows a simple repetition of one single motif. This motif is drawn in a basic module and the subdivided lines in this module are based on arcs of concentric circles. This pattern can be classified in the first frieze group, F_1 as it contains only translation symmetry.

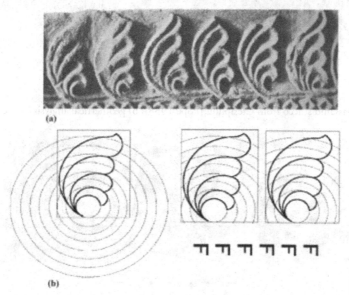

Fig. 2. a) Sassanid stucco from Ctesiphon [Pope 1938]; b) geometrical analysis by the authors

Fig. 3 is slightly different from fig. 2. The whole panel here is comprised of two different motifs repeated in an alternating rhythm. The figure in the right side shows the structure of the design. It shows that all motifs in this frieze are put on the accurate places emerging from geometrical dividing system. In order to surround two symmetrical parts of the motif, this frieze is based on a basic square frame, which is divided into two sections. By dividing each side of the square into two parts and by drawing the same square inside and also by drawing two tangent circles based on these subdivided lines, the motifs can be placed in an accurate form. This figure is also classified in the third frieze group, F_3, containing translation and vertical reflection symmetries.

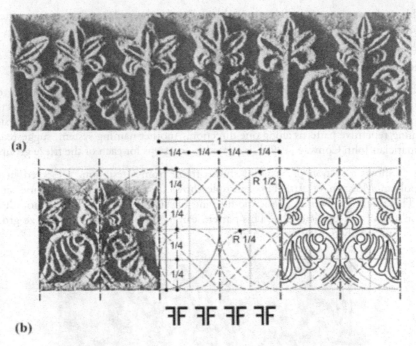

Fig. 3. a) Sassanid stucco from Ctesiphon [Pope 1938]; b) geometrical analysis by the authors

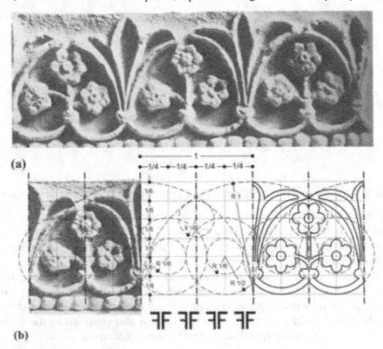

Fig. 4. a) Sassanid stucco from Ctesiphon [Pope 1938]; b) geometrical analysis by the authors

By use of arcs and curvilinear forms Sassanid architects found the best place of each motif in fig. 4. The radii of these arcs are based on divisions of the basic square. The large arc is drawn by diameter of two basic squares in order to place the leaves. The intersection of two large arcs determines the location of the flowers. This frieze is made based on repetitive unit that is classified in the third frieze group, F_3, containing translation and vertical reflection symmetries.

Fig. 5 shows a stucco panel of a royal hunting scene framed with frieze patterns.[14] In this panel, five different friezes are seen. Each of them will be analyzed separately in what follows.

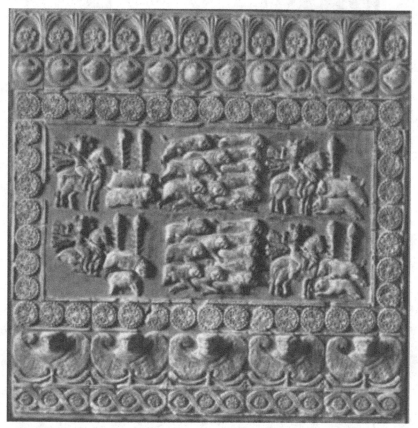

Fig. 5. Sassanid stucco ornamental frame of King hunting scene-Chahar-Tarchan
[Ghirshman 1962]

Fig. 6 is one section of a frieze from fig. 5. The line drawing shows the substructure of the design. This frieze, similar to the previous examples, is drawn based on the basic square module and its divisions. This frieze follows the third frieze group, F_3, containing translation and vertical reflection symmetries.

Fig. 7 is another frieze of fig. 5. In this case the animal motif is repeated in such a way that can be classified in the third frieze group, F_3, containing translation and vertical reflection symmetries.

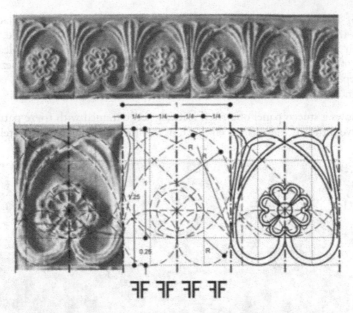

Fig. 6. Section of a frieze with a geometrical analysis by the authors

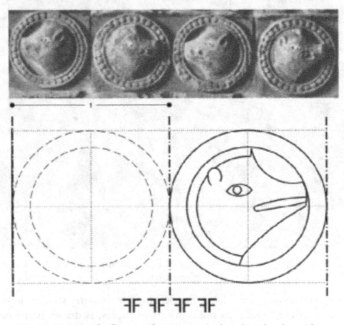

Fig. 7. Section of a frieze with a geometrical analysis by the authors

The motifs in fig. 8 are similarly drawn based on the basic square module. By drawing a circle inscribed in the square and dividing it by its diameters, the placement of the petals is found. This figure follows two different types of frieze groups. The design of each motif can be considered as the seventh frieze group, F_7, containing all symmetries, translation, horizontal and vertical reflection, and rotation, while the repetition of the frieze follows the first frieze group, F_1, contains only translation symmetry.

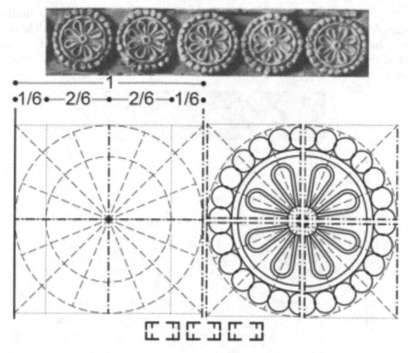

Fig. 8. Section of a frieze with a geometrical analysis by the authors

In Fig. 9 the frieze is created by repetition of the motif in a way that is classified in the first frieze group, F_1, containing only translation symmetry. However, the motif itself is made by using vertical reflection and follows the third frieze group, F_3, containing translation and vertical reflection symmetries.

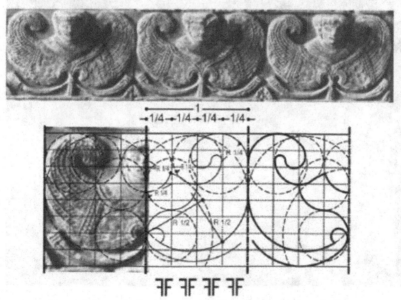

Fig. 9. Section of a frieze with a geometrical analysis by the authors

Fig. 10 is the frieze on the bottom of the royal hunting scene in fig. 5. Similar to other examples, these motifs are drawn on the basis of the basic square module and its divisions. This frieze is based on the repetition of one unit in such a way that can be classified as the fourth frieze group, F_4, containing translation and rotation (by a half-turn) symmetries.

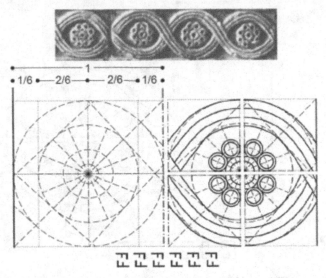

Fig. 10. Section of a frieze with a geometrical analysis by the authors

Four kinds of friezes are seen in fig. 11. These friezes make the frame for the main design. In the next part each of these friezes will be analyzed separately, in detail.

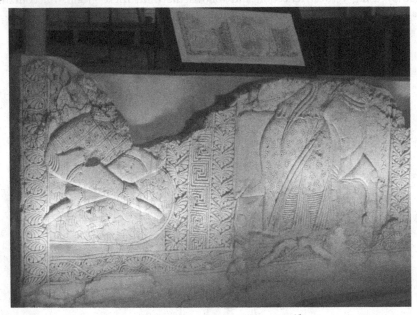

Fig. 11. Sassanid stucco, Bandian[15]

Fig. 12 shows one of the friezes in fig. 11, which is based on the fifth frieze group, F_5 containing translation, glide reflection and rotation (by a half-turn) symmetries. In this frieze as well the basic square plays an important role in shaping the motifs. By dividing the square into sixteen units, the substructure for the design of the motif is created.

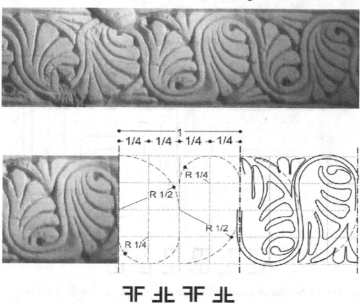

Fig. 12. Section of a frieze with a geometrical analysis by the authors

Fig. 13 can be considered as the fifth frieze group, F_5, containing translation, glide reflection and rotation (by a half-turn) symmetries. The substructure of the motif shows that dividing the basic module could help the artisans to design accurately.

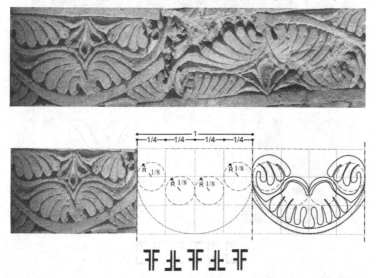

Fig. 13. Section of a frieze with a geometrical analysis by the authors

Fig. 14, another frieze pattern from fig. 11, can be considered as the fourth frieze group, F_4, containing translation and rotation (by a half-turn) symmetries. This kind of pattern was common in the ancient world and perhaps was created under the influence of Greek-Parthian art from the previous period.

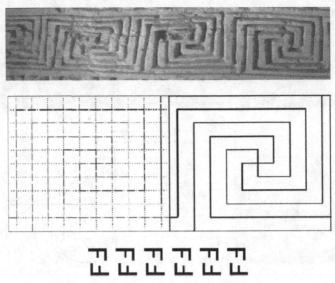

Fig. 14. Section of a frieze with a geometrical analysis by the authors

Fig. 15 is the final frieze pattern in Bandians stucco shown in fig. 11. The motif has been drawn in a basic square that is divided into six units. However, the next motif does not start from the last square but from the last 1/3 section of it. This frieze follows the sixth frieze group, F_6, containing translation and horizontal reflection symmetries.

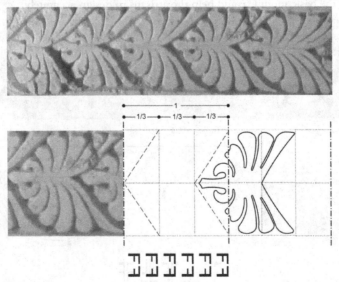

Fig. 15. Section of a frieze with a geometrical analysis by the authors

4.2 Wallpaper Groups

A periodic pattern extended in two linear directions in order to cover the two-dimensional plane is known as a wallpaper pattern. The two smallest linear independent translation vectors T1 and T2 in the pattern's symmetry group are generators for the underlying lattice structure of the pattern. The lattice divides the plane into identical parallelogram-shaped sub-images called lattice units or tiles. The symmetry group of a wallpaper pattern has to be one of the seventeen distinct wallpaper groups [Liu et al. 2004].[16]

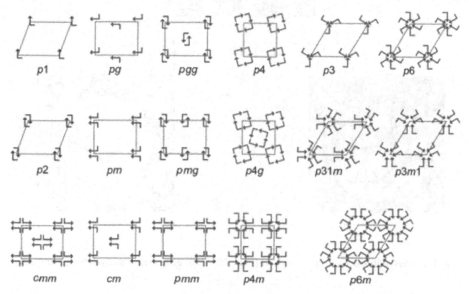

Fig. 16. The seventeen wallpaper groups [Plass et al. 2007]

	pl	p2	pm	pg	cm	pmm	pmg	pgg	cmm	p4	p4m	p4g	p3	p3m1	p31m	p6	p6m
180		Y				Y	Y	Y	Y	Y	Y	Y				Y	Y
120													Y	Y	Y	Y	Y
90										Y	Y	Y					
60																Y	Y
T_1		Y		Y(g)		Y	Y(g)	Y(g)		Y		Y(g)			Y		Y
T_2						Y	Y	Y(g)		Y		Y(g)			Y		Y
D_1					Y				Y		Y	Y		Y	Y		Y
D_2									Y		Y	Y					Y

Table 2. Y means the symmetry exists for that symmetry group; empty space means no. Y(g) denotes a glide reflection [Plass et al. 2007]

The square frame with a circle frame inside, shown in fig. 17, is one of the most common examples of Sassanid stucco. These squares are put adjacent to each other in order to create the whole panel. Vegetal forms in the corner of the square are designed based on rotational symmetry. For extending this figure in the surface they can be categorized in the "p1" wallpaper group.

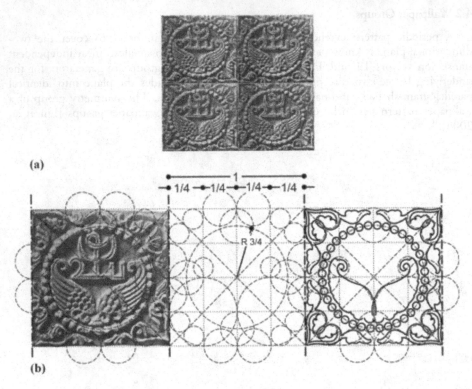

(a)

(b)

Fig. 17. a) Sassanid stucco from Ctesiphon [Pope 1938]; b) geometrical analysis by the authors

At the center of the square in fig. 18, one octagon is created by intersecting the arcs containing the same radius. It makes a proper place to locate the central flower. It is interesting to note that the sides of the two squares in the middle that created an octagram star are shown as woven together in an under-over pattern. This sample also shows the extension of modules in two directions. The designing of a one fourth of the negative space between the frame of the circle and the square has been considered in order to create a newer form through the extension. Embedding a circle frame in a square frame, using square's proportions to determine the circle's proportions, and its inner components can show the progressing in the composition. Designers shaped a quarter of a pattern to transform the negative area of square corners into new positive forms after repetition of modules in the whole panels. In these samples, we can see relations among main circles and their role in forming secondary ruler lines in design. It can be classified in the "pmm" wallpaper group.

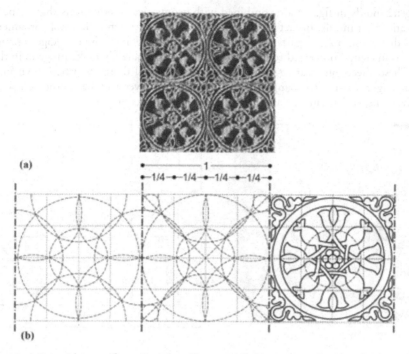

Fig. 18. a) Sassanid stucco from Ctesiphon [Pope 1938]; b) geometrical analysis by the authors

The motif of the panel in fig. 19 includes vertical axis symmetry. The leaves in each motif have been made based on arcs with the same radius. These arcs have created the geometrical substructure of the whole panel. This sample can be considered in the "pm" wallpaper group.

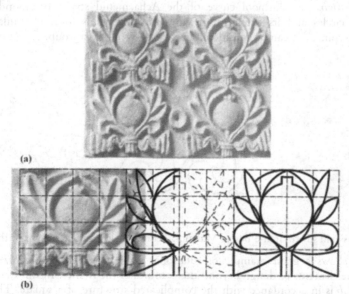

Fig. 19. a) Sassanid stucco from Ctesiphon [Ferrier 1989]; b) geometrical analysis by the authors

Vegetal motifs in fig. 20 are combined with geometrical subdivisions that shape the best locations for motifs. In fact with a rotational dividing system, the whole ornamental panel is divided into some parts according to the central point. These changes are great evolutions in central order and rotational symmetry that gradually make progress in these fields. These effects on creating more complex geometrical design will be shown in the following figures. In this example, the forms of the leaves can be considered as the repetitive units, which can be classified in the "p4" wallpaper group.

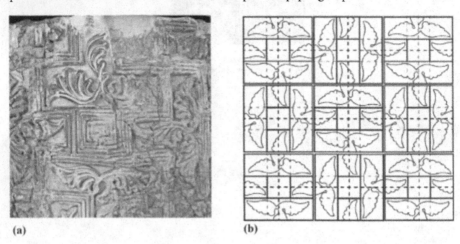

(a) (b)

Fig. 20. a) Sassanid stucco, Iran-e-Bastan Museum, Tehran; b) geometrical analysis by the authors

Fig. 21 is an advanced example in the application of rotational symmetry. It shows the progress of going beyond basic frames in Sassanid stucco ornament. It also shows the use of polar geometry and rectangular geometry synchronically. In this sample, by using the proportion of 1:4 and dividing them into tiny details, they achieve a pattern known as *Farreh-Gerdab,*[17] a whirlpool curve of the Achaemenid style, corresponding to a structure of circles and its extension in any direction. This form is similar to the Archimedean spiral.[18] It can be considered in the "p4" wallpaper group.

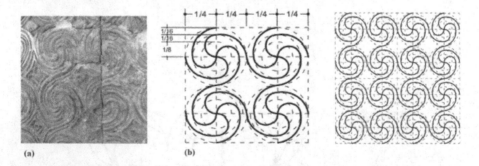

(a) (b)

Fig. 21. a) Sassanid stucco, Iran-e-Bastan Museum, Tehran; b) geometrical analysis by the authors

Fig. 22 shows a good example of rotational symmetry, central organization and extending the elements of design beyond the confines of the frames. In this example, the *Farreh-Girdab* is in accordance with the complicated structure of a square. The central diamond is made by overlapping the spirals. This ornamental pattern goes beyond a

simple geometrical structure of the square to achieve a balance, making it possible to reproduce decorative forms from static compositions into dynamic, complicated compositions. Two different systems of geometry have been combined to create a new productive modulation. Each square frame is an independent design that can make a new design when combined with others. This continuous repetition is limitless. Going beyond frames based on geometrical features of simple square pieces is the most important feature of this stucco. This sample can be considered as the "p4m" wallpaper group.

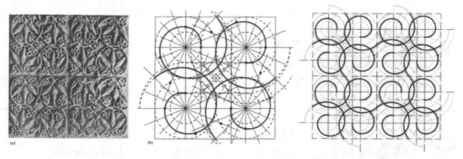

Fig. 22. (a): Sassanid stucco from Ctesiphon [Pope 1938]. (b): Geometrical analysis by authors.

5 Results

In preparation for drawing conclusions regarding the use of the practical geometry and geometric frieze groups as organizing elements in the design of Sassanid stucco ornament, all the above-mentioned stucco patterns are arranged in the following table.

Sassanid stucco	Repetitive unit	Features
		Simple repetition of one motif. The first frieze group. Translation symmetries.
		Two different motifs. Alternating rhythm. The third frieze group. Translation and vertical reflection symmetries.
		Third frieze group. Translation and vertical reflection symmetries. Alternating rhythm.

Sassanid stucco	Repetitive unit	Features
		The third frieze group. Translation and vertical reflection symmetries.
		The third frieze group. Translation and vertical reflection symmetries.
		The seventh frieze group. Translation, horizontal and vertical reflection, and rotation symmetries.[*]
		Vertical symmetry. Motif follows the third frieze group. Frieze is based on the first frieze group.
		The fourth frieze group, F_4, contains translation and rotation (by a half-turn) symmetries.
		The fifth frieze group, F_5, contains translation, glide reflection and rotation (by a half-turn) symmetries.
		The fifth frieze group, F_5, contains translation, glide reflection and rotation (by a half-turn) symmetries.

Sassanid stucco	Repetitive unit	Features
		The fourth frieze group: Translation and rotation (by a half-turn) symmetries.
		The sixth frieze group: Translation and horizontal reflection symmetries.
		Rotational symmetry. "p1" wallpaper group.
		Designing quadrant of motives in corners. Create new motifs during repetition Reach to rotational symmetry. "pmm" wallpaper group.

Sassanid stucco	Repetitive unit	Features
		Vertical symmetry. "pm" wallpaper group.
		Going beyond the basic frame. Complexity in design. Combining rotational and orthogonal geometry Rotational symmetry. "p4" wallpaper group.
		Combining of polar and rectangular geometry Complexity in design Combining various geometrical systems. "p4" wallpaper group.
		Combing rectangular and polar geometrical system. New rhythms rather than simple rhythms of basic squares. Complexity in design. Extension of basic frames. "p4m" wallpaper group.

Table 3. Organization of stucco patterns in the present study

6 Discussion

Vividness, accuracy, proportional settings, symmetry and symphonic design and also the use of expressive and eloquent motifs and skillful applications of design principles seem natural and granted in all stages of Persian culture [Pope 1965]. Persians have for centuries been mathematically minded, and some principles of Persian design reflect this certain type of mathematical thinking [Pope 1938].

This research suggests that in Sassanid stucco ornaments there are strong relations between the whole and parts, regulating lines, proportions and repetition rhythms. These connections define the progress of practical geometry through Sassanid stucco ornament. By repeating the same figures and changing their interrelations, a great range of patterns is obtained. When the primary motif has been identified and the process has been defined, even a very complex structure can be analyzed by identifying its components. Our analysis shows that in the Sassanid period artisans and architects demonstrated high achievements in complex geometry rules. They must have understood and found repetitive units and considered them as main design elements for drawing and execution of the stucco patterns. They extended basic frames and repetitive units to obtain geometric motifs and create geometric relations among basic frames and other parts of stucco design. By considering repetitive units, we classified these stucco ornaments in the seven frieze symmetry groups. Figs. 2, 8 and 9 follow the first frieze group, F_1, and they contain translation symmetry. Figs. 3, 4, 6, 7 and 9 (the motif itself), are classified by the third frieze groups, F_3, containing translation and vertical reflection symmetries. Figs. 10 and 14 are based on the fourth frieze group, F_4, and contain translation and rotation (by a half-turn) symmetries. Figs. 12 and 13 follow the fifth frieze group, F_5, containing translation, glide reflection and rotation (by a half-turn) symmetries. Fig. 15 is classified as the sixth frieze group, F_6 which contains translation and horizontal reflection symmetries. And finally fig. 8 (the motif itself) is on the basis of the seventh frieze group, F_7 that contains all symmetries; translation, horizontal and vertical reflection, and rotation. Some of these examples can also be considered in relation to the seventeen wallpaper groups. In fig. 17 the plane design can be classified as "p1" and fig. 18 as "pmm". In fig. 19, the whole design can be classified as "pm", figs. 20 and 21 as "p4"; fig. 22 as "p4m".

The study has led us to conclude that Sassanid artisans paid significant attention to rhythm as the main element of design. The application of multiple rhythms and the creation of new rhythm from simple rhythms was one of the main characteristics of the ornament design in the Sassanid era (fig. 22). Sassanid architectural ornaments suggest the creation of new motifs during the repetition of primary motifs (figs. 17, 18, 22). One example of evolution is the application of sinusoidal forms to make an ornamental pattern on the basis of the reverse repetition of motifs (fig. 12).

Complex spiral and wavy forms were used in this period. In addition, significant progress in this field is the synchronization of polar geometry with rectangular geometry, which creates more complex geometrical patterns (figs. 21, 22). Another development in Sassanid stucco is designing a quarter of the main design and transferring it in order to make a whole design with the help of rotational symmetry (fig. 22).

7 Conclusion

In conclusion we can summarize the most important findings in practical geometry existing in Sassanid stucco ornaments as follows: 1) division of motifs into repetitive

units; 2) consideration of the concept of rhythm as the main design element; 3) presence of alternative and sinusoid rhythms with repetition of two or more motifs and creating new rhythms from simple rhythms and new motifs during the repetition of primary motifs; 4) use of rotational symmetry; 5) synchronization of polar and rectangular geometry and transmitting motifs by design a quarter as a repeated unit; 6) reliance on division of arcs and circles and their overlapping to go beyond the simple proportion; 7) modular-based design; 8) increase of rhythms from simple to complex rhythms with various motifs. In addition, in designing the motifs, Sassanid artisans used repetitive units in such a way that we were able to classify them according to frieze groups and wallpaper groups. These features demonstrate the ability of the Sassanid architects to understand the geometry and apply practical geometry in the process of creating stucco ornament.

While patterns in Sassanid stucco design lend themselves to our contemporary geometrical knowledge (i.e., frieze groups and wallpaper groups), we cannot verify to what extent Sassanid artisans conceptualized these ideas. However, we can conclude that they possesses a high level of mathematical and geometric knowledge, as they dealt with the same set of issues as we discuss in our own time. The application of that mathematical knowledge and execution of the stucco ornaments verifies the high level of practical geometry among Sassanid architects and artisans

Notes

1. Babylon was an ancient Empire of Mesopotamia in the Euphrates River valley. It flourished under Hammurabi and Nebuchadnezzar II but declined after 562 B.C. and fell to the Persians in 539 B.C.
2. The Achaemenid Empire (550–330 B.C), was founded by Cyrus the Great, who became king of Persia in 559 B.C. and defeated his overlord Astyages of Media in 550. The Achaemenid Empire was the largest that the ancient world had seen, extending from Anatolia and Egypt across western Asia to northern India and Central Asia.
3. The Parthian Empire (247 B.C.–224 A.D.), also known as the Arsacid Empire is a period of Persian history closely connected to Greece and Rome. The Parthians defeated Alexander the Great's successors, the Seleucids, conquered most of the Middle East and southwest Asia, controlled the Silk Road and built Parthia into an Eastern superpower.
4. The Sassanid Empire was the last pre-Islamic Persian Empire, from 224 to 651 A.D.. The Sassanid Empire was recognized as one of the two main powers in Western Asia and Europe, alongside the Roman Empire and its successor, the Byzantine Empire, for a period of more than 400 years.
5. Kīš (or Kish) is modern Tell al-Uhaymir (Babil Governorate, Iraq), and was an ancient city of Sumer. Kish is located some 12 km east of Babylon, and 80 km south of Baghdad (Iraq).
6. Ctesiphon, the imperial capital of the Parthian Arsacids and of the Persian Sassanids, was one of the great cities of ancient Mesopotamia. The ruins of the city are located on the east bank of the Tigris, across the river from the Hellenistic city of Seleucia. Today, the remains of the city lies in Baghdad Governorate, Iraq, approximately 35 km south of the city of Baghdad.
7. Hisār is an ancient hill near the Dāmghān, a city in Semnan Province, Iran, 342 kilometres from Tehran.
8. Mesopotamia is a toponym for the area of the Tigris-Euphrates river system, largely corresponding to modern-day Iraq, northeastern Syria, southeastern Turkey and southwestern Iran.
9. Persepolis (Old Persian Pārsa, Takht-e Jamshid) was the ceremonial capital of the Achaemenid Empire (550 B.C.–330 B.C.).
10. Istakhr was an ancient city located in southern Iran, in Fars province, five kilometers north of Persepolis. It was a prosperous city during the time of Achaemenid Persia.
11. Ardashir I was the founder of the Sassanid dynasty. He revolted against Artabanus, the last king of the Arsacid dynasty of Parthia and ruled over the territories of the Parthian empire, received

the submissions of the kings of the Kushans and of Turan (Pakistan and Baluchistan, respectively) in the east, and gained control of Merv in the northeast.

12. The Seleucid dynasty was a Greek-Macedonian state that was created out of the eastern conquests of Alexander the Great. At the height of its power, it included central Anatolia, the Levant, Mesopotamia, Persia, today Turkmenistan, Pamir and parts of Pakistan.

13. Shāpūr I was the second Sassanid King (241-272 A.D.). He fought three major campaigns against the Romans, in 242-4, 252-6, and 260. In the last campaign, the Roman emperor Valerian was captured and killed by the Persians.

14. This tablet is kept in Philadelphia museum.

15. Bandian is an ancient fire temple in Iran. Found at the site, near the town of Daregaz, 1150 km northeast of Tehran near the Turkmenistan border, were a stucco-decorated hall with columns, Sassanid Pahlavi inscriptions, and at last some remains of brick architecture, which are considered to be one of the most invaluable finds of that period.

16. The practical value of understanding the seventeen wallpaper groups is that correct pattern classification can be performed after verifying the existence of only a small set of symmetries, specifically four rotations (180°, 120°, 90°, and 60°), and four reflections along axes parallel to either unit lattice parallelogram boundaries T_1 and T_2 or unit lattice diagonals D_1 and D_2. It is clear from Table 2 that each symmetry group corresponds to a unique sequence of yes/no answers to whether the pattern contains each of these eight types of fundamental symmetry.

17. The *Farreh-Gardab* was the most important motif of the Achaemenid period, which is believed to have been influenced by Greek art.

18. It is the locus of points corresponding to the locations over time of a point moving away from a fixed point with a constant speed along a line which rotates with constant angular velocity. Equivalently, in polar coordinates (r, θ) it can be described by the equation: $r = a + b\theta$.

References

AFHAMI, Reza and Mahmood TAVOOSI. 2007. Regulating lines in Persian elite's relief, Apadana palace stairway, *Persepolis*, vols. 2-3, pp. 67-76. Tehran: Negareh. Shahed University Press (in Persian).

BALTRUŠAITIS, Jurgis. 1938. Sassanian stucco: ornamental. Pp. 601-603 in *A Survey of Persian Art from Prehistoric Times to the Present*, A. U. Pope and F. Ackerman, eds. New York: Oxford University Press.

BONNER, Jay. 2003. Three traditions of self-similarity in fourteenth and fifteenth century Islamic geometrical ornaments. Pp. 1-12 in *ISAMA/BRIDGES Conference Proceedings*, University of Granada, Spain, 2003, Reza Sarhangi and Nathaniel Friedman, eds. Granada.

CONWAY, John. 1992. The orbifold notation for surface groups. Pp. 438-447 in *Groups, Combinatorics and Geometry* (Proceedings of the L.M.S. Durham Symposium, July 5-15, Durham, U.K., 1990), M. W. Liebeck and J. Saxl, eds. London Mathematical Society Lecture Notes Series, 165.

CROMWELL, Peter R. 2009. The search for quasi-periodicity in Islamic 5-fold ornament. *Mathematical Intelligencer* **31**: 36-56.

ETTINGHAUSEN, Richard. 1979. The Taming of the Horror Vacui in Islamic Art. *Proceedings of the American Philosophical Society* **123**: 15-28.

FELTHAM, Heleanor. 2010. Lions, Silks and Silver: The Influence of Sasanian Persia. *Sino-Platonic Papers*. Philadelphia: University of Pennsylvania.

FERRIER, Ronald W. 1989. *The Arts of Persia*. New Haven and London: Yale University Press.

GHIRSHMAN, Roman. 1962. *Iran: Parthians and Sassanians*, transl. S. Gilbert and J. Emmons. London: Thames and Hudson.

GODARD, André. 1965. *The Art of Iran*. Translated from the French by Michael Heron. London: George Allen and Unwin Ltd.

HARPER, P. Oliver. 1986. Art in Iran v. Sasanian art. *Encyclopaedia Iranica*, vol. II, Fasc. 6, pp. 585-594. http://www.iranicaonline.org/articles/art-in-iran-v-sasanian. Last accessed 2 March 2012.

HERZFELD, Ernst. 1923. *Der Wandschmuck der Bauten von Samarra und seine Ornamentik.* Berlin: Verlag Dietrich Reimer.

KRÖGER, Jens. 1982. *Sasanidischer Stuckdekor.* Mainz: P. von Zabern.

LAWLER, Robert. 1982. *Sacred Geometry*, London: Thames & Hudson.

LIU, Yanxi, T. ROBERT and Y. TSIN. 2004. A Computational Model for Periodic Pattern Perception Based on Frieze and Wallpaper Groups. *IEEE Transactions on Pattern Analysis and Machine Intelligence* **26**, 3 (March 2004): 354-371.

LU, Peter J. and STEINHARDT, Paul J. 2007. Decagonal and Quasi-Crystalline Tilings in Medieval Islamic Architecture. *Science* **315**: 1106-1110.

MOOREY, P. Roger Stuart. 1978. *Kish Excavations*, 1923-1933. Oxford: Clarendon Press.

MOUSAVI, Ali. 2008. A Survey of the Archaeology of the Sasanian Period during the past three decades. *e-SASANIKA* **1**. http://www.humanities.uci.edu/sasanika/pdf/Ali-Mousavi-eSasanika1.pdf. Last accessed 2 March 2012.

ÖZDURAL, Alpay. 2000. Mathematics and Arts: Connection between Theory and Practice in the Medieval Islamic World. *Historia mathematica* **27**: 171-201.

PLASS, Katherine E., Adam L. GRZESIAK and Adam J. MARZGER. 2007. Molecular Packing and Symmetry of Two-Dimensional Crystals. *Accounts of chemical research* **40**, 4: 287-293.

POPE, U. Arthur. 1965. *Persian Architecture.* New York: Braziller.

———. 1938. The Significance of Persian Art. In *A Survey of Persian Art from Prehistoric Times to the Present*, vol. 1. A. U. Pope and F. Ackerman, eds. New York: Oxford University Press.

PORADA, Edith. 1965. *Ancient Iran: The Art of pre-Islamic Times.* (Art of the World series). London: Methuen.

REUTHER, Oscar. 1938. Sasanian architecture. Pp. 492-578 in *A Survey of Persian Art from Prehistoric Times to the Present*, A. U. Pope and F. Ackerman, eds. New York: Oxford University Press.

ROAF, Michael. 1989. The Art of the Achaemenians. Pp. 26-49 in *The Arts of Persia*, R. W. Ferrier, ed. New Haven and London: Yale University Press.

SAMMI, Ali. 1984. *Sassanian civilization*, Shiraz: Shiraz University Pub.

SARHANGI, Reza. 1999. The Sky Within: Mathematical Aesthetics of Persian Dome Interiors. *Nexus Network Journal* **1**: 87-97.

VITRUVIUS. 2009. *On Architecture.* Richard Schofield, trans. London: Penguin Classics.

About the author

Mahsa Kharazmi is a Ph.D. student of Art studies at Tarbiat Modares University, Tehran, Iran. She is interested in geometric ornament and the relationship between mathematics and architectural ornament. She obtained her M.A. in 2010 with a thesis entitled "The Study of the Evolutional Process of Geometric Patterns in the Persian Architectural Ornament (Sassanid-Seljuq era)" under the advisement of Dr. Afhami and Prof. Tavoosi. Now she is working on her Ph.D. dissertation in the same field.

Reza Afhami is an architect and art historian who work on relationships between political power and art in ancient Iran, especially during the Achaemenid period.

Mahmood Tavoosi is Professor in ancient Persian culture and literature and and art historian with an interest in mythology.

Carol Bier

Center for Islamic Studies
Graduate Theological Union
2400 Ridge Road
Berkeley CA 94709 USA
carol.bier@gmail.com

Research

The Decagonal Tomb Tower at Maragha and Its Architectural Context: Lines of Mathematical Thought

Keywords: algorithm,
architecture, art, decagon,
dodecagon, geometry, grid,
history of mathematics,
interlocking, intersecting, Iran,
iteration, Mongol, Myron
Bement Smith, Nasir al-Din
Tusi, nonagon, ornament,
overlapping, pattern, pentagon,
plane, polygon, prism, Seljuk,
symmetry, tomb tower

Abstract. Of several brick tomb towers constructed at Maragha in western Iran before the Mongol conquests, one in particular, Gonbad-e Qabud (593 H. / 1196-97 C.E.), has generated significant recent attention for its unique patterns with pentagons and decagons. Gonbad-e Qabud is also unusual in having a decagonal plan. While both plan and decoration distinguish it from earlier and later towers at Maragha and elsewhere on the Iranian plateau, the ornamental patterns follow a long line of experimentation with geometric expressions that grace many pre-Mongol buildings in Iran. This article examines in particular the overlapping polygons and radial symmetries of the tympanum of the cubic Gonbad-e Sork (542 H. / 1148 C.E.) at Maragha, and the pentagons and squares of the tympanum of the later octagonal tomb tower (486 H. / 1093 C.E.) nearby at Kharraqan. Drawing from archival sources (plans, elevations, photographs), analysis of plane patterns, and comparative architectural data, this article reevaluates the cultural significance of Gonbad-e Qabud, seeking to situate it within the histories of mathematics, architecture, and the arts.

Introduction: Decagonal intentionality

The decagonal and pentagonal symmetries present in the geometric ornamentation of the Gonbad-e Qabud at Maragha in western Iran (figs. 1, 10) have attracted widespread attention among scientists and mathematicians in recent years [Bier 2011a; Bonner 2003; Cromwell 2009; Lu and Steinhardt 2007a; Lu and Steinhardt 2007b; Makovicky 1992; Makovicky 2007; Makovicky 2008; Saltzman 2008]. But the fact that the monument itself is decagonal in plan (fig. 2) has been missing from this discussion, in which the building has been mischaracterized as octagonal, repeating mistakes of earlier publications. In 1937 M.B. Smith carefully documented the tomb towers at Maragha, producing measured scale drawings, black and white photographs, and sketches made on site, all of which are now held in the Archives of the Freer Gallery of Art [Myron Bement Smith Collection]; his annotated field plan (fig. 2) documents the decagonal exterior with an interior decagonal chamber. Daneshvari [1982; 1986] examined plans and elevations, noting the decagonal form of both interior and exterior. That it once had a conical roof composed of ten planar triangular facets, hints of which are visible in fig. 1, covered with turquoise glazed brick [Myron Bement Smith Collection], was also noted by Daneshvari [Daneshvari 1982: 289]. Other authors have documented and commented upon the metamorphic patterns [Makovicky 2008: 130; Wilber 1939; Bier 2011a], in which five-, six-, seven-, eight-, nine-, and (half) ten-pointed interlaced stars (figs. 3, 5) ornament the spandrels filling the spaces above the arches in the rectangular niched enclosures of the building's ten faces, each of which arises from the decagonal plan and is framed by a pair of engaged columns, one column placed at each exterior angle. The number ten was expressively important in the development of the plan and its

prismatic elevation: the ten triangular facets of the roof, ten rectangular facades framed by engaged columns and framing ten arched tympanums with spandrels above. The interior chamber is decagonal, with recessed niches that complement the exterior form (fig. 2), providing a base for what was once the polyhedral conical roof. Above the niches of the interior is a twenty-sided zone of transition composed of ten blind arches and ten squinches that once supported an interior dome [Daneshvari 1982: fig. 126]. Above these interior arches and squinches is a band of inscription in Arabic, quoting verses 1-4 of chapter 67 (*al-Mulk*) of the Qur'an (discussed below), which may help to inform our understanding of this monument in its time.

The significance of the ornamental pattern that surrounds the lower exterior reaches of the building (figs. 1, 10) has achieved widespread attention because of the mathematical implications of its visual complexity that resides in combinations of five-fold and ten-fold symmetries [Lu and Steinhardt 2007a, 2007b; Makovicky 1992; Makovicky 2007; Makovicky 2008]. But decagonal intentionality extends beyond this broad band of pattern and encompasses the entire structure from the plan and its prismatic form and decagonal interior chamber to the decagonal base of its pyramidal roof; clearly, the geometry of the decagon both in theory and in practice was a primary consideration of those responsible for this building's overall design and construction [Bier 2011a].

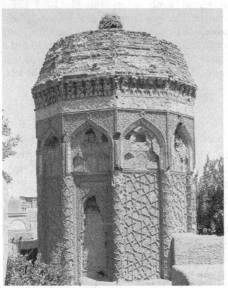 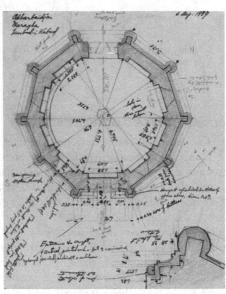

Fig. 1. Gonbad-e Qabud, Maragha, Iran (593 H. / 1196-97 C.E.), view from WNW. Photograph by Myron Bement Smith 1937. Black and white negative (L254-11) [Myron Bement Smith Collection]

Fig. 2. Plan of Gonbad-e Qabud, Maragha, Iran. Annotated field drawing by Myron Bement Smith, 6 August 1937. Ink, pencil and color on paper [Myron Bement Smith Collection]

A reassessment of this building's cultural significance is warranted to articulate why the focus on the number ten is so vitally important for both the history of art and the history of mathematics.

Dating of Gonbad-e Qabud and its cultural environment

The dating of Gonbad-e Qabud to 593 H. / 1196-97 C.E. has been generally accepted; it rests upon Godard's historical deduction [Godard 1936: 143], placing its construction a decade after that of the tomb of Mo'mene Khatun in Nakhchevan [ArchNet], Azerbaijan, considered its model; Godard does mention reading "593" in negative impressions in the plaster where the inscription would have been [Godard 1936: 143]. Although both towers are prismatic with a decagonal plan and have engaged corner buttresses, the geometric decoration of the two decagonal buildings is not identical; that at Nakhchevan includes a pattern based on twelve-pointed stars in combination with five-pointed stars [Wilber 1939: fig. 12], and columns of ten-pointed stars in a linear arrangement. To understand the potential chronological implications of these patterns for one another, further study is needed to establish a typological development of geometric patterning in pre-Mongol ornament. But if the late twelfth century is accepted for Gonbad-e Qabud, that would place this building in a period of local rule by the Ahmadili family, who were Atabegs of Maragha [Luther 1987; Minorsky 1960], during a time of rivalry among the Sunni Ahmadili and the Shi'i Isma'ilis [Minorsky 2011], at the close of the Saljuq period shortly after the conclusion of Saljuq suzerainty in Iran and just prior to the drama and ferocity of the Mongol conquests of Iran, which began in 1219, with Maragha taken in 1221. Among the cultural highlights of the last decade of the twelfth century in Maragha was the composition in Persian by Nezami Ganjavi (1141-1209 C.E.) of his romantic epic, Haft Paykar ("Seven Portraits" or "Seven Beauties"), dedicated in one of two surviving manuscript traditions to Ala' al-din, who was ruling from Maragha. Related to this early literary appearance of Persian prior to the Mongol conquests and further distinguishing this building from its fraternal twin at Maragha is the incorporation of Persian verses following the foundation inscription in Arabic on the tomb tower at Nakhchevan [O'Kane 2009: 33, fig. 2.6].

Local tradition associates Gonbad-e Qabud with the mother of Hulegu Khan, Ilkhanid ruler of Iran in the thirteenth century. This association, however, is refuted by Godard [1934; 1936] on the basis of religion: neither Hulegu nor his mother, Sorghaghkani Beki, were Muslim, and this refutation has been accepted and repeated by others [Myron Bement Smith Collection; Daneshvari 1982]. Sorghaghkani Beki[1] was the mother of four sons of Mongol lineage, who inherited Chinggis Khan's empire – her youngest son, Kublai Khan, became Great Khan in 1260 and ruled over much of Asia after 1264, establishing the Yuan Dynasty from his new capital at Khanbalic, now Beijing. Hulegu was granted the southwestern territory of the Mongol Empire and he continued a policy of determined military expansion, capturing Baghdad in 1258, which brought a close to the Abbasid Empire when the seat of the Caliphate was removed to Syria. Hulegu soon returned to Maragha, and established the capital of the Ilkhanate there in 1259, where he founded an observatory (mentioned in [Makovicky 1992: 67; Chorbachi and Loeb 1992; Saltzman 2008]) and appointed Nasir al-Din Tusi chief astronomer [Saliba 2007: 244]. Born to an Isma'ili family, Nasir al-Din Tusi later became a Twelver Shiite Muslim; in the face of the Mongol conquests, he had sought protection in the Isma'ili fortress stronghold at Alamūt [Hourcade 1984], which was taken by the Mongols in 1256 and the libraries there burned. The Maragha observatory, which he oversaw, is considered to be one of the earliest monuments built under Ilkhanid patronage [Blair 2004]; recent archaeological excavation has revealed what have been identified as the remains of this observatory on a high plateau five kilometers to the south of the town [Kleiss 2002; Vardjavand 1979]. Within the annals of the history of science, Maragha was indisputably a major center for the advancement of scientific research in

astronomy and mathematics [Sezgin 1998]. Kleiss [2002] mentions an extensive system of artificial caves five kilometers west of Maragha, in which he describes "catafalque-like blocks," associated by legend as the burial place of Nasir al-Din Tusi (d. 1274).

While a pre-Mongol scientific community at Maragha has not yet been historically established, it is conceivable that the Gonbad-e Qabud, with its decagonal plan and exceptional geometric ornamentation, represents the efforts of local endeavors that engaged both mathematics and the craft of building.

Enumeration of the Gonbad-e Qabud, its inscriptions and its decoration

Based upon meticulous architectural study of the monuments at Maragha by Myron Bement Smith in 1937, through measured plans and extensive black and white photographic documentation [Myron Bement Smith Collection], one may readily recognize that the building is decagonal in plan, rising as a ten-sided prism with a round engaged column at each exterior angle (figs. 1-2), constructed of baked brick laid upon a stone foundation. Each exterior wall comprises an arched niche with a tympanum and projecting beveled archivolt that springs from above an engaged column (fig. 5), all contained within a tall rectangle, spandrels filling the area to each side of the pointed arch (fig. 1). Within each arch there is a five-lobed arch (fig. 5) composed of a shallow three-tiered muqarnas. All of these surfaces are decorated with intricate geometric patterns composed of polygonal nets executed in cut brick and turquoise glazed ceramic. Above the arches and beneath the cornice is a band of inscription in an elaborate foliated Kufic style of Arabic script (fig. 3) with several interlaced letters executed in turquoise mosaic faience (i.e., glazed bricks cut to shape), which extends around the building's ten sides. From the top of the stone foundation to the height of the springing of the arches a broad band of geometric ornament wraps around the building (fig. 1, 10), including all ten engaged columns but only nine sides (the entrance façade is omitted).[2]

This ornamental band is executed in cut brick [Myron Bement Smith Collection] and shows no evidence of any glazed ceramic (despite publication to the contrary [Makovicky 1992: 69]). This is the band of ornament with pentagonal symmetries so carefully analyzed in the publications of Makovicky [1992; 2007; 2008] and Lu and Steinhardt [2007a; 2007b], and discussed by Bonner [2003]. The exterior decorated architectural elements, both glazed and unglazed, comprise a revetment set in plaster [Myron Bement Smith Collection]; the revetment is not integral with the structure of the tower (figs. 3, 5-6), which is among several reasons for its damaged condition.

The exterior ornamentation of the Gonbad-e Qabud is constructed of baked brick, some glazed, some unglazed, some cut, some whole. The standard brick dimension was square, as recorded by M.B. Smith, 22.5 x 22.5 cm by 5.5 cm thick [Myron Bement Smith Collection]. Except for the entry façade, each rectangular face encloses a rectangular niche comprising a panel articulated in an angular polygonal net outlined by ribs in high relief and a curvilinear interlacing in lower relief (figs. 1, 10). This broad band of visually complex geometric ornament wraps around nine faces of the building, including all ten engaged columns [Myron Bement Smith Collection; Bier 2011a]. This band of ornament is surmounted by a pointed arch in each niche, which springs from the engaged columns and has a beveled edge slightly projecting and bearing a Kufic inscription (fig. 5).[3]

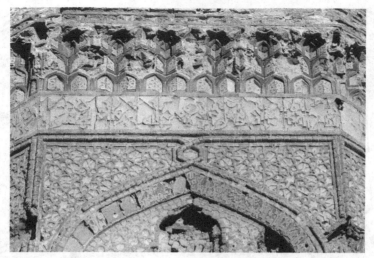

Fig. 3. Gonbad-e Qabud, Maragha, Iran. Entry façade detail (upper). Photograph by Myron Bement Smith 1937. Black and white negative (L243-10) [Myron Bement Smith Collection]

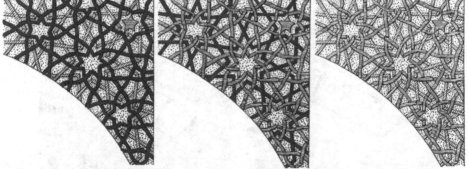

Fig. 4. Gonbad-e Qabud, Maragha, Iran. Upper spandrel, analyses by the author after Wilber [1939: fig. 17]. Three layered design of 5-6-7-6-pointed stars.
a, left) Top layer (unglazed ceramic s-curved strips) forming curvilinear polygonal net;
b, center) Lower layer (turquoise glazed ceramic strips) forming angular polygonal net;
c, right) Base layer of stucco, shown stippled, as indicated by Wilber [1939: fig. 17]) showing 6- and 7-pointed stars in negative space with 5-pointed star applied. Note that Wilber has also indicated ceramic construction breaks in polygon networks

The main arch of the niche on each facet contains a five-lobed arch that comprises a shallow three-tiered muqarnas (fig. 5); both the larger arch, and the smaller arches, and the spandrels above them, bear geometric ornament. The smaller arches bear individual designs with rotational symmetry. The upper spandrels carry a layering of two superimposed polygonal nets in which five-, six-, seven-pointed stars are interlaced (fig. 4). The topmost layer shows a curvilinear net (fig. 4a), composed of buff (unglazed) ceramic strips, with S-curves, and the lower layer is angular (fig. 4b), composed of turquoise-glazed strips that are straight (without curves). The two polygonal nets share the same center points, but the star forms of each polygonal net interlace on two separate levels. The superimposed polygonal nets are set against a ground layer of plaster [Wilber 1939: fig. 17] (fig. 4c).

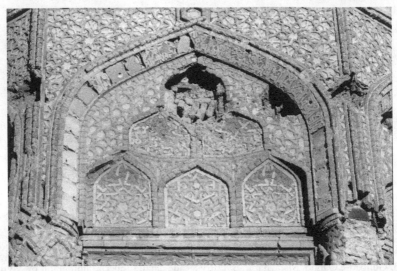

Fig. 5. Gonbad-e Qabud, Maragha, Iran. Entry façade detail: arch with tympanun and five-lobed arch composed of three-tier muqarnas. Photograph by Myron Bement Smith 1937. Black and white negative (L243-11) [Myron Bement Smith Collection]

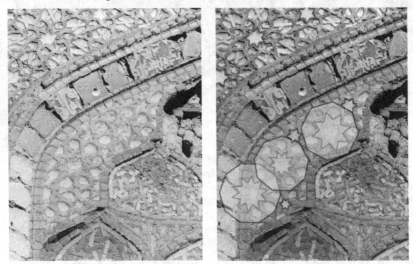

Fig. 6. a, left) Detail of a fig. 5; b, right) the same detail with stars highlighted in both upper and lower spandrels, showing progression of 8-, 9-, and 10-pointed stars in the lower spandrel

In the spandrels of the five-lobed arches (fig. 5), all of the decoration is unglazed. Here, eight-, nine-, and (half) ten-pointed stars radiate with petal-sharing (fig. 6) of the 9- and (half) 10-pointed stars [Seherr-Thoss and Seherr-Thoss 1968: pl. 36], once again lending a sense of visual complexity to the overall decorative scheme.

The visual complexity is especially evident in the spandrels, where the artisans have taken liberties in rendering the progressive sequences of 5-, 6-, 7- (fig. 4), and 8-, 9-, and (half) 10-pointed stars (figs. 5-6), adjusting lines and angles of the star polygons to allow for their diminution or expansion (fig. 4), and by "petal-sharing" of the 9- and (half) 10-

pointed stars (fig. 6). In the pattern of panels surrounding the ten-sided building, the local pentagonal and decagonal symmetries (fig. 10) are confounding to the untrained eye; that pattern also makes use of minor adjustments, as for example, in the inclusion of five-pointed stars in a lower corner [Makovicky 2007: fig. 2a].

The prismatic form of the building rises more than fourteen meters from the ground [Daneshvari 1982: 289], and rests upon a stone foundation. Limiting the visual extent of the decagonal prismatic form is a three-tiered cornice (figs. 1, 3) with muqarnas executed in glazed ceramic, which rises above an elaborate band of inscription in Arabic in Kufic style with bifurcate serifs on ascending letters. The elaborate cornice visually joins the decagonal prism and the polyhedral conical roof, each flat facet of which rises from above one of the ten sides of the building. A lower crypt is cruciform in plan with a low domical brick vault that exhibits eight-fold symmetry [Myron Bement Smith Collection; Daneshvari 1982: figs. 125-126]. The interior decagonal chamber is approached from the front (NW) by an elevated portal that would have originally had a set of stairs; the surfaces of the interior walls, niches, arches, and squinches are all plastered [Myron Bement Smith Collection]. There is evidence of an interior brick dome [Myron Bement Smith Collection; Daneshvari 1982: 289], a feature characteristic of other tomb towers on the Iranian plateau [Hillenbrand 1994: 253-330].

The varieties of geometric expressions are indeed extensive. They are all mathematically significant for their time, fitting within a substantial architectural lineage of experimentation in the expression of geometric forms from the tessellations of polygons and star polygons to the intersections of polygons in cut brick [Bier 2002], to the generation of polygonal nets and sub-grids [Bonner 2003], some of which illustrate multiple patterns superimposed upon one another and highlighted by colored glazes, the earliest example of which appears on the Gonbad-e Sork [Godard 1936; Wilber 1939] also located in Maragha (fig. 7). Developments in technologies and the use of materials are also noted at this time, ranging from the nearly exclusive use of unadorned fired brick (as at Kharraqan [Stronach and Young 1966; Bier 2002]) to the incorporation of glazed ceramic in one, two, three, or more colors, and from the use of cut mosaic faience to the application of glazed ceramic tile [Wilber 1939].

Saljuq architectural monuments exhibit extraordinary diversity in form, as well as in the incorporation of geometric ornament. This is particularly evident in tomb towers [Hillenbrand 1994: 253-330; Stronach and Young 1966; Shani 1996], although not exclusive to them [Korn 2010]. In general, an octagonal plan is far more frequently attested than other forms; similarly, for decoration, the symmetries that more easily tessellate the plane with translations to create periodic patterns with two-, four-, and eight-fold rotations, as well as those with three- and six-fold isometries, appear more often than patterns that incorporate five-fold and ten-fold symmetries [Grünbaum and Shephard 1989: chs. 1-2]. The consistent focus on the decagon in the plan, interior chamber, surface ornament, and roofing at Gonbad-e Qabud offers clear evidence of a concern that goes beyond visual impact. Although the general form of this decagonal tower is not unique, some of its geometric ornament seems to be, but many of its architectural elements find parallels elsewhere, relating it to other pre-Mongol monuments on the Iranian plateau [Hillenbrand 1994; Korn 2010].

Expressions of geometry in Iran in the eleventh and twelfth centuries

Gonbad-e Sork [Seherr-Thoss and Seherr-Thoss 1968: pls. 30-33], also referred to as Gonbad-e Qermez, is the earliest of five tomb towers still standing at Maragha [ArchNet].[4] Its construction is dated by the portal inscription in baked brick set on a base of stucco that is intricately carved above the entrance on the north side of the building [Milwright 2002]. The inscription, in a Kufic style of Arabic, follows the arcuate lines of the tympanum (fig. 7a) and gives the name of the builder and date of construction (542 H. / 1148 C.E.), as read by [Herzfeld]. The building is square in plan, with an engaged column at each corner. These architectural features are shared with the earlier tomb of the Samanids in Bukhara [Hillenbrand 1994: 287-290], the undated Gonbad-e Alaweyan in Hamadan [Shani 1996], and the later Gonbad-e Ghaffariya dated 1328 C.E. [Kleiss 2002], which is also in Maragha. The circular corner buttresses also appear in two octagonal tomb towers at Kharraqan (fig. 8), which are dated to the late eleventh century. Unusual features at Gonbad-e Sork include the incorporation of occasional glazed bricks in its ornamental revetment [ArchNet; Seherr-Thoss and Seherr-Thoss 1968: pl. 32], and an elaborately designed tympanum (fig. 7a) over the portal [Seherr-Thoss and Seherr-Thoss 1968: pl. 31] in which turquoise glazed ceramic strips articulate interlaced nonagons. This is considered to be the earliest use of glaze ceramic in Iranian architecture of the Islamic period [Wilber 1939; Necipoğlu 1995: 99 (but see note 6 below)]. The Gonbad-e Ghaffariya, although similar in form architecturally, incorporates a higher proportion of glazed bricks and more extensive use of mosaic faience with additional colors [Myron Bement Smith Collection; ArchNet]. Also unusual for its time are the double blind arches on each face of the Gonbad-e Sork, which are reflected in the interior elevation, and the patterned brickwork of the double blind niches, which uses both vertical and horizontal alignment of bricks to create the visual effect of float-patterned twill textiles. These features are also present in the Gonbad-e Alaweyan in Hamedan, where the vertical bricks project and carved stucco is affixed in the recesses [Shani 1996: figs. 6 and 32-33]; in the absence of a foundation inscription, Shani attributes this building to the late twelfth century on the basis of architectural comparisons and historical context. Each of these three square prismatic structures incorporate decorative brickwork in which the patterns reflect the laying of bricks, either vertically or horizontally.[5]

The geometric decoration in the tympanum of Gonbad-e Sork is unique among monuments on the Iranian plateau (fig. 7a-d). Within the pointed arch is an extraordinary four-layered design that includes three polygonal nets sharing the same central point.[6] The base plane is carved stucco [Wilber 1939: fig. 10]; superimposed on this are three successive layers of ceramic strips that articulate interlaced (overlapping) polygons. At the base, one interlaced layer of pattern shows six overlapping nonagons (plus nine partial nonagons), creating three elongated hexagons per nonagon, establishing a three-fold symmetry, and leaving a six-pointed star in negative space at the center (fig. 7b); this layer is highlighted by the use of turquoise-glazed strips (fig. 7a), unique for this date. This polygonal net interlaces with a second polygonal net (fig. 7c) composed of a double hexagonal grid of interlacing regular hexagons in buff (unglazed) ceramic [Seherr-Thoss and Seherr-Thoss 1968: pl. 31]. The placement of this grid allows for a centrally located regular hexagon surrounded by six partial hexagons (fig. 7c), each of which has a (partial) six-pointed star in the center created by the third, topmost layer. The uppermost layer is constructed of unglazed strips in higher relief and consists of six overlapping regular dodecagons, also yielding a centrally placed six-pointed star (fig. 7d) that has a

different orientation than the six-pointed star reserved by the overlapping nonagons (fig. 7b). Three additional dodecagons are hinted at in each of three corners of the arch, indicated in the analytical drawing (fig. 7d). The overlapping dodecagons interlace with one another, but not with the lower polygonal nets. Above the arched tympanum that contains this unified geometric pattern in its arch, with the surrounding inscription band and a succession of brick borders, are the spandrels, which bear a tessellation with three-fold symmetry in cut bricks, both glazed and unglazed (fig. 7). Symmetries with overlapping polygons are also present in cut-brick ornament that decorates the exterior of the Gonbad-e Alaweyan in Hamadan [Shani 1996].

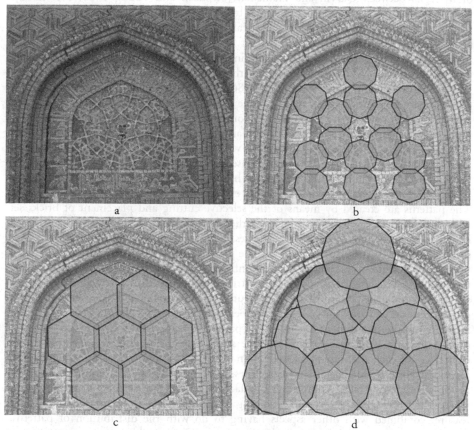

Fig. 7. Gonbad-e Sork, Maragha, Iran (542 H. / 1148 C.E.). Tympanum above entryway, showing three interlaced polygonal nets centered around the same point (analyses by the author). a) Color transparency (C162) by Hans C. Seherr-Thoss, detail (Seherr-Thoss Photographs of Islamic Architecture, Freer Gallery of Art and Arthur M. Sackler Gallery Archives, Smithsonian Institution, Washington, D.C. Gift of Sonia P. Seherr-Thoss); b) Interlaced nonagons; c) Interlaced hexagons; d) Interlaced dodecagons. Note that traces in clay imply the extension of polygons beyond the boundary of the innermost tympanum

Gonbad-e Sork also exhibits more complicated patterns with interlocked elements executed in unglazed bricks on the engaged columns that frame the entryway [Seherr-Thoss and Seherr-Thoss 1968: pl. 30]. Like the brickwork of the sidewall niches, which visually replicates twill weaves, these patterns share visual affinities with contemporary pattern-woven textiles. The engaged columns are capped by stone capitals, another

unusual feature of the period and region. The polyhedral roofing arrangement with an eight-sided pyramid is also unusual for its prominent octagonal zone of transition visible on the exterior. The transition zone is composed of bare brick and houses segmented squinches that represent an early appearance of this feature on the plateau. The clear and conscious geometry of structure is also evident in the upper panels of inscriptions, which incorporate interlaced quadrants extending from tall ascending letters.

Also relevant to the discussion of geometric patterns composed of interlocking elements and overlapping polygons are two tomb monuments at Kharraqan, located east of Maragha between Qazvin and Hamadan [Stronach and Young 1966; Bier 2002]. Constructed of brick and once surmounted by a dome, each tower displays eight niched rectangular vertical faces joined by cylindrical engaged buttresses. Built twenty-six years apart, the two buildings stand as a pair of octagonal towers rising more than twelve meters above the plain (fig. 8).[7] Each building bears an Arabic inscription that gives its date of construction. The earlier tower, to the east, was built in 460 H./1067-68 C.E. The later tower, to the west, was built in 486 H./1093 C.E. The historical inscriptions each contain, in addition to a date, the name of the architect (who seems to be the same person for both monuments), and an additional name, presumably that of the deceased, tentatively suggestive of Turkic ethnicity [Blair 1992: 135]. The exterior vertical faces of both octagonal prisms are entirely covered with geometric patterns in which extended axes of symmetry yield periodic patterns based on reflection and glide reflection. As at Gonbad-e Qabud, the buildings are clad in bricks set as revetment, the patterns visually serving to clothe the monument, leaving no exterior parts beneath the dome unadorned. The patterns are created by means of the selective cutting and placement of bricks set with mortar. The eastern tower, which is earlier, bears more than thirty patterns disposed on its eight faces and connecting buttresses. The western (later) tower has well over seventy patterns on its exterior surfaces. The play of patterns, in every instance, is based upon an algorithm consisting of a unit configuration of cut bricks that is consistently repeated to fill a designated space. Geometric relationships thus revealed are emergent structures within the pattern that is at once unitary and systemic. The presence of a third dimension, created by the relationship between bricks and mortar, seems almost incidental to the two-dimensionality of the pattern as perceived by the viewer. The play of darkness and light articulates the visible surfaces of the buildings, appearing on all eight faces of each monument as well as on the engaged columns or buttresses, which serve both to separate and join adjacent faces. The entryway of each monument, as well as the adjacent two faces, comprising five faces together, shows recessed mortar joints, whereas the back three faces, and adjoining buttresses, show flush mortar joints. This feature, combined with other aspects having to do with the distribution of patterns, suggests a clear sense of symmetry in the conception of each building.

The bricks are set in mortar and laid to form an elaborate array of symmetrical patterns that play with repeated themes of projection and recess, light and shadow, solid and void, offering numerous variations on a theme that plays continually with the passage of light without the addition of color in the earliest examples. The tombs at Kharraqan conform to the characteristics of these early examples, which pre-date the emergence of the use of color in glazed bricks and mosaic faience, both of which later appear at Maragha. The extraordinary number of patterns on the later tower at Kharraqan is unrivalled within the corpus of Saljuq brick monuments [Bier 2002].

Apart from the entry façade – which in each case is reserved for the most complicated pattern, placed in the tympanum above the entrance – there is no sense that any one

pattern is more significant than any other. As for geometry, there does not seem to be any consistency or progression in the choice of patterns. The eye is not drawn to a single central focal point. Rather each panel and area designated by pattern presents multiple centers. The range of patterns displays an evident awareness, even if by way of experimentation, of the play of symmetry with its inherent ambiguities and emergent geometric relationships. Horizontal and vertical reflections and glide reflections are much in evidence, as are rotational symmetries. There is clearly play with the cut-brick units, which combine to form triangles, squares, hexagons and six-pointed stars, octagons and eight-pointed stars, and dodecagons. There is considerable attention given to illusionary interlace, visually effected by the selective cutting of bricks and their specific juxtaposition. Sometimes, as in the case of interlaced octagons and interlaced dodecagons at Kharraqan, the centers are specifically marked by a projecting dot, a feature also noted in the tympanum at Gonbad-e Sork.

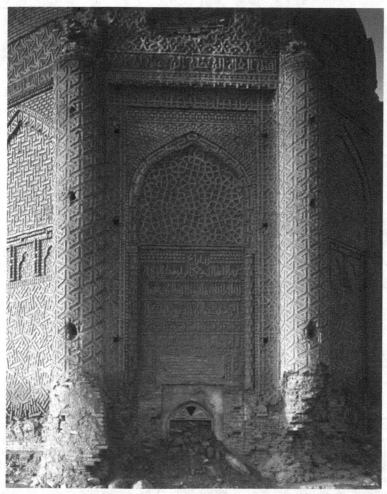

Fig. 8. Tomb tower (western), Kharraqan, Iran (486 H. / 1093 C.E.). Entry façade with tympanum and inscriptions. Color transparency (C112) by Hans C. Seherr-Thoss. (Seherr-Thoss Photographs of Islamic Architecture, Freer Gallery of Art and Arthur M. Sackler Gallery Archives, Smithsonian Institution, Washington, D.C. Gift of Sonia P. Seherr-Thoss)

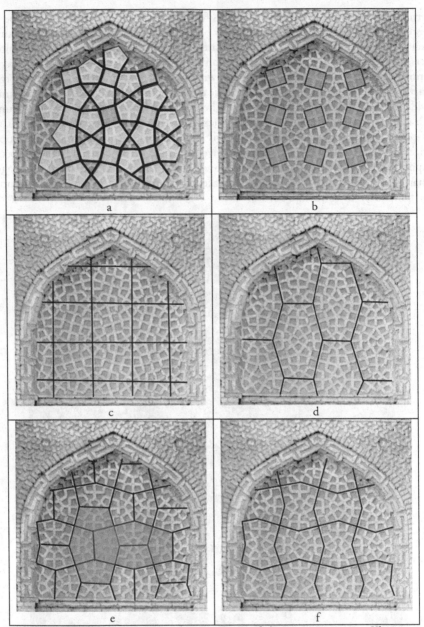

Fig. 9. Analysis of the pattern in the tympanum of the western tower at Kharraqan (shown in fig. 8) yields many possible readings (analyses by the author). a) pentagons, visible as executed in cut brick; b) squares (negative space between four pentagons); c) underlying square grid reveals a design unit that is repeated with perpendicular glide reflections forming a tessellation; d) by connecting centers of some pentagons, a tessellation of vertical hexagons is established; e) by connecting centers of other pentagons, a tessellation of horizontal hexagons is established; by overlapping these two hexagonal tessellations, a tessellation of pentagons is achieved, as illustrated; f) perpendicular lines crossing at the center of each square intersect to form a tessellation of perpendicular "bowties," each composed of two pentagons

As at Gonbad-e Sork and elsewhere, the face with the entryway (fig. 8) has received more elaborate treatment. In some areas the mortar is deeply recessed, allowing the play of light and shadow to help define the geometric patterns made by the arrangement of bricks. The entry façades, including the entry face and the faces adjacent to it on each side, show a greater proportion of recessed mortar, giving a sense of higher relief to the patterns in contrast to those faces not visible from the front of the building. Taken together, these two buildings provide early and incontrovertible evidence of a truly passionate fascination with the phenomena of patterns. In the case of the earlier tower, the tympanum above the entrance bears a geometric pattern of interlace which forms twelve-pointed stars in negative space, repeated nine times, in which the name *Allah* (God) is inscribed [Bier 2002: 73].

What is particularly relevant to the study of patterns with pentagons is the tympanum of the later (western) tower at Kharraqan (figs. 8, 9), which also shows polygonal nets. Analysis of the pattern (figs. 9a-f) shows a highly unusual design that allows for various readings – the repetition of pentagons, squares, and triangles (fig. 9a) creates a pattern in which many different tessellations may be recognized, each of the tessellations covering the plane with no gaps and no overlaps (figs. 9b-f). Symmetry analysis of the seemingly simple pattern of sectioned pentagons, squares and triangles results in the identification of an underlying square grid (fig. 9c), in which the design unit is repeated by perpendicular glide reflections to form a tessellation. The pattern exhibits both ambiguity and visual complexity, and relates this monument to Gonbad-e Qabud in unexpected ways.

Connecting the centers of selected pentagons executed in cut brick (fig. 9a) results in a tessellation of hexagons with a vertical orientation (fig. 9d), or a horizontal orientation. By superimposing these two tessellations, another tessellation is achieved (fig. 9e) of pentagons! Each hexagon, whether vertical or horizontal in orientation, is composed of four such pentagons, and each pentagon has two right angles. By dividing each pentagon in half, yet another tessellation results, this time of a quadrilateral also having two right angles. Perpendicular lines drawn through the center of each square (fig. 9f) results in the tessellation of a double pentagon, or "bowtie," with orientations perpendicular to one another. In order to achieve this exceptional flexibility, each of the shapes has particular characteristics, the underlying geometry of which renders this high degree of pattern play and allows for great visual ambiguity. The smallest quadrilateral has two right angles, such that, reflected across the long axis, two quadrilaterals form a pentagon with four sides of equal length, two right angles, and one longer side (fig. 9e). Four such pentagons (each with a different orientation) compose a hexagon (figs. 9e). We may recognize in the cut brick elements the four-fold orientation of pentagons (fig. 9a), and the two orientations of squares (fig. 9b). The playfulness of the pattern resists easy visual analysis by the untrained eye and allows for the identification of many underlying polygons and grids. This is surely an indication of a sophisticated understanding of angles, lines, numbers and shapes in relation to two-dimensional space, and the recognition of what we call today symmetries and tessellations, described by various terms such as polygonal net, polygons in contact, and dualized grids [Saltzman 2008; Cromwell 2010; Kaplan 2005]. Below the tympanum (fig. 8) is an historical inscription in Arabic and a Qur'anic excerpt [Ali 1978: ch. 23, v. 115], which is unique to the western tower.[8]

As for ornament, there are other monuments in Iran of the Saljuq period and later, for which pentagonal or decagonal elements are paramount. The north dome of the Congregational Mosque in Isfahan (Masjid-e Jomeh) is built of brick and is constructed

with a centralized pentagonal design that can be read in at least two ways (illustrated in [Grabar 1993: 147; Grabar 1990]), lending emphasis either to the concentric pentagons and their extensions, or to the rhombs and triangles created by the intersections of the extensions of the two pentagons. Alternatively, considering the three-dimensionality of interior space beneath the dome, each rib line may be seen to represent a plane that cuts a section through the dome.

Turning our attention away from the unique patterns with pentagonal shapes on the tympanum of the later tower at Kharraqan, and in the pattern surrounding the shaft of Gonbad-e Qabud in Maragha, one must return to consideration of the decagonal structure of Gonbad-e Qabud, which is very rare. The neighboring Gonbad-e Sork and Gonbad-e Ghaffariya are both square prisms, which along with octagonal prisms and cylindrical forms occur far more frequently as the architectural form for tombs on the Iranian plateau. For the Saljuq period, octagonal tomb towers are considered the norm [Hillenbrand 1994; Stronach and Young 1966; Shani 1996]. Several exceptions are worthy of note. Two hundred kilometers to the north, in what is today the Republic of Azerbaijan, stands the mausoleum tower of Mo'mene Khatun [ArchNet] in Nakhchevan, which shares with Gonbad-e Qabud an articulated decagonal plan with a correlation between interior chamber and exterior elevation. Godard [1936] pointed to the similarities in plan and elevation of these two monuments; they are both constructed of brick on a stone foundation and the tomb of Mo'mene Khatun is also likely to have had a ten-sided polyhedral roof. The exterior façade, however, is decorated with interlaced geometric patterns that show ten-, twelve- and thirteen-pointed stars, interlacing with 10-, 12-, and 13-gons [ArchNet]. In contrast to Gonbad-e Qabud, where all of the inscriptions are Arabic, the main inscription beneath the cornice of the Mo'mene Khatun monument displays an early appearance of Persian poetic verses [O'Kane 2009: 32].

The interior decagonal chamber with ten recessed niches finds a local parallel in a neighboring tomb at Maragha, the cylindrical tower ("Circular Tower" [Myron Bement Smith Collection]), dated by a foundation inscription to 563 H. / 1167-68.C.E. Although many other tomb towers on the Iranian plateau have a cylindrical exterior, they do not have decagonal interiors. Two other monuments have niched decagonal interior chambers, but their exterior form is quite different. One of these is the early fourteenth-century flanged tower at Bastam, around which a later shrine complex was built [Hillenbrand 1982]. Farther afield geographically but similar in date to the Gonbad-e Qabud, is the mausoleum of Kilic Arslan II (1155-1192 C.E.) in Konya, Turkey [ArchNet], which also has a decagonal plan and a ten-sided polyhedral dome that was once covered with blue tiles [Redford 1991: 55]. It is located at the center of the Alaeddin Mosque complex, founded earlier but construction of which continued until 1220; this mausoleum is associated with the burial of all but one of the Saljuq Sultans of Rum, who ruled in Anatolia. Redford describes the complex as a "curious mélange of disparate architectural elements and styles" [1991: 54].

Cultural significance of funerary architecture in Iran

There can be no doubt about the cultural significance of pre-Mongol Iranian tomb towers with respect to funerary architecture. Indeed, Hillenbrand devotes to mausolea nearly a quarter of the text of his book documenting the forms of Islamic architecture [Hillenbrand 1994: 253-330]. For the post-Mongol Ilkhanid period of the thirteenth century, Blair states that "the greatest architectural projects ... are tomb complexes" [2004], which served as models for the fifteenth-century Gur-e Mir, Timur's tomb in

Samarkand, and ultimately the Taj Mahal in Agra in the seventeenth century. Ghazan (ruled 1295-1304) was the first Mongol khan to become Muslim (in 1295); he commissioned his vizier, Rashid al-Din, to write a history of the world, which was completed during the reign of Ghazan's brother and successor, Oljeitu. The cultural significance of tomb monuments, before and after the Mongol conquests, is suggested in this work, called *Jami' al-Tavarikh* (*Compendium of Chronicles*):

> Until now it has been the custom of the Mongol emperors of Genghis Khan's *urugh* [lineal descent] to be buried in unmarked places far from habitation in such a way that no one would know where they were ... When the emperor became Muslim ... he said, "Although such was the custom of our fathers ... there is no benefit in it. Now that we have become Muslim we should conform to Islamic rites" Since he was in the capital Tabriz, he chose it as the site [of his tomb] and laid the foundation himself outside the city to the west ... They have been working on it for several years now, and it is planned to be much more magnificent than the dome [i.e., tomb] of Sultan Sanjar the Seljuq in Merv, which is the most magnificent building in the world [Komaroff and Carboni 2002: 105].

When Yakut traveled to Merv in the mid-thirteenth century, he described the tomb of Sultan Sanjar as being beneath a great dome that was "blue and could be seen from a day's journey" [quoted in Wilber 1939: 23, n. 25]. Over the centuries, this visual aspect from afar has also been attributable to other domed monuments of the Saljuq period [Redford 1991: 55].

While architectural beauty, historical context, and commemorative significance are themes treated at length in the literature on the history of art and architecture, what often seems lacking is recognition of the cultural significance of architectural monuments with respect to the history of mathematics.[9] Parallel developments in art and mathematics in the eleventh and twelfth centuries have yet to be treated in an integrated manner, although Necipoğlu, in a chapter devoted to theory and praxis, mentions that they occur in tandem [1995:162]. Within the development of pre-Mongol brick, glazed ceramic, and stucco decoration, there seems to be a close approximation of patterns that offer visual solutions to geometric problems relating to numbers, shape, and the nature of space [Bier 2009] among new advances in algebra and geometry [Berggren 2007: 49]. But such parallels have not yet been addressed systematically, despite the admirable efforts of Necipoğlu to gather and analyze relevant documentary sources in providing context for the undated scroll in the Topkapi Palace Museum collections [Necipoğlu 1995].

Geometric forms of expression and contemporary mathematical thinking

The question of mathematical import in the patterns and form of Gonbad-e Qabud is not just of rhetorical interest, nor solely related to contemporary issues today concerning quasi-periodicity. But moving from general statements about the visual character of particular monuments and their ornament to the identification of specific relationships between patterns and mathematical thinking in Iran during the eleventh and twelfth centuries is complicated in part by the discrete histories of each of our disciplines, as well as by our different methodologies and epistemologies, to say nothing of Orientalism and historical Western attitudes towards the history of science.[10]

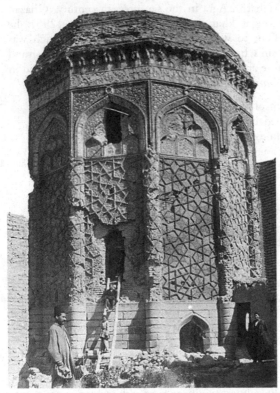

Fig. 10. Gonbad-e Qabud, Maragha, Iran. a) Pattern with pentagonal and decagonal symmetries around shaft of tomb tower, with 'girih' tiles highlighted in one panel [Lu and Steinhardt 2007a: S6 after photo by A. Sevruguin; reproduced with permission of P. Lu]; b) Drawing of one face (after Dastur Corp.) reproduced in [Daneshvari 1982: fig. 128]

Grabar correctly notes that geometry in the arts is expressive rather than representational [1993: 142], a distinction of critical importance to understanding the significance of pattern in Islamic art [Bier 2008]. For the period of the eleventh and twelfth centuries, with one hint of an exception – the association of the north dome of congregational mosque (Masjid-e Jomeh) in Isfahan with Omar Khayyam, based on an earlier supposition of Schroeder extended by Alpay Özdural [1995; 1998] – no one has yet linked specific monuments chronologically to the history of mathematics in Iran. The development of a systematic set of links will require extensive research and correlation of comparative data drawn from architecture and the arts, including textiles [Bier 2004, 2007]. For the moment, we may at least sketch a course for such a project, focusing on plane patterns and progressing from the iteration of a single shape (such as one form of brick), to the repetition of simple shapes to form a tessellation that covers the plane with no gaps and no overlaps, to the cutting, setting and laying of bricks in patterns with polygons and star polygons and the overlapping of polygons to form polygonal nets, occasionally with the addition of glazed color. Dealt with as two-dimensional patterns exhibiting symmetry of the plane, such designs are achieved through combinations of material, craft and technology, by means of which units and shapes relate to points, vectors, and angles, which together express geometric relationships and trigonometric ideas.

To consider the third dimension (spatial), one would add the differentiated forms of hemispherical domes, conical and polyhedral cones, the segmentation of squinches in zones of transition and the treatment of muqarnas, all of which are relevant to solid geometry, spherical trigonometry and conic sections. Mathematics in the eleventh and twelfth centuries in Iran comprised precisely these topics, as well as dissections and algebraic and geometric approaches to the solution of quadratic and cubic equations [Rashed 1994]. The evolutionary development of mathematical thinking that expanded upon the corpus of works of Euclid, Apollonius and others, translated from Greek into Arabic, likely found expression in the contemporary phenomena of experimentation with architectural structures and decoration, discussed above, but this remains to be demonstrated.

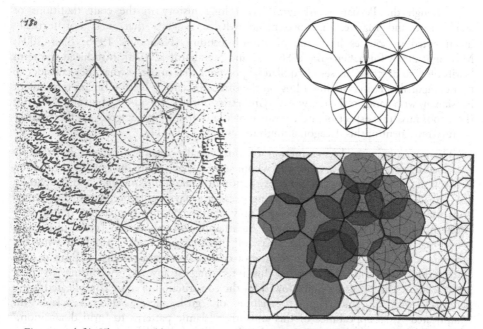

Fig. 11. a, left) *Khatam mukhammas* (pentagonal seal) from Bibliothèque national, Paris, ms persan 169, folio 180a, [Chorbachi and Loeb 1992: fig. 1];
b, upper right) Reconstruction of *khatam mukhammas* by Chorbachi [Chorbachi and Loeb 1992: fig. 4a] using overlapping decagons;
c, lower right) Reconstruction of unit cell at Gonbad-e Qabud by Saltzmann [2008: fig. 7] using grid dualization (author's highlighting of overlapping decagons)

Chorbachi is probably correct in introducing the term "tessellation" [Chorbachi and Loeb 1992: 288] to translate what Özdural [1996] and others have called "interlocking similar or corresponding" forms. She also recognized the relationship of the problems, which are set forth in the undated Paris manuscript BN ms persan 169 (fig. 11a), to what have come to be called Penrose tiles [Chorbachi and Loeb 1992: 284-286]. But she notes that the "step by step construction instructions are not given; neither is the theoretical significance of the given proportions" [Chorbachi and Loeb 1992: 290], although she reconstructed the pentagonal seal by means of overlapping decagons (fig. 11b) [Chorbachi and Loeb 1992: 291, fig. 4a]. Perhaps she and Loeb did not push this understanding far enough to recognize that the pentagonal seal (*khatam mukhammas*) is not only the self-contained design of an equilateral five-pointed star created by

overlapping decagons (fig. 11b), as reconstructed from folio 180a in the undated Paris manuscript (fig. 11a), but that it may also serve as the generative form to yield a planar pattern of overlapping decagons (fig. 11c), which relates to the decagonal/pentagonal pattern on the Gonbad-e Qabud (fig. 10). Such a system of "interlocking similar" decagons also obtains from the construction methods used by Makovicky [2007] with regard to the ornament of Gonbad-e Qabud, but with neither reference to the Paris manuscript nor recognition of the implications of its use as a generative form. By linking the *khatam mukhammas* (fig. 11a-b) to the striking pattern at Maragha (fig. 11c), we may infer a relatively precise chronological connection among the history of mathematics and the history of art, for which documentary evidence in this period otherwise remains elusive.

Although the Persian word *girih* has a long history in the craft traditions of architecture and rug-weaving, present knowledge suggests that it is not textually documented in sources until the nineteenth century [Necipoğlu 1995: Blair 2004; Milwright 2001; Pugachenkova 1986]. Lu and Steinhardt [2007a] introduced the term "girih tiles" to describe the set of equilateral polygons that underlie what they consider to be a decagonal, quasi-crystalline tiling on the fifteenth-century Darb-e Emam monument in Isfahan, with roots in the decagonal symmetries of the Gonbad-e Qabud (fig. 10). But they, too, miss this aspect of the relevance of the overlapping decagons on the twelfth-century revetment of this decagonal tomb tower (figs. 1, 10, 11).

The two-dimensional construction of this visually complex pattern is variously described by different authors, none of whom seem to have made the specific connection between the textual description and construction of *khatam mukhammas* and the pattern at Gonbad-e Qabud in which overlapping decagons may readily be identified as a dual grid, following in the tradition we can now identify on the tympanum of the later (western) tower at Kharraqan. Lu and Steinhardt [2007a] ascribe "girih tiles" to a conceptual breakthrough from the "network of zigzagging lines," based on what has otherwise often been attributed to the use of compass and straightedge to form designs and periodic patterns characterized by interlacing strapwork. According to their interpretation, this breakthrough allowed for the construction of more complicated "girih patterns," with an underlying tessellation of "girih tiles." Saltzman relates the complicated visual appearance of this and other Islamic patterns to "grid dualization," which he describes as "the use of an underlying polygonal grid from which the design is derived" [Saltzman 2008: 154]. Such dual lines are often constructed using an edge mid-point rule, as in the Gonbad-e Qabud. From the perspective of both designer and practitioner, Bonner demonstrates the same results by means of a "polygonal technique" with sub-grids [Bonner 2003]. Other authors [Cromwell 2009; Lee 1987; Fleurent 1992; Kaplan 2005] ascribe similar procedures to the practical construction of such patterns using different terminology, including "polygons in contact" [Kaplan 2005] and "star and polygon compositions" [Necipoğlu 1995: 92]. The actual processes that craftsmen used in the twelfth century have not been determined definitively, but mathematicians at that time endeavored to understand relationships between geometry and algebra [Rashed 1994] and actively sought demonstrations for proofs based on Euclidean models [Kheirandish 2008]. Dissections were part of the mathematical curriculum, as were compass and straightedge constructions [Berggren 2007; Rashed 2005].

Such geometric patterns proliferate on the Iranian plateau in architectural monuments of the eleventh and twelfth centuries, including tomb towers, minarets, shrines, and mosques of the pre-Mongol period [Korn 2010]. They also appear on

monuments built with Mongol patronage in the following decades [Blair 2004; Wilber 1969]. One would like to interpret their appearance in the eleventh and twelfth centuries as formative, and those of subsequent generations as normative within the confines of Islamic art and architectural ornament.

Two final points at this juncture may secure this contemporaneous interlocking of the histories of mathematics and architecture at Maragha. The first concerns the anonymous manuscript, "On Interlocking Similar or Congruent Figures" (Paris BN ms persan 169), discussed by Chorbachi [Chorbachi and Loeb 1992] and by Özdural [1996], which is appended to the text of the work by Abū'l-Wafā al-Būzjānī (d. 998), *Kitāb fīmā yahtā ju ilayhi al-sāni' min a'māl al-handasa* (*A book on those geometric constructions which are necessary for a craftsman*), in the copy held at the Bibliothèque national in Paris, indicating its relevance to issues of art and practice. The second concerns a different copy of the text of al-Buzjani at the Süleymaniye Library Istanbul [Necipoğlu 1995: 134-37, figs. 99-102], which had been copied for Ulugh Beg's royal library in Samarqand, indicating its continued relevance and usefulness as a manual of practical geometry in the Timurid capital in the fifteenth century. Ulugh Beg, grandson of Timur, was himself an astronomer and established an astronomical observatory on the model of Maragha.

Conclusion

Given the unique combination of architectural form and patterns of Gonbad-e Qabud in Maragha, that there is an emphasis on geometry is obvious (figs. 1, 3, 5, 10). The visual complexity of the dual pattern around the shaft of the monument, with its local pentagonal and decagonal symmetries, when viewed in the context of the decagonal prismatic structure with its ten-sided pyramidal roof, is potentially all the more significant in the context of an actively engaged mathematical community seeking to explore visual aspects of theoretical understanding with practical applications [Özdural 2000]. Although the presence of such a community in pre-Mongol Maragha remains speculative, it is reinforced by the very selection of Maragha in the period after the Mongol conquests as the location for the new astronomical observatory after the taking of Alamūt, where there was an earlier observatory at which Naṣīr al-Dīn Ṭūsī worked out what came to be called the "Tusi couple," which subsequently influenced the development of planetary theories in the Renaissance [Saliba 2007]. In the taking of Baghdad in 1258 the rich scientific library holdings were preserved and brought to Maragha [Saliba 2007: 244], where new instruments were developed and crafted, affecting subsequent developments in the observatory of the court of Hulegu's brother, Kublai Khan [Sezgin 1998: 266-76], and later the astronomical observatory of Ulugh Beg in Samarqand.

But even more relevant is the position Gonbad-e Qabud takes within the lineage of architectural decoration among Saljuq and pre-Mongol monuments, as evident especially in tomb towers on the Iranian plateau. Not only is there a clearly identifiable development of planar patterns based on the practical understanding of symmetry as an organizing principle (achieved through iteration of a design algorithm [Bier 2009] in cut bricks, and then with the addition of color), but there is also a noticeable evolution in experimentation with overlapping and interlacing convex polygons and star polygons, from ancient conventions of three-sided triangles and six-pointed stars, and squares and eight-pointed stars, to the appearance of secondary pentagons in polygonal nets of twelve-pointed stars, to hexagons and double hexagon grids interlacing with nonagons with a superimposed net of overlapping dodecagons, the last combination introduced at

Gonbad-e Sork also in Maragha (fig. 7). The Gonbad-e Qabud then brings to bear a conscious progression of 5-, 6-, and 7-pointed stars laid out in a dual grid (figs. 3, 4), and a geometric progression of 8-, 9- and (half) 10-pointed stars in an artistic rendering of rayed stars with petal-sharing (figs. 5, 6), situated above the visually complex pattern with a dual grid around the shaft of the monument (fig. 10). Parallel to these extraordinary and creative developments in the geometric structures and decoration of architecture are the problems set forth in texts of contemporary mathematics (fig. 11a), the understanding and practical articulation of which (figs. 10, 11c) is evident in these monuments. This direction holds great potential for future research to guide our further appreciation and comprehension of Gonbad-e Qabud as not only a nexus of architecture and visual mathematics, but a nexus also for the history of art and architecture and the history of mathematics.

Acknowledgments

For access to the Freer Gallery of Art and Arthur M. Sackler Gallery of Art Archives (Ernst Herzfeld Collection, Myron Bement Smith Collection, Seherr-Thoss Collection) at the Smithsonian Institution in Washington, DC, I am indebted to David Hogge, Archivist. Thanks also to Xavier Courouble, Consultant Cataloguer of the Ernst Herzfeld Collection. The analytical illustrations have the benefit of guidance received from John Sharp, to whom I wish to express my personal appreciation.

Notes

1. Recent scholarship [Jackson 2005] places the death of Sorghaghtani Beki in 1252, and refers to a subsequent burial in a Christian Church in Gansu. A Kerait princess, and the daughter-in-law of Chinggis Khan, she was herself a Nestorian Christian and is known to have retained her religious practice throughout her life. There are, however, Christian monuments at Maragha, mentioned by Kleiss [2002] in his enumeration of monuments of Azerbaijan.
2. Statements such as that in [Lu and Steinhardt 2007a: SOM-S6] and [Makovicky 2007: 1382] need to be amended to take into account the decagonal plan [Bier 2011a].
3. According to Daneshvari [1982] these badly damaged inscriptions were likely also Qur'anic passages.
4. *Gonbad* means dome, and is the term used to described a domed tomb tower; both *sork* and *qermez* mean "red," so "Red Tomb" or "Red Tomb Tower" are both reasonable translations.
5. On Gonbad-e Ghaffariya this only appears on the engaged columns [ArchNet].
6. Milwright [2002] makes note of a dark blue boss marking the center, which is just barely evident in published photographs. Also cited in [Stronach and Young 1966: 15], the spandrels of the entry façade in the later tomb tower at Kharraqan "each support a circular setting for a glazed boss" (see fig. 8). In this case the date of the earliest use of glazed ceramic in the architecture of Iran must be pushed back to the late eleventh century.
7. Much of the following section is drawn from [Bier 2002].
8. For interpretation of the Qur'anic excerpts in relation to the geometric patterns at Kharraqan, see [Bier 2002; 2008]. This is expanded on in [Bier 2011b].
9. Exceptions are the work of Chorbachi [Chorbachi 1989; Chorbachi and Loeb 1992], Özdural [1995; 1996; 1998; 2000; 2002], and Necipoğlu [1995].
10. For an outstanding discussion of such Western attitudes, see "The Notion of Western Science: 'Science as a Western Phenomenon,'" Appendix 1 in [Rashed 1994: 332-49].

References

ALI, A.Y. 1978. *The Holy Qur'an: Text, Translation and Commentary*. Washington D.C.: The Islamic Center.

[ArchNet] ArchNet. http://archnet.org (an international web-based community based at MIT's Design Lab in the School of Architecture and Planning, with a focus on Muslim cultures and civilizations).

BERGGREN, J. L. 2007. Mathematics in Medieval Islam. Pp. 515-675 in *The Mathematics of Egypt, Mesopotamia, China, India, and Islam: A Sourcebook*, V.J. Katz, ed. Princeton: Princeton University Press.

BIER, C. 2002. Geometry and the Interpretation of Meaning: Two Monuments in Iran. Pp. 67-78 in *Bridges: Mathematical Connections in Art, Music, and Science*, R. Sarhangi, ed. Winfield KS.

————. 2004. Pattern Power: Textiles and the Transmission of Mathematical Knowledge. Pp. 144-153 in *Appropriation, Acculturation, Transformation: Proceedings of the 9th Biennial Symposium of the Textile Society of America*, C. Bier, ed. Textile Society of America.

————. 2007. Patterns in Time and Space: Technologies of Transfer and the Cultural Transmission of Mathematical Knowledge across the Indian Ocean. *Ars Orientalis* 34: 174-196.

————. 2008. Art and *Mithal*: Reading Geometry as Visual Commentary. *Iranian Studies* 41, 4: 491-509.

————. 2009. Number, Shape, and the Nature of Space: Thinking through Islamic Art. Pp. 827-851 in *Oxford Handbook for the History of Mathematics*. E. Robson and J. Stedall, eds. Oxford: Oxford University Press.

————. 2011a. Taking Sides, but Who's Counting? The Decagonal Tomb Tower at Maragha. Pp. 497-500 in *Bridges Conference (Mathematical Connections in Art, Music, Science*, R. Sarhangi, et al., eds. Phoenix: Tessellations Publishing.

————. 2011b. Qur'an, *Amthal*, and Geometry on the Iranian Plateau in the 11th and 12th Centuries. Presented at "Workshop: Cultural Responses to the Qur'an", 18 November 2011, American Academy of Religion Annual Meeting (AAR), San Francisco. Forthcoming.

BLAIR, S. 1992. *The Monumental Inscriptions from Early Islamic Iran and Transoxiana*. New York: E. J. Brill.

BLAIR, S. 2004. IL-KHANIDS ii. ARCHITECTURE. *Encyclopaedia Iranica*, Online Edition. Available at: http://www.iranicaonline.org/articles/il-khanids-ii-architecture. Last accessed 6 April 2012.

BONNER, J. 2003. Three Traditions of Self-Similarity in Fourteenth and Fifteenth Century Islamic Geometric Ornament. Pp. 1-12 in *Meeting Alhambra: ISAMA-Bridges Conference Proceedings*. J. Barrallo, et al., eds. Granada: University of Granada.

CHORBACHI, W. K. 1989. In the Tower of Babel: Beyond Symmetry in Islamic Design. *Computers and Mathematics with Applications* 17: 751-789 (rpt. in *Symmetry 2: Unifying Human Understanding*, I. Hargittai, ed. New York: Pergamon, 1989, pp. 751-789).

CHORBACHI W.K. and A. LOEB. 1992. An Islamic Pentagonal Seal (from Scientific Manuscripts of the Geometry of Design). Pp. 283-305 in *Fivefold Symmetry*, I. Hargittai, ed. Singapore: World Scientific.

CROMWELL, P. R. 2009, The Search for Quasi-Periodicity in Islamic 5-Fold Ornament. *Mathematical Intelligencer* 31, 1: 36-56.

————. 2010. Hybrid 1-point and 2-point Constructions for Some Islamic Geometric Designs. *Journal of Mathematics and the Arts* 4, 1: 21-28.

DANESHVARI, A. 1982. Complementary Notes on the Tomb Towers of Medieval Iran. 1: The Gunbad-i Kabud at Maraghe 593/1197. Pp. 287-295 in *Art et Société dans le Monde Iranien*, C. Adle, ed. Paris: Editions Recherche sur les civilisations.

————. 1986. *Medieval Tomb Towers of Iran*. Malibu: Undena Press.

DE BLOIS, F. 2002. HAFT PEYKAR. *Encyclopaedia Iranica*, Online Edition. Available at: http://www.iranicaonline.org/articles/haft-peykar. Last accessed 6 April 2012.

FLEURENT, G. M. 1992. Pentagon and Decagon Designs in Islamic Art. Pp.263-281 in *Fivefold Symmetry*, I. Hargittai, ed. Singapore: World Scientific.

GODARD, A. 1934. *Les Monuments de Marāgha*. Publications of the Société des études iraniennes, no. 7. Paris: E. Leroux.

————. 1936. Notes Complementaires sur les Tombeaux de Maragha. *Athar-e- Iran* 1: 125-60.

GRABAR, O. 1990. *The Great Mosque of Isfahan*. New York: New York University Press.

————. 1993. *The Mediation of Ornament*. Princeton: Princeton University Press.

GRÜNBAUM, B. and G. C. SHEPHARD. 1989. *Tilings and Patterns: An Introduction*. New York: W.H. Freeman and Company.

[HERZFELD] Ernst Herzfeld Collection, Freer Gallery of Art and Arthur M. Sackler Gallery Archives, Smithsonian Institution, Washington DC.

HILLENBRAND, R. 1982, The Flanged Tomb Tower at Bastam. Pp. 237-261 in *Art et Sociéte dans le Monde Iranien*, C. Adle, ed. Paris: Editions Recherche sur les civilisations.

———. 1994. *Islamic Architecture: Form, Function, Meaning*. New York: Columbia University Press.

HOURCADE, B. 1984. ALAMŪT. *Encyclopaedia Iranica*, Online Edition. Available at: http://www.iranicaonline.org/articles/alamut-valley-alborz-northeast-of-qazvin-. Last accessed 6 April 2012.

JACKSON, P. 2005. *Mongols and the West*. New York: Longman.

KAPLAN, C. S. 2005. Islamic Star Patterns from Polygons in Contact. *GI '05: Proceedings of the 2005 Conference on Graphics Interface*. http://www.cgl.uwaterloo.ca/~csk/papers/kaplan_gi2005.pdf. Last accessed 6 April 2012.

KHEIRANDISH, E. 2008. Science and *Mithal*: Demonstrations in Arabic and Persian Scientific Traditions. *Iranian Studies* 41, 4: 465-89.

KLEISS, W. 2002. AZERBAIJAN xii. MONUMENTS. *Encyclopaedia Iranica*, Online Edition. Available at: http://www.iranicaonline.org/articles/azerbaijan-monuments. Last accessed 6 April 2012.

KOMAROFF, L. and S. CARBONI, eds. 2002. *The Legacy of Genghis Khan: Courtly Art and Culture in Western Asia, 1256-1353*. New York: The Metropolitan Museum of Art.

KORN, L. 2010. SALJUQS vi. ART AND ARCHITECTURE. *Encyclopaedia Iranica*, Online Edition. Available at: http://www.iranicaonline.org/articles/saljuqs-vi. Last accessed 6 April 2012.

LEE, A. J. 1987. Islamic Star Patterns. *Muqarnas* 4: 182-197.

LU, P. J. and P. J. STEINHARDT. 2007a. Decagonal and Quasi-Crystalline Tilings in Medieval Islamic Architecture," *Science* 315 (Feb. 22): 1106-1110. (Supp. Online Material, figs. S1-S8, www.sciencemag.org/cgi/content/full/315/5815/[page]DC1)

———. 2007b. Response to 'Comment on "Decagonal and Quasi-Crystalline Tilings in Medieval Islamic Architecture. *Science* 318 (November 30): 1383.

LUTHER, K. A. 1987. ATĀBAKĀN-E MARĀĠA. *Encyclopaedia Iranica*, Online Edition. Available at: http://www.iranicaonline.org/articles/atabakan-e-maraga-also-called-ahmadilis-a-family-of-local-rulers-of-maraga-who-ruled-from-the-early-6th-12th-cent. Last accessed 6 April 2012.

MAKOVICKY, E. 1992. 800-Year-Old Pentagonal Tiling from Maragha, Iran, and The New Varieties of Aperiodic Tiling It Inspired. Pp. 67-86 in *Fivefold Symmetry*, I. Hargittai, ed. Singapore: World Scientific.

———. 2007. Comment on 'Decagonal and Quasi-Crystalline Tilings in Medieval Islamic Architecture. *Science* 318 (November 30): 1383a.

———. 2008. Another Look at the Blue Tomb of Maragha, A Site of the First Quasicrystalline Islamic Pattern. *Symmetry: Culture and Science* 19, 2-3: 127-151.

MILWRIGHT, M. 2001. GEREH-SAZI ii. ARCHITECTURE. *Encyclopaedia Iranica*, Online Edition. Available at: http://www.iranicaonline.org/articles/gereh-sazi. Last accessed 6 April 2012.

———. 2002. GONBAD-E SORK. *Encyclopaedia Iranica*, Online Edition. Available at: http://www.iranicaonline.org/articles/gonbad-e-sork. Last accessed 6 April 2012.

MINORSKY, V.. 1960. Aḥmadīlīs. *Encyclopaedia of Islam*, 2nd ed., P. Beam, et al., eds., vol. 1, pp. 300-301. Leiden: E. J. Brill

———. 2011. Marāgha. *Encyclopedia of Islam*, 2nd ed. P. Beam, et al., eds., vol. ?, pp. ??-??. Leiden: Brill.

NECIPOĞLU, G. 1995 *The Topkapi Scroll: Geometry and Ornament in Islamic Architecture*. Santa Monica: Getty Center for the History of Art and the Humanities.

O'KANE, B. 2009. *The Appearance of Persian on Islamic Art*. New York: Persian Heritage Foundation.

ÖZDURAL, A. 1995. "Omar Khayyam, Mathematicians, and *Conversazioni* with Artisans," *Journal of the Society of Architectural Historians* **54**, 1 (March 1995): 54-71.

———. 1996. On Interlocking Similar or Corresponding Figures and Ornamental Patterns of Cubic Equations. *Muqarnas* **13**: 191-211.

———. 1998, A Mathematical Sonata for Architecture: Omar Khayyam and the Friday Mosque of Isfahan. *Technology and Culture* **39**, 4: 699-715.

———. 2000. Mathematics and Arts: Connections between Theory and Practice in the Medieval Islamic World. *Historia Mathematica* **27**,2: 171-201.

———. 2002. The Use of Cubic Equations in Islamic Art and Architecture. Pp. 165-179 in *Nexus IV: Architecture and Mathematics*, K. Williams and J. F. Rodrigues, eds. Fucecchio (Florence): Kim Williams Books.

PUGACHENKOVA, G.A. 1986. ARCHITECTURE iv. Central Asia. *Encyclopaedia Iranica*, Online Edition. Available at: http://www.iranicaonline.org/articles/architecture-iv. Last accessed 6 April 2012.

RASHED, R. 1994. *The Development of Arabic Mathematics: Between Arithmetic and Algebra*. Dordrecht and Boston: Kluwer.

———. 2005. *Geometry and Dioptrics in Classical Islam*. London: Al-Furqaan Islamic Heritage Association.

REDFORD, S. 1991. The Alaeddin Mosque in Konya Reconsidered. *Artibus Asiae* **51**: 54-74.

SALIBA, G. 2007. *Islamic Science and the Making of the European Renaissance*, Cambridge, MA: MIT Press.

SALTZMAN, P. 2008. Quasi-Periodicity in Islamic Geometric Design. Pp. 153-168 in *Nexus VII: Architecture and Mathematics*, K. Williams, ed. Torino: Kim Williams Books.

SEHERR-THOSS, S. P. and H. C. SEHERR-THOSS 1968. *Design and Color in Islamic Architecture: Afghanistan, Iran, Turkey*. Washington, D.C.: Smithsonian Institution.

SEZGIN, F. ed. 1998. *The School of Maragha and Its Achievements, Islamic Mathematics and Astronomy*, vol. 50-51. Frankfurt: Publisher?.

SHANI, R. 1996. *A Monumental Manifestation of the Shi'ite Faith in Late Twelfth-Century Iran: The Case of the Gunbad-i 'Alawiyan, Hamadan*. Oxford Studies in Islamic Art XI. Oxford: Oxford University Press.

MYRON BEMENT SMITH COLLECTION, Freer Gallery of Art and Arthur M. Sackler Gallery Archives, Smithsonian Institution, Washington DC. Gift of Katharine Dennis Smith, 1973-1985.

STRONACH, D. and T. C. Young, Jr. 1966. Three Octagonal Seljuq Tomb Towers from Iran. *Iran* **4**: 1-20.

VARDJAVAND, P. 1979. La Découverte archéologique du complexe scientifique de l'observatoire de Maraqé. Pp. 527-536 in *Akten des VII. Internationalen Kongresses für Iranische Kunst und Archäeologie* (Munich, 7-10 September 1976). Berlin.

WILBER, D. 1939. The Development of Mosaic Faience in Islamic Architecture in Iran. *Ars Islamica* **VI**: 16-47.

———. 1969. *The Architecture of Islamic Iran: The Il-Khanid Period* (1955). Princeton: Princeton University Press

About the author

Carol Bier is a Visiting Scholar (2010-12) with the Center for Islamic Studies at the Graduate Theological Union in Berkeley CA and Research Associate at The Textile Museum in Washington DC (2001-12), where she served as Curator for Eastern Hemisphere Collections (1984-2001). Her current research focuses on the historical development of Islamic patterns as intersections of geometry, art, religion, and philosophy.

Maryam Ashkan

200 Robbie Lane
San Marcos, Texas, 78666
USA
maryamashkan@gmail.com

Yahaya Ahmad

Department of Architecture,
Faculty of Built Environment,
University of Malaya
Lembah Pantai
50603 Kuala Lumpur, MALAYSIA
yahaya@um.edu.my

Keywords: Dome typologies;
dome morphology; conical
domes; polyhedral domes;
geometry; Iran; Central Asia;
Middle East

Research

Significance of Conical and Polyhedral Domes in Persia and Surrounding Areas: Morphology, Typologies and Geometric Characteristics

Abstract. The aim of this paper is to identify the unique features of the conical and polyhedral domes which topped a majority of distinct tomb towers during the early Islamic era. As opposed to previous general historic studies, this paper introduces a new analytical approach which allows the complete comprehension of the formal architectural language of conical and polyhedral domes based on an epistemological premise of their space syntax. Through an analytic review of selected examples, the paper suggests and addresses the origin of conical domes, their formal morphological compositions and typological forms based on the number of their external shells from the Seljuk era throughout the Timurid period in Iran and nearby regions. The theoretical framework for the formal language of conical and polyhedral domes sheds new light on undiscovered information about the essential characteristics of Persian domes in this region.

1 Introduction

Some of the most enduring signs of Seljuk architecture are the distinct types of polyhedral and conical domes which still stand in Azerbaijan, Turkey, Iran, Turkmenistan, and Uzbekistan. These edifices are commonly well-known as a primitive architectural formula for the Islamic funerary buildings topped with conical and polyhedral shells which mainly appeared in the Seljuk period. From the architectural point of view, such edifices are remarkable due to their influence on structural design and commonality of the huge and complex configurations of Islamic funerary architecture later. In comparison with the number of existing domes, the studies concerning the commonality of their typological and morphological features, that is, their formal architectural language, are scarce and suffer from the lack of in-depth analysis of their special characteristics.

In this matter, despite the pre-Islamic background of conical domes in this region, the main objective of this research is to discover the formal language of conical and polyhedral domes, including their origin, morphological features, and typological structure during Islamic periods. The central idea adopted in considering of the examples chosen in this study differentiates from the previous general historical analysis in that it dwells on the initial spatial features and their formal structure, which evolved naturally over time from the Persian culture from which it comes. To achieve such objectives, an understanding of their conceptual evolutions and style development over historical eras is also required.

Such a study can not only bring to light chronological issues regarding the development of the conical and polyhedral domes in Persia and nearby countries, but can also provide a new methodology for understanding the formal language of other sorts of

Nexus Netw J 14 (2012) 275–290
DOI 10.1007/s00004-012-0112-x; *published online* 24 May 2012
© 2012 Kim Williams Books, Turin

traditional Islamic domes in this zone. Meanwhile, despite the simple architectural grammar of such domes, analyzing the powerful compositional relationship of their components and distinct styles helps to compile contemporary design criteria for the purpose of preserving the traditional aesthetical aspects in present-day dome design.

This paper is arranged into three parts as follows: 1) a historical outline of evolution of the polyhedral and conical domes since the early Islamic era, by reviewing famous examples; 2) elaboration of their derived common morphological features and typical components; and finally 3) classification of their common typologies based on the number of their internal and external shells.

2 Conical and polyhedral domes

2.1 Terminology

While the term of dome has been used similarly in different literatures both in the Eastern and Western architectures [Michell 1978; Pope 1965; Stierlin 2002; Smith 1971; Wilber 1969], there has been a major architectural contrast between the composition of their spatial elements. Structurally speaking, Eastern domes were supported on "squinches" which generally originated from Persia [Ashkan and Yahya 2009b], as opposed to Western domes, which were systematically erected on "pendentives" originally appearing in Turkey [Altin 2001].

Chronologically, the architectural compositions of Persian domes underwent major changes both structurally and aesthetically as they appeared in different dynasties, especially, during Islamic periods, eventually ending up with the appearance of three main typologies of domes: conical, pointed, and bulbous (fig. 1) [Ashkan and Yahaya 2009a].

Conical Pointed Bulbous

Fig. 1. Three main styles of domes in Iran and nearby regions. Drawings: Authors

This paper aims to shed light on architectural constitution of conical and polyhedral domes (as subsets of conical domes) which contributed remarkably to the establishment of essential features for the rapid development of the other, later types of Eastern domes.

2. 2 Origins and types

On one hand, conical domes display a great diversity in architectural compositions, materials, and configuration arrangements. They may be considered as a kind of spatial synthesis that evolved over a long course of socio-cultural developments beginning with the appearance of the Seljuks in the Middle East and Central Asia [Pope 1976; Grabar 1963] up to the end of fifteen century. Historically, the origin of the conical dome is still uncertain, though some historians believe they may have been influenced by sources as varied as Turkish tents, Sabian temples, Chinese watch-towers, and Palmyran tower tombs [Ayatollahi 2003; Hillenbrand 1994]. André Godard [1965] and Oleg Grabar [1963; 2006] believe some of these monuments were originally used as Zoroastrian fire temples (fig. 2) in Iran and nearby territories, and were then transformed into tomb towers (by adding a *mihrab*) during the early Islamic era.

Fig. 2. An example of the Zoroastrian fire temple, Sassanid period, *Amol*, Iran. Photo: Authors

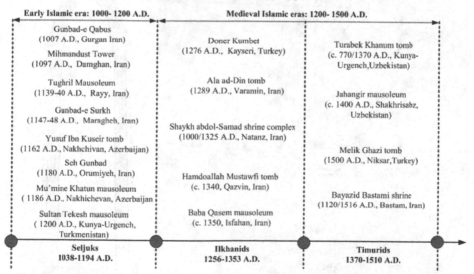

Fig. 3. Timeline of the development of conical and polyhedral domes and the selected dominant samples. Source: Authors

On the other hand, tomb towers topped with either a conical or a polyhedral shell are a primary typology of the memorial function edifices known as mausoleums which mainly appeared in the Seljuk era (1038-1194 A.D.) [Pope 1976; Bosworth 1996] and finally reached its acme in the Ilkhanid era (1256-1353 A.D.).

After that, their configurations were extensively enhanced in the Timurid period by the addition of lavish ornaments, especially in those edifices located in Iran and Central Asia [Wilber 1969]. In fact, these dynasties gave conical constructions their distinctive characteristics, as will be shown in the following brief survey of the dominant examples of each period (fig. 3). Essentially, the main reason beyond their rapid construction more likely lies in a small step beyond the traditional simplicity of burial practice, rooted in the dictates of the religious orthodoxy in the early Islamic epoch [Hillenbrand 1994; Ayatollahi 2003].

Historically, as a result of the flourishing of Persian architecture due to the rising power of the Seljuks [Creswell 1958], the great diversity of buildings used for funerary purposes (more than for religious purposes) were based on either cylinderal or cubed shapes topped by conical domes [Saoud 2003].

The famous Gunbad-e Qabus at Gurgan in Iran (1007 A.D.) is the earliest tomb tower (over 1000 years old) with a solid conical shell. It is the largest Seljuk dome with a 9.70m span and 57m height (fig. 4). Monumentally, its style holds an important place in the Seljuk architecture [Pope 1976], which was used later on as a model for developing cylinder or cube-based forms throughout Iran and surrounding areas [O'Kane 1998; Saoud 2003].

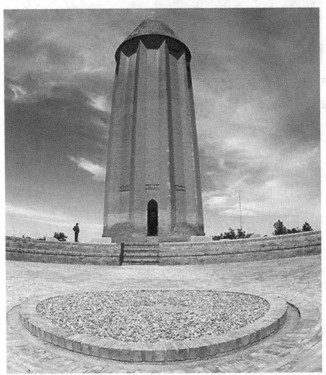

Fig. 4. The famous Gunbad-e Qabus tomb tower, Gurgan, Iran. Photo: Authors.

In the case of conical shells, although the external shell of the Mihmandust (1097 A.D.) tower with its cylindrical base is missing, Sykes [2003] stated that it was most likely topped by a conical shell. Another example is the Tuqril tomb tower (1139-1140 A.D.), which probably represents a more advanced and elegant architecture, distinguished from its origin, the Qabus tower.

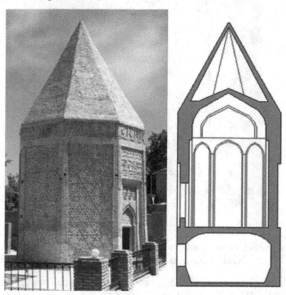

Fig. 5. An example of the early Seljuk tomb towers: Yusuf Ibn Kuseir tomb, Nakhichevan, Azerbaijan. Photo/Drawing: Authors

In addition, the construction of tomb towers went forward in Iran with the erection of the Red Dome tomb crowned by a polyhedral double-shell (Gunbad-e Surkh) (1147-48 A.D.). This building is the oldest of the five tomb towers erected in the city of Maragheh [Hatim 2000: 193-198]. It, in fact, is one of the earliest monuments decorated by using mosaic tiles [Godard 1965]. Soon after, the standing tomb of the Yusuf Ibn Kuseir (1162 A.D.) was built by the Seljuks in Azerbaijan [Hillenbrand 1994] (fig. 5). Though the Seh Gunbad (Three Domes; 1180 A.D.) was erected generally based on the tradition of tomb towers of the Maragheh city, André Godard [1965] noted that this building was basically transformed from the Zoroastrian fire temple into the tomb during the Islamic era.

By the end of the twelfth century, the Mu'mine Khatun mausoleum in Azerbaijan (fig. 6) and Sultan Tekesh in Turkmenistan might be considered as the tomb towers which reflected the dissimilar design patterns [Hoag 1987]. The tomb tower of Mu'mine Khatun (1186 A.D.) in the city of Nakhichevan, with its missing polyhedral shell is a reflection of the Armenian architectural style popular in Azerbaijan in this period [Michell 1995]. Its decagonal brick load-bearing system and lavish ornaments initially distinguished its architectural character from that of the Persian examples. The mausoleum of Sultan Tekesh (1200 A.D.), located at Kunya-Urgench in Turkmenistan, is also one of the few existing monuments from the pre-Mongol era with a height of 30 m. [Blair and Bloom 1995]. The flanged wall of its drum is approximately similar to its origin, the "Qabus tower" in Iran.

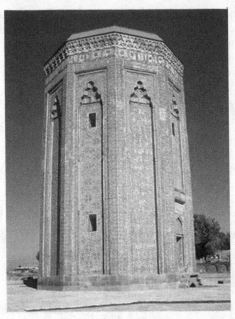

Fig. 6. An example of the Seljuk tomb towers surrounding regions of Iran: Mumine Khatun tomb, Nakhichevan, Azerbaijan. Photo: Authors

In the Anatolian district of the Seljuk Empire, tomb towers were structurally distinguished from the Persian ones through the deep influences of Armenian models [Stierlin 2002]. According to Hillenbrand [1999], these tomb towers, in some aspects, preceded Iranian samples as a model in which either pyramidal or conical shells rested on either cylindrical or polygonal bases. In contrast, their final distinct appearances correspond with respect to four main issues: 1) with use of local stone rather than bricks (common in Iran and the other regions); 2), compositional articulation between the cubic base and the cylindrical bearing system; 3) varying degrees of ornament; and 4) the use of an exterior ring of blind arches.

Fig. 7. Armenian Cathedral of the Holy Cross, Akhtamar Island, Turkey. Photo: Authors

Unsurprisingly, Christian influences are also marked in the final formal configuration of Anatolian towers rather than the other regions studied; this included the use of plain conical shell erected on a high drum, which originated from the standard contemporary Armenian churches [Hillenbrand 1994] (fig. 7). These all inspired local Muslim masters to employ vernacular elements rather than an architecture based on Persian vocabularies.

In this manner, indigenous Armenian models [Stierlin 2002] are strongly reflected in the construction of Doner Kumbet (1276 A.D.) at Kayseri, with its conical roof supported on a massive base [Blair and Bloom, 1995]. Additionally, the small surrounding fortification of the Mama Khatun (Hatun) mausoleum (c. 596-1200 A.D.) at Tercan might be considered a rarely-used pattern in comparison with the other examples studied [Petersen 1999]. But the complex manifests a strong correlation of the Christian impact which, as a whole, also echoes the sense of Turkic conical funerary architecture before the Mongol invasion.

During several Mongol invasions (beginning in 1219 A.D.) and "the genocide of Persian master builders" [Memarian 1988], a brief decline occurred in contributions of domed architectural design; but the material culture of the Middle East and Central Asia flourished again during the reign of later Mongol rulers, especially the Ilkhanids (1256 A.D.) and Timurids (1370- 1510 A.D.) [Michell 1978].

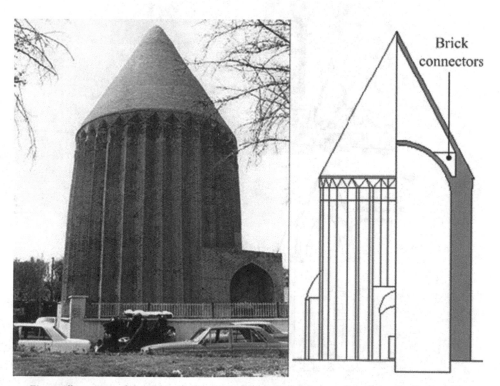

Fig. 8. Illustration of the Ilkhanids' "contribution into the structural configuration" of tomb towers; (a) Ala ad-Din tomb, Varamin, Iran. Photo/Drawing: Authors

Although the construction of conical and polyhedral domes decreased considerably in comparison with the Seljuk era, there were two specific architectural achievements during the Ilkhanid period. Structurally, small brick connectors were introduced for the purpose of attaching the internal and external shells at a regular distance, such as those in the Al ad-Din tomb (1289 A.D.) at Varamin in Iran (fig. 8), a flanged tower 18 m. heigh with a span of 9 m. [Pirnia and Memarian 2003]. These internal connectors between shells were developed compositionally as internal stiffeners and utilized again in the mausoleum of Jahangir (1400 A.D.) at Shakhrisabz in Uzbekistan [Golombek and Wilber 1988]. It is one of the super-dimension examples of conical domes with the height of 27m (fig. 9).

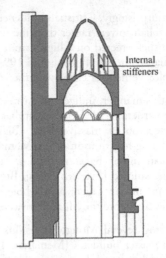

Fig. 9. Jahangir mausoleum, Shakhrisabz, Uzbekistan. Drawing: Authors

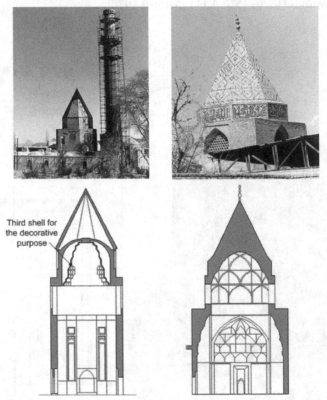

Fig. 10. Two examples of the use of turquoise tile works on the external shells of tomb towers, Ilkhanid, Iran. a, left) Shaykh Abdol -Samad shrine complex, Natanz. Photo: Authors; b, right) Baba Qasem tomb, Isfahan. Photos/Drawings: Authors

The second innovation was the extensive use of turquoise tile works for the decoration of the exterior face of external shells of towers and the rich interior works of muqarnas [Wilber 1969]. In this regard, the Iranian cases are, firstly, the Shaykh abdol-Samad shrine complex (fig. 10a; 1325 A.D.) within its triple-shell dome [Seherr-Thoss and Seherr-Thoss 1968] in Isfahan, which adjoined the unique Friday mosque of the historic city centre of Natanz; secondly, the Hamdoallah Mostawfi tomb (ca. 1340 A.D.), which is considered one of the novel Ilkhanid edifices in Qazvin. From the structural point of view, the construction of the Baba Qasem tomb (1400 A.D., fig. 10b) in Isfahan validated the consecutive erections of the solid polyhedral shells even throughout the Ilkhanid epoch.

The construction of conical and polyhedral domes became less important during the Timurid period due to two main reasons. First, by developing the use of pointed domes erected on mausoleums as a part of more complex urban units, the individual usage of funerary buildings was apparently abandoned, especially in the Central Asia. Second, with the introduction of the bulbous style resulting in the expansion of both structural and architectural designs in Iran, the construction of conical and polyhedral domes became an obsolete tradition [Ashkan and Yahaya 2009a].

Nevertheless, this era was mainly dedicated to the improvement of architectural and structural configurations of the prior samples, such as adding a shell, greater improvement of geometrical proportions [Ashkan and Yahaya 2009b], and attaching huge portals and sometimes terracotta panels [Hillenbrand 1999].

The primary example of such developments is the Turabek Khanum tomb (1370 A.D.) at Kunya-Urgench in Turkmenistan, which has a span of 9 m. (fig. 11a). Its rich decorations, huge portal, and the third shell are the certain testament of the Timurid epoch [Byron 1982: 121; Golombek and Wilber 1988] (fig. 11b).

The triple-shell dome of the Bayazid Bastami shrine complex (1516 A.D.) at Natanz in Iran, with a span of 8 m. and a height of 20 m., can be considered another novel example (fig. 11c) demonstrating the advancement of structural design by adding a third shell to enhance its stability [Hejazi 1997]. At the same time, in the Ottoman Empire in Turkey, the most popular shape of conical towers remained unchanged from that of the previous style, i.e., the cylinder form with the simple two-shell composition, such as the Melik Ghazi tomb (1500 A.D.) at Niksar in Turkey (fig. 11b).

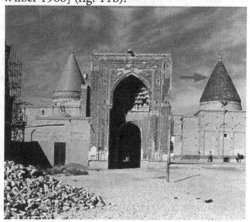

Bayazid Bastami shrine complex, Bastam, Iran.
Photo: Authors

This building was restored or reconstructed by Ottoman rulers in the middle of the fifteenth century [Petersen 1999].

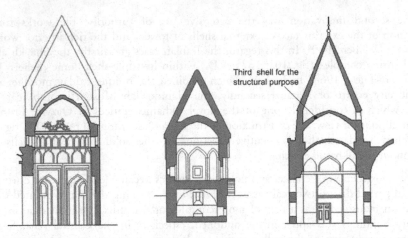

Fig. 11. Three samples of the conical domes in the Timurid era: a, left) Turabek Khanum tomb, Kunya- Urgench, Uzbekistan; b, center) Melik Ghazi tomb, Niksar, Turkey; c, right) Bayazid Bastami shrine complex, Bastam, Iran. Drawings: Authors

On the whole, the conical and polyhedral tomb towers in Iran, Uzbekistan, and Turkmenistan are twice or even three times larger in size than the examples in Turkey and Azerbaijan (whose heights vary between 10 m. and 15 m.). For sure, the number of cases and their distinct arrangements clearly proved that such domes were more popular in Iran than in the other regions studied.

In conjunction with the actual architectural and structural contrasts, the examples of two territories are particularly remarkable; these are Iran, Azerbaijan, Turkmenistan, and Uzbekistan, on one hand, and on the other hand, Turkey. The harmonic composition of Anatolian examples, in fact, are a reflection of their Christian roots, in contrast to the Zoroastrian tradition, which might have admittedly been a basis for the architectural archetypes of tomb towers in Persia and surrounding areas.

Regarding the interior designs of the studied cases, the domes in Iran and the Central Asia are much richer in the complicated stucco decorations and lavish tile works than are the edifices in Turkey and Azerbaijan, with their monochromatic reliefs. Nevertheless, the location of the crypts of the Turkish examples might be rooted in their Christian origin, while the chambers of graves of the Iranian and Central Asian buildings were chiefly placed underground.

The skillful use of the local, regionally available materials and the related well-developed construction techniques are predominant in the all of the cases studied, including the use of stone (e.g., in Turkey) and brick (e.g., in Iran and Uzbekistan).

3 Common morphological features of the conical and polyhedral domes

The final configuration of the conical domes resulted from the continuous development of four main components or "vocabularies". In this regard, if the traditional conical dome is contemplated as a sentence, its elements can be considered as the vocabularies by which the sentence is written and read. Morphologically, the common vocabularies of such domes are namely: load bearing system, transition tier, drum, and shells (fig. 12). Additionally, the incipient arrangements of the internal stiffeners and brick connectors mainly came to light in the Ilkhanid era, in order to connect the internal shell to the external shell. These structural elements have been prevented the collapse of the shells that used to take place frequently.

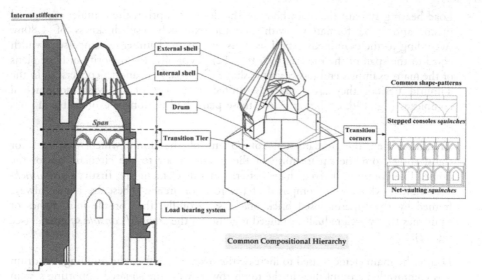

Fig.12. Illustration of the common morphological features of conical domes. Drawings: Authors

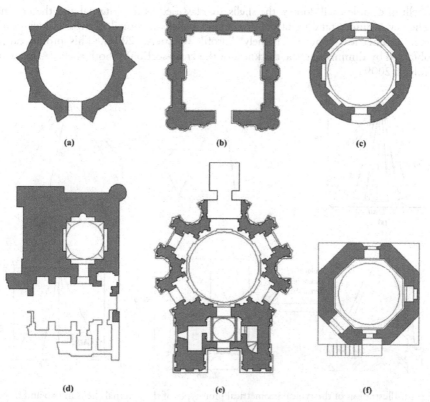

Fig. 13. Illustration of sample floor plans: (a) Gunbad-e Qabus, 1007A.D., Iran; (b) Gunbad-e Surkh, 1147-48 A.D., Iran; (c) Seh Gunbad, 1180 A.D., Iran ; (d) Jahangir mausoleum, 1400 A.D., Uzbekistan; (e) Turabek Khanum tomb, 1370 A.D., Uzbekistan; (f) Melik Ghazi tomb, 1500 A.D., Turkey. Drawings: Authors

- **Load bearing system:** the main body of the dome comprises the cylinder, octagonal prism, and cube formations with the approximately wall-thickness of 1.80m. According to the examined vertical sections, the main chamber encompasses a width equal to the span of the internal shell (fig. 12). Typically, the majority of floor plans of the main examples embrace a simple shape (fig. 13a, b, c, and f); conversely, in the Timurid period, they are frequently united as a part of the vast monumental complexes (fig. 13d, c). Nevertheless, these plans had no longer evolved based on a given pattern.

- **Transition tier:** the fundamental component of the dome which was used for transferring from the square form of the ground floor to the circular base of the dome. The common derived shape-patterns of this element are, firstly, the *squinch-net vaulting* which were composed of the rows of arches. These are almost always framed by the superimposed brick brackets; secondly, the console mini-arches or squinches that were gradually arranged together as the *stepped console squinches* (see fig. 12).

- **Drum:** the main element used to increase the overall height of the building; the drum was commonly accomplished in the tomb towers with the squared upporting system that were regionally popular in Iran and the Central Asia.

- **Shell:** in double-shell domes, the shells are classified as the internal and the external. The key in understanding of the diversities of shells is rooted in the consideration of their geometrical concepts, namely, "profile" [Huerta 2006]. This profile can be obtained by diminishing the thickness of the cross-section of both shells [Ashkan and Yahaya 2009a].

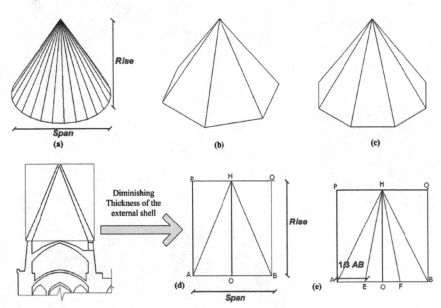

Fig. 14. Illustration of the typical geometrical prototypes of the external shells in two and three dimensions. Drawings: Authors

The external shell of a tomb tower, that is, what appeared from the outside of the edifice, is the only architectural item that was conceptually identified as a synonymous feature in the entire corpus of examples studied. In the three-dimensional analysis, the typical forms of this component are named as the conical (fig. 14a), hexagonal (fig. 14b), and octagonal (fig. 14c) in which the conical and the hexagonal patterns are extensively amalgamated as the most usual models throughout the periods studied.

By diminishing the thickness of the external shell, the couple of triangles are commonly derived based on certain geometrical relationships between the space and the rise of the domes; first, the isosceles (if the rise ≠ the span; fig. 14d), second, equilateral triangles (if the span = the rise; fig. 14e).

Owing to the profiles of the internal shells, the popular patterns are respectively gained as the saucer (Tughril mausoleum), the pointed as the most ubiquitous form (Turabek Khanum mausoleum, Jahangir mausoleum, Bayazid Bastami shrine, Yusuf Ibn Kuseir tomb), the semi-circular (Hamdoallah Mustawfi tomb) and finally the semi-elliptical as the earliest form of the internal shell (Gunbad-e Qabus). This diversity of patterns can undoubtedly verify the early attempts of master builders to find an appropriate model, both structurally and architecturally.

From the geometrical point of view, the pointed internal shell constitutionally consists of either two or four small arcs arranged proportionally according to a closed relationship between the span and the rise (fig. 15). A discussion of the traditional methods of geometrical designs, drawings of small arcs and their associated proportional designs is beyond the scope of this paper (for further references, see [Ashkan and Yahaya 2009a] and [Dold-Samplonius 2000]).

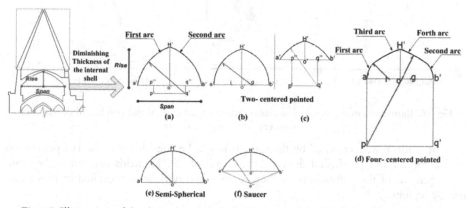

Fig. 15. Illustration of the derived geometrical archetypes of the internal shells: (a) Turabek Khanum mausoleum; (b) Jahangir mausoleum; (c) Bayazid Bastami Shrine; (d)Yusuf Ibn Kuseir tomb; (e) Hamdoallah Mustawfi tomb; (f) Tughril mausoleum. Drawings: Authors

4 Common typological styles of the conical and polyhedral domes

One of the motives for a morphological survey was essentially to determine the programmatic approach for clarifying typological commonality of such domes. Therefore, the typological study relies on an overall view of the common arrangements of the dome's spatial elements. The constitution of shells, which is derived as the

synonymous feature of the conical and polyhedral domes, is thus manipulated for the stylistic categorization of the conical and polyhedral domes. According to the number of the shells, these domes are classified as one-shell, double-shell, and triple-shell (fig. 16). The one-shell domes are more frequently found during the Seljuk than the other periods. Interestingly, the tomb towers topped by the solid octagonal and hexagonal shells were predominant over the other forms and also their constructions simultaneously continued until the Timurids in Iran and surrounding areas.

Overall speaking, the double-shell domes were the most common shape in the periods studied, especially in the Ilkhanid era. However, a few triple-shell examples can verify that they originated in the double-shell prototype in which a shell was frequently constructed for, firstly, a decorative purpose (Shaykh Abdol Samad shrine complex, see fig. 10a) and, secondly, for providing the structural stability, perhaps as a result of an improvement in structural knowledge, mainly during the Timurid era.

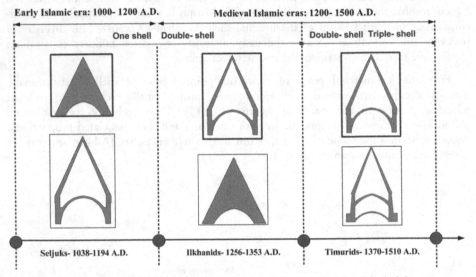

Fig. 16. Illustration of the typological classifications of the conical and polyhedral domes over historic era. Drawings: Authors

The tomb towers crowned by three shells might be considered as the last generation of the conical and polyhedral domes, by the end of the Timurids era, when the rapid developments of the pointed and bulbous domes had noticeably prevailed in Persia and nearby regions.

5 Conclusion

Conical and polyhedral domes are one of the distinctive aspects of Persian domes which constitute an essential milestone in the development of funerary monuments as a cultural tradition after the appearance of Islam in Iran and surrounding areas

As was stated at the beginning, conical and polyhedral domes chronologically underwent the systematic evolutions during the Seljuk, the Ilkhanid, and finally the Timurid periods, when they reached their acme. Morphologically, four main components – namely, the load bearing system, the transition tier, the drum, and the shells, which are divided into the internal and the external – were derived identically. In addition, the internal shell embraces the various models including the semi-elliptical, the

semi-circular, the pointed, and the saucer models. These shapes are geometrically compatible with the external shell shape, ensuring the structural stability of the whole configuration. This was also the purpose of the internal stiffeners also inserted between the external and internal shells; this approach was subsequently carried out in the compositions of other sorts of Eastern domes, such as the bulbous and the pointed domes in Iran and surrounding areas.

Typologically, the order of shells of the conical and polyhedral domes, which were grouped into single shell, double-shell, and triple-shell, also provide insight into the characteristics of structural designs of these imposing structures. By the identifying a set of attributes for these tomb towers, this paper has tried to show that the configurations of the conical and polyhedral domes are more or less similar, in spite of visual dissimilarities in designs.

The recognition of the formal language of such domes may shed new light on the principles of morphological and typological analysis of the traditional domes in Persia and nearby regions that can be used as design standards in contemporary architecture: firstly, to preserve the close relationship between the past and the present; secondly, to pursue the emergence of the specific aesthetic harmony in the traditional designs of the Iranian domes.

Acknowledgments

The authors gratefully acknowledge Professor Christopher Long from the School of Architecture at the University of Texas at Austin for his crucial advises on this paper. His academic involvement in the research has greatly contributed to the betterment of the paper content. The authors also take an opportunity to sincerely thank the anonymous referees for their constructive comments that improved the presentation of the paper.

References

ALTIN, M. 2001. The Structural Analysis of Domes: From Pantheon until Reichstag. Pp. 197-208 in Historical Constructions 2001. Possibilities of numerical and experimental techniques. *Proceeding of the 3rd International Seminar of Historical Construction,* 7-9 November 2001, P.B. Lourenço, P. Roca, eds. Guimarães, Portugal: University of Minho.

ASHKAN, M., and A. YAHAYA. 2009a. Discontinuous Double-Shell Dome through Islamic eras in the Middle East and Central Asia: History, Morphology, Typologies, Geometry, and Construction. *Nexus Network Journal* 12, 2: 287-319.

———. 2009b. Persian Domes: History, Morphology, and Typologies. *International Journal of Architectural Research* 3, 3: 98-115.

AYATOLLAHI, H. 2003. *Book of Iran: The History of Iranian Art.* Iran, Tehran: The Ministry of Culture and Islamic Guidance.

BLAIR, S.S., and J. M. BLOOM. 1995. *The Art and Architecture of Islam.* New Haven: Yale University Press.

BOSWORTH, C. E. 1996. *The New Islamic Dynasties.* New York: Columbia University Press.

BYRON, R. 1982. *The Road to Oxiana.* New York: Oxford University Press.

CRESWELL, K. A. C. 1958. *A Short account of the Early Muslim Architecture II.* Oxford: Claren Don Press. (p. 83-87)

GODARD, A. 1965. *The Art of Iran.* Michael Heron, trans. New York, Washington: Frederick A. Praeger.

GOLOMBEK, L., and D. WILBER. 1988. *The Timurid Architecture of Iran and Turan.* New Jersey: Princeton University Press.

GRABAR, O. 1963. The Islamic dome: Some considerations. *Journal of the Society of Architectural Historians* 22, 4: 191-198.

———. 2006. *Islamic Art and Beyond: Constructing the Study of Islamic Art,* Vol. 3. Aldershot, UK: Ashgate Publishers.

HATIM, G. A. 2000. *Mimari-i Islami-i Iran dar dawrah-i Saljuqian* (Islamic Architecture of Iran during the Seljuks). Tehran: Muassasah-i Intisharat-i Jihad-i Danishgahi . (In Persian.)

HEJAZI, M. M. 1997. *Historical Buildings of Iran: Their architecture and Structure.* Southampton: Computational Mechanics Publications.

HILLENBRAND, R. 1994. *Islamic Architecture: Form, Function, and Meaning.* New York: Columbia University Press.

HILLENBRAND, R. 1999. *Islamic Art and Architecture: The Ilkhanids and Timurids.* London: Thames and Hudson. (p. 196- 202)

HOAG, J. D. 1987. *History of World Architecture: Islamic Architecture.* New York: Rizzoli.

HUERTA, S. 2006. Galileo was Wrong: The Geometrical Design of Masonry Arches. *Nexus Network Journal* **8**, 2: 25-52.

MEMARIAN, G. H. 1988. *Statics of Arched Structures* (*Niyâresh-e Sâzehâye Tâghi*), Vol. 1. Tehran: University of Science and Technology Press. (In Persian)

MICHELL, G., ed. 1978. *Architecture of the Islamic World: Its History and Social Meaning.* New York: Thames and Hudson.

O'KANE, B. 1998. Dome in Iranian Architecture, Iranian Art and Architecture, [Retrieved November, 21, 2010, On-line, http://www.cais-soas.com/CAIS/Architecture/dome.htm].

PETERSEN, A. 1999. *Dictionary of Islamic Architecture.* London: Routledge Press (Reprint edition).

PIRNIA, M., and Q. Memarian. 2003. *Recognition of Persian Architectural Styles.* Tehran: Pazhoohandeh. (In Persian)

POPE, A. U. 1965. *Persian Architecture.* London: Thames and Hudson Press.

———. 1976. Introducing Persian Architecture. Pp. 52-68 in *A Survey of Persian Art*, J. Gluck, A. U. Pope and P. Ackerman (eds.). Tehran: Soroush Press.

SAOUD, R. 2003. Muslim Architecture under Seljuk Patronage (1038-1327). Foundation for Science, Technology, and Civilization (FSTC). http://www.muslimheritage.com/features/default.cfm?ArticleID=347. Last accessed 25 March 2012.

SEHERR-THOSS, S. P. and H. C. SEHERR-THOSS 1968. *Design and Color in Islamic Architecture: Afghanistan, Iran, Turkey.* Washington. D.C.: Smithsonian Institution Press.

SMITH, E. B. 1971. *The Dome: A Study in the History of Ideas.* New Jersey: Princeton Press.

STIERLIN, H. 2002. *Islamic art and Architecture: From Isfahan to the Taj Mahal.* London: Thames and Hudson.

SYKES, S.P. 2003. *History of Persia* (3rd ed.). London: Routledge Publisher.

WILBER, D. N. 1969. *The Architecture of Islamic Iran: The Il-Khanid Period.* New York: Greenwood Press.

About the authors

Maryam Ashkan was born in Iran in 1978, and graduated with the M. Arch degree in 2003 from Qazvin Azad University, Dept. of Architecture and Urban Design. After receiving her master's degree, she started her professional career as an architect in local architectural firms until 2006. In August 2010, she received her Ph.D. in architectural history from the University of Malaya, Kuala Lumpur, in the Faculty of Built Environment. She has also published several academic papers on historic Eastern domes in the Middle East and Central Asia.

Associate Professor Dr. Yahaya Ahmad received his Bachelor of Arts in Architecture (1986), Master of Construction Management (1987) and Master of Architecture (1988) from Washington University, USA; and his Ph.D in Conservation Management from the University of Liverpool, UK (2004). He has published many academic papers on conservation and is directly involved in many conservation projects. He was involved in the drafting of the National Heritage Act (2005) Malaysia, headed the nomination team to prepare the nomination dossier for Melaka and George Town for listing on the World Heritage List, and headed expert teams in the re-construction of Melaka fort. He was seconded to the Department of National Heritage as Deputy Commissioner of Heritage Malaysia 2007-2009, and was elected as ICCROM Council Member 2007-2011.

Hooman Koliji

School of Architecture Planning
and Preservation
University of Maryland
Building 145
College Park, MD 20742 USA
koliji@umd.edu

Research

Revisiting the Squinch: From Squaring the Circle to Circling the Square

Keywords: squinch, squaring the circle, imagination, geometry, symbolism, Persian architecture, Friday Mosque, domes, vaults

Abstract. "Squaring the circle," constructing a square that has the same area in a given circle using compass and straightedge, has long been a subject for intellectual investigations among mathematicians and philosophers from antiquity to the pre-modern era. The search for this unattainable ideal articulation found its way into Persian architecture with a different approach: circling the square. This architectonic approach, complementing the philosophical view, started from the square at hand, the chamber, to the circle of the vault. The transformation of the cubic to the domical space is mediated through the squinch, intermediary structural element that unifies the two structures. The two seemingly opposite directions of transforming of one form to another (i.e., square to circle or vice versa) allude to the metaphysical and material attributes involved in this process. This paper discusses the mutual relationship between the intellectual and material transformations and the intermediary role of the squinch.

Introduction

Formation of a domical space over a square plan, by means of geometry, is one of the characteristics of the Irano-Islamic architecture. Pythagorean and Euclidean notions of transcendental geometry, in which forms and figures hold qualitative (and cosmic) attributes, from the ninth century, in Persian architecture, had already made the act of transforming shapes comparable to an alchemic act in which qualities transmute to new ones.[1] Therefore, transforming the lower chamber (square form) into the upper vault (circular form) implied a cosmological act. However, unlike the way this is carried out in actual construction – proceeding from square to circle – in theoretical terms this transformation started from the circle. That is why some scholars believe that "[Persian] traditional architecture can be seen as a development of the fundamental theme of the transformation of the circle through the triangle into the square" [Ardalan and Bakhtiar 1973: 29]. Countless ornaments portraying diverging and converging geometric shapes, with or without structural attributes, substantiate the unique role geometry has played in traditional architecture to express symbolic meanings. Such symbolism associated with the transformation of square to circle led to the arch being conceived as "the beginning of architecture,"[2] and the vault and dome as essential elements, for "without them, architecture is incomplete" [Buzurgmihri 1992: 9]. Classified under practical geometry, architecture, demonstrated the use of the theoretical geometry in practice.[3] The domical space, which that manifested historically intriguing geometrical theorem of squaring the circle, received much architectonic attention.

The Friday Mosque of Isfahan: A millennium of squaring the circle

Located in central Iran, the Friday Mosque of Isfahan (fig. 1) is a prominent architectural expression of Seljuk rule in Persia (1038-1194). What makes this edifice one of astonishing beauty is the vertical elaboration of the structure, its vaulted brick

structures, and its domed structures from the Seljuk period. The augmented brick vault structures of the Friday mosque in Isfahan represent a level of perfection in Seljuk brick structures (see [Pirniya 2007; Haji Ghasemi 2001]). The mosque has over ten centuries of construction history and features 476 existing cupolas including two major domes, four *iwan*s,[4] and several half vaults. Blunt has described the building in this way:

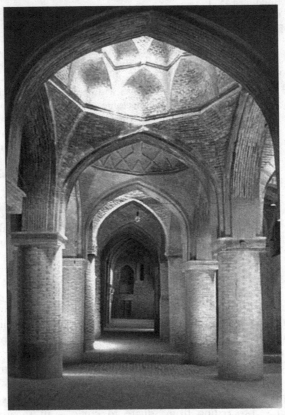

Fig. 1. General view of the shabistan of the Isfahan Friday mosque.
Copyright: MIT Libraries, Aga Khan Visual Archive; photograph by Khosrow Bozorgi.
Reproduced by permission.

The building is constructed in a succession of arches: first a single broad arch in the center of each wall, with pairs of narrow arches cutting the corners; smaller aches in the squinches; and finally, sixteen little arches below the dome itself [Blunt 1966: 33].

The repetition of increasingly smaller arches plays the central role in the vertical elaboration of the vaults and the domes.

The *shabistan*,[5] a covered arcade space typical of the traditional architecture of mosques, comprises more than 450 vaults in the Friday mosque. Moreover, a remarkable number of cupolas feature markedly different structural and visual patterns. Such variety in the reflective ceiling plan is surprising within almost a consistent grid pattern plan (fig. 2). Asterisk-like geometric patterns, "like blossoms generated by the geometry of the circle" [Ardalan and Bakhtiar 1973: 75], are found in many variations of the reflective

ceiling plan, all of which are embedded in or framed by the square transforming the vertical columns to the domical surface of the vault (fig. 3). Sectional studies, from the time of André Godard (1881-1965) to Eugenio Galdieri (1925-2010), who conducted archeological excavations and worked on the restoration of the mosque in the past decades, prove that many of these star patterns are not only decorative; but also play a critical role in bearing weight and in the structure of the vault. Some of the patterns that do not represent the main structure of the vault still adhere to a brick structure, are bound by the rules of construction, and are therefore structural on their own. Because the *shabistans* of the Friday mosque were built in different time periods, they are also representative of the techniques of vault-making of their time, while at the same time demonstrating indelible structural beauty.

This paper will concentrate on the Mosque's sophisticated vaults and dome structures—particularly as they relate to geometry and the transition from the square configuration of the lower chamber to the circle structure of the upper vault. Included herein is a detailed investigation of the geometrical and tectonic implications of such a transition. Two pertinent historical treatises on practical geometry and vault design also facilitate our study in this regard.

Fig. 2. Plan of the Friday mosque of Isafahan showing the reflective ceiling plan. Various asterisk-like geometric patterns of the shabistans make each individual vault space unique. Courtesy of Parsa Beheshti Shirazi

Fig. 2b. Detail of the reflected ceiling plan of the Friday mosque of Isafahan

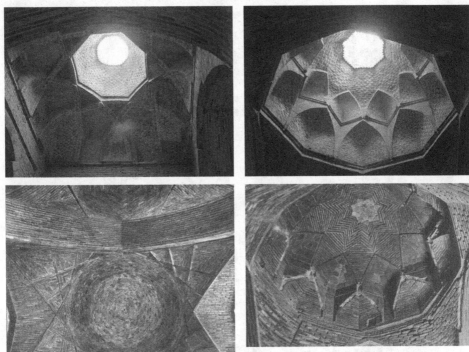

Fig. 3. Example images of vault patterns. Two top images: Courtesy of Farshid Emami. Two bottom images: Courtesy of Special Collections, Fine Arts Library, Harvard University. Reproduced by permission

From Chamber to Vault

The Seljuk use of structural squinches and the supreme transformation of the square into the circle through geometry represents the acme of a very conscious resolution, while the development of a more simplified geometrical resolution integrating square, triangle, and circle through the world of colors and patterns in a super-conscious totality indicates the esoteric blossoming of the Safavid synthesis [Ardalan and Bakhtiar 1973: 29, 31].[6]

Expressing tectonic and structural development, the spatial transition evidenced in the Isfahan Mosque from the cubic chamber to the domical space above is a dominant feature of Irano-Islamic architecture [Pirniya 2007; Haji Ghasemi 2001; Buzurgmihri 1992]. However, the roots of this practice can be traced back to the stone architecture of Sassanid palaces. This spatial paradigm often introduces an intermediate space (i.e., the squinch), which, by means of geometry and the use of triangles, transforms the square into the circle. Highly sophisticated mathematical and geometrical measures underlie this transitional space, which acts as a transition between the cubic and spherical spaces. This transformation can be seen in terms of the two-dimensional (horizontal) plane and the three-dimensional (vertical) volume.

Horizontal plan: interlocking geometrical patterns

The two-dimensional phase of transforming the square into the circle necessitates a geometric investigation of how equilateral polygons are incorporated into a square. Specifically, by dividing a circle's perimeter into equal segments, a series of polygons emerge from the circle. This is made possible through the use of "practical geometry," and is considered to be the foundation for most Persian architectural geometric patterns known as *girih* (lit. knot).

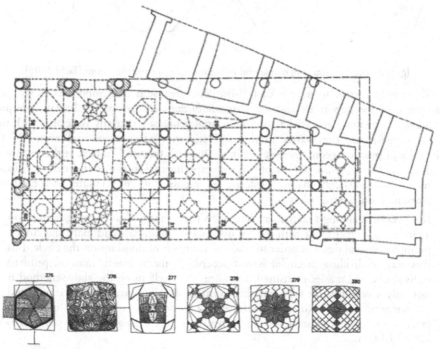

Fig. 4. Examples of the reflective ceilings of the shabistan space (left) and entry corridor vault patterns (right). Source: [Jabal Ameli 1995]

Widely prevalent between the tenth and fourteenth centuries, treatises of practical geometry were "how-to" manuals prepared by mathematicians, astronomers, and geometricians of the courts for artisans and architects, providing them with practical instructions for making geometric *girih* patterns. Core to these geometric exercises were the techniques for dealing with circle and embedding polygons in them. Such two-dimensional exercises served as the underpinning intellectual practice for the transformation of the square plan of the bay into the circular form of the vault. Mastery of this procedure would eventually lead to the production of numerous geometric patterns of the vaults in the orthographic projection. The ceilings of the *shabistan* spaces of the Friday mosque represent a variety of such formal explorations in planar view, as shown in Fig. 4.

Abū'l-Wafā al-Būzjānī was a Persian mathematician, geometer, and astronomer of the tenth century who described various methods of drawing polygons within a circle. In his seminal practical treatise, *Kitab fima Yahtaju Ilaihi al-Kuttab wa al-Ummal min 'Ilm al-Hisab Kitāb fīmā yahtā ju ilayhi al-sāni' min a'māl al-handasa* (*A book on those geometric constructions which are necessary for a craftsman*), he devoted several chapters to this issue. The book comprises twelve chapters, as well as an introduction entitled "On Understanding the Straightedge, Compass, and Square," which discusses the importance of using accurate tools for facilitating the truthfulness of geometric practices. Chapters 3, 4, and 5 discuss in detail how to draw polygons within a circle and vice versa (fig. 5).

Fig. 5. Al-Būzjānī's drawing equilateral polygons using a compass. From [Jazbi 2005]

What is important to note is that al-Būzjānī's treatise is contemporaneous with the emergence of the new brick and masonry *shabistan* structure of the Friday Mosque.[7] Moreover, numerous decorative two-dimensional geometric patterns associated with that period suggest that the master mason and his apprentices were well aware of the principles of practical geometry detailed in al-Būzjānī's treatise.[8] In fact, at the beginning of his third chapter, al-Būzjānī disapproves of experimental methods of dividing a circle's perimeter to equilateral shapes. Instead, he argues for an accurate and methodic calculation, as articulated below:

> It is prevalent amongst craftsmen that when they want to draw a polygon in or on a circle, they experiment with the leg distance of a compass and mark the circle's perimeter several times in order to find the numbers of divisions on the circle. But this way of dividing [a circle] is not acceptable for architects-masons, prudent individuals, and master craftsmen. Dividing the circle using the above method is not only a very difficult task, but the points of division are also approximate and are not accurate. Therefore, the preferred act for architect-masons and masters of craft is to conceive it in a way that ensures that the length of the polygon is identified first. ...[9]

Al-Būzjānī's instructions for drawing polygons and shapes within other shapes can be considered one of the earliest documents used by architects and craftsmen in Iran after

the Arab conquests. Strong parallels can be drawn between solutions devised for patterns in the vaults and dome of the Friday mosque and geometric investigations in al-Būzjānī's treatise.

For example, one such parallel is found between drawing a pentagon within a circle and the North Dome of the Friday Mosque, known as the Khaki Dome,[10] in which a pentagonal pattern comprises a five-pointed star that is integrated as ribs to the dome structure:

> [the dome's] supports are articulated so as to reflect the structure of its zone of transition. The latter, with its richly outlined muqarnas,[11] appears like the bejeweled base for an astounding dome whose ribs have formed a complex geometric pattern generated by a pentagon around a (probably) open oculus [Grabar 1990: 39].

Al-Būzjānī introduced three different methods to accomplish this. The following is a translation of his first method for this problem:

> If we wish to embed an equilateral pentagon in a circle, we first draw the diameter ADG, and from point D which is the center, we draw the perpendicular line of DB. Then we divide radius AD at point H in half, and draw an arc centering H and with the radius of HB until it intersects diameter AG in point R. Then centered on B and with radius BR, we draw arc RT to cut arc BT. This arc is one fifth of the circumference. Now, we find out arcs TY, YK, KE, and EB equal to BT and draw these chords to find the equilateral pentagon of BTYKE.[12]

Fig. 6. Upper left) Drawing of an equilateral pentagon embedded within a circle according to al-Būzjānī [Jazbi 2005];
upper right) Khaki dome of Friday mosque: Courtesy of Special Collections, Fine Arts Library, Harvard University. Reproduced by permission;
lower right) Khaki dome, the reflective ceiling drawing [Jabal Ameli 1995]

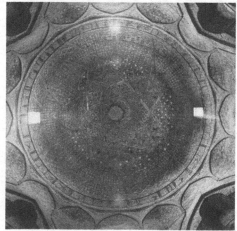

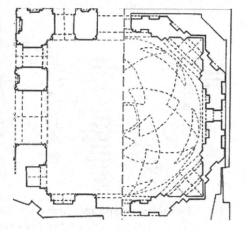

Due to the necessity of construction, in which the lower square is constructed first, the architect needed to perform the transition starting from the square shape after which he embedded other polygons within the square to transform it into a circle.

Bujzani discussed the notion of drawing polygons in or on other polygons in chapter 6, "On Drawing Shapes in and on Shapes." There he explained the methodology of how to locate various polygons within a square – a practice that masons needed in transforming the plan of the base geometry into the vault of the Friday Mosque. Such geometrical exercises required changing the tools of drawing into the tools of building, such as a mason's square and ropes or string for drawing lines to perform like a compass in construction. Contemporary master mason Asghar Sharbaf, whose father and grandfather were also master masons, documented this practical tradition and indicated that the first stage in making a muqarnas is to draw it in planar form [Sharbaf 2006]. Additionally, Persian architectural drawings of the sixteenth century, known as the *Topkapi Scroll*, contain many interlacing geometric *girih* patterns intended for execution in three-dimensional forms of ribbed vaults and muqarnas, which often required making a full-scale drawing on the floor and projecting it to the upper levels by means of plumb lines. The abstract nature of *girih* patterns, while inevitably governed by strict laws of geometry (as seen above), also required creativity in its process of conception. While many of the interlocking patterns featured vegetal motifs that originated from the natural world, the architect-engineer "deliberately reworked naturalistic motifs into unreal forms that gave free reign to the artistic imagination" [Necipoğlu 1995: 75], expressing a two-dimensional space, the drawing of which reflects a three-dimensional space.

Vertical elevation: the arch, the beginning of architecture

Structurally, the vertical transformation is made possible through the use of arches. The arch is considered as the first step in the birth of the cupola, an essential element in this architectural progression [Buzurgmihri 1992]. The first stage in the construction process is to build four arches on the columns of the lower structure, uniting them. In plan form, these arches are consistently projected on the geometry of the square. Developing a process for constructing the arch provides an essential basis for further transformation of the structure with the goal of completing a vault. A considerable number of the vaults in the Friday Mosque were built after the fifteenth century, a period from which a valuable treatise on vault and cradle vault construction has survived.

Fig. 7. Different arch types and matrix of calculation from the original manuscript of al-Kashi's *Risāleh Tāq va Ajaz* [Jazbi 1987]

Fig. 8. Different arch types from a Farsi translation of al-Kashi's treatise [Jazbi 1987].
From left to right, arches # 1, 2, 3, 4, and 5

Ghiyath al-Din Jamshid Kashani (1380-1429), known as al-Kashi, Persian Islamic scientist and geometer of the fifteenth century, extensively wrote on measurement, calculation, and making arches, vaults, and domes in his seminal treatise, *Miftah al-hisab* (Key of Arithmetic).[13] Al-Kashi also introduced five major types of arches and methods for drawing them (figs. 7 and 8) in his work *Risāleh Tāq va Ajaz*. He suggested that Islamic arches were often pointed arches and that by spanning two pillars, thereby defining a chamber, they provided support for the vault or the dome [Jazbi 1987]. Depending on the size of the span, al-Kashi also introduced methods of calculation for making arches and vaults.

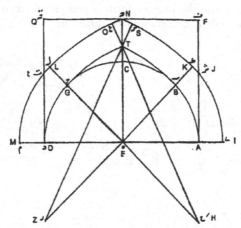

Fig. 9. Arch type 2, which according to al-Kashi was the most popular at his time [Jazbi 1987]

Al-Kashi indicated that in his day the second type of arch was more popular. In the fourth chapter of *Miftah al-hisab*, a treatise on arches and vaults, he explained the method by which the arch is found:[14]

Draw a half circle on AD, span of the arc. Continue AD from both sides equal to the thickness of the arch until points I and M are found. Consider E as the center of the half circle. Divide the arch of the half circle to four equal segments, points A, B, C, G, and D. Extend BE and GE [respectively] to EH and EZ equal to AC, and the lines of BK and GL equal to DM, which is the thickness of the arch. On center E draw JM and KL arcs, on center H, draw arc GT, and on center Z draw arc BT. Connect HT and ZT and extend them equal to the thickness of the arch until points O and S are found. Draw arc LO from center H and arc KS from center Z. draw perpendicular lines of SN and ON from TS and TO.[15]

When this procedure is followed, the compound arc ABTGD comprises the arc of the entry and TN represents the thickness of the arch (fig. 9).

Al-Kashi's arches required the use of a compass and a straightedge on paper, followed by the use of rope, string, and plumb lines in the ensuing construction process. In the translation from paper to the actual space, the architect had to identify in space the center points of circles and intersecting points using accurate measurements, while having at the same time to imagine "invisible" lines that preceded the construction process. Pirniya [2007] believed that for smaller cupolas, the mason would not have used formwork for arches; instead, the mason would have relied on experience, memory and, above all, his imaginative capability to visualize the space prior to the actual construction.

The drawings in fig. 10 show the vault rib structures of chamber no. 60 (according to plans in [Galdieri 1984]) of the Friday Mosque.[16] The domical space results from the cross arches forming rib structure, which also produces an ornamental pattern. Geometry here functions both in two dimensions (the plan of the ribs represent a star in the square) and in three dimensions (the rib structure), which then simultaneously transforms the lower cubic space into the upper domical space. As such, the ribs form a series of interlocked arches providing structural support for the filling bricks. As the perspective demonstrates, the spaces between the arches are filled in as the ornamental architectural structures of muqarnas. Once the interior form is completed, then a second and third layer of bricks cover the vault, creating a smooth sphere-like volume in the space below.

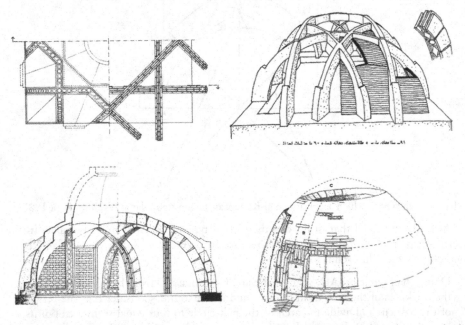

Fig. 10. Arch no. 60 of Friday Mosque demonstrating aesthetic role (upper left) and structural role (upper right, lower left) of the rib structure [Jabal Ameli 1995]

Masons and architects who were involved in conceiving and building the Friday Mosque were most likely well-versed in techniques of erecting arches and vaults, considering the significance of the city in which the mosque was to be located. According to Grabar,

[these techniques] are wonderful examples of the operation of an ahistorical vernacular practice, which over the centuries cleaned and repaired the lonely covered spaces of the mosque. There is little point in trying to establish a chronology of the domes or of the transformations affecting supports. What does appear here is that, from some moment yet to be determined, the culture and technical competence of Isfahan built up and maintained the large space of its mosque in the consistent language of brick derived forms [Grabar 1990: 37].

Indeed, such ahistorical vernacular methods for building the three-dimensional vault space were not restricted to the Friday Mosque, but were widely executed across geographical and temporal horizons in pre-modern Iran.[17]

The transition to three dimensions

Through the use of spatial geometry, the four corners of the square morph into a circular shape, by means of a variety of patterns of squinches (fig. 11). The squinch evolved from somewhat simple forms during the pre-Islamic era (for example, Sarvistān Palace) to tectonic perfection during the Seljuk period. As Eric Schroeder indicated,

By courageous experiment and the intelligent observation of failure, the Seljuks built in the twelfth century what is practically the ideal dome, made possible by the advance of mathematical science in the eighteenth [century] [quoted in Blunt 1966: 34].

Treatises of the time, such as those of al-Būzjānī and al-Kashi, documented the construction of domes and the calculation methods used to build them. Later, the squinch evolved to the augmented ornamentations of the Safavid period in the fifteenth to seventeenth, and eventually to non-structural and decorative geometric pattern finishes (rasmi-bandi).[18]

Fig. 11. Transition from square to circle through use of triangles and squinches. After the seventeenth and eighteenth centuries, non-structural transitional spaces emerged; see [Buzurgmihri 1992]

This progression from merely structural purposes (pre-Islamic, early Islamic) to more visual decorations (post-Safavid) reveals the immense significance of transforming squares into circles in Persian architecture as both structural and decorative solutions. This visual process reached its zenith during the post-Safavid period, when geometric patterns appear in the interior surface of a vault with no structural function. This progression from structural function to ornamentation, a constant desire to elaborate this transition

through time, strongly suggests that the process of squaring the circle was seen as more than a structural solution. It can be considered a meditative practice associating essential cultural and symbolic conceptions to the artefacts built.

The squinch, from sensible reality to intellectual ideality

Geometric principles enabled architects and masons to push tectonic limits and create higher spaces with larger structural spans. In studying the transitional space as a material construct, major typologies of these three-dimensional structures and geometries were discovered. Geometric patterns in the Friday Mosque demonstrate an almost limitless variety of forms that were derived from brick. As Grabar indicated:

> The 476 cupolas in one building, almost all of them different from each other, create a festival of vaulting which does not fail to arouse all but the most jaded designers or historians. The cupolas can be seen from the outside as a sea of bubbles from which occasionally emerges an exhilarating island of arches and segments of vaults... . The ceilings consist of small cupolas among which the same anarchical voluptuousness rules as among supports. ...[They] show a range in quality and success that is just as great as the time span separating them [Grabar 1990: 36-37].

While the three-dimensional geometric space is essential to the construction of the dome, it can also contain highly symbolic expressions in two-dimensional view. These two concurrent representations of geometry – one in the material construction of the actual domical space, and the other in the mental construing of the symbolism and intellectual content within that space – link geometry to our cognitive faculties. The interplay between "depth and surface" achieved by an imaginative participation constantly reminds us of the importance of the simultaneity of reality and ideality in an Irano-Islamic worldview.

The collection of geometric patterns seen in the vaults of Isfahan's Friday Mosque gave birth to masterful types of transitional elements we know as squinches, which have both symbolic and tectonic relevance. Constantly repeated through time and in elaborated artful forms, the spaces created by squinches can be perceived as semi-universal structural-conceptual truths. These patterns are "incorporated into a building by timeless piety and are not to be judged or evaluated in chronological terms" [Grabar 1990: 10-11]. Ardalan and Bakhtiar explained the symbolism of the chamber and dome as following:

> The square, the most externalized form of creation, represents, as earth, the polar condition of quantity, whereas the circle, as heaven, represents quality; the integration of the two is through the triangle, which embodies both aspects. The square of earth is the base upon which the Intellect acts in order to reintegrate the earthly into the circle of heaven. Reversing the analogy, the square, as the symbol of the manifestation of the last of the created worlds, reverts to the first; thus the heavenly Jerusalem is seen as a square in its qualities of permanence and immutability, and the circle is seen as earthly Paradise. The end of the world is seen symbolically as the "squaring of the circle" – the time when heaven manifests itself as a square, and the cosmic rhythm, integrating itself into this square, ceases to move [Ardalan and Bakhtiar 1973: 29].

The geometry used in erecting vaults offers meditative attributes capable of contributing to the creation of mental conceptions of the world. From archetypal shapes

to exquisitely elaborated geometries, there is a consistent message – an expectation of geometry to express meanings belonging to a higher reality. The triangle, envisioned as a mediating influence between the circle and the square, unifies the structure and decoration. While the former is bound to the realm of reality, the latter seeks to achieve an idealized world. Residing between these two worlds, the triangle holds qualitative attributes and becomes an imaginal being, inviting the viewer to creatively participate in exploring the playful space of "depth and surface," to contemplate "matter and meaning," and to be reminded of the "temporal and eternal" nature of human existence.

The squinches of the Friday Mosque go far beyond demonstrating the technical skills of generations of masons in forming innovative asterisk-like structures seen in reflective plans. They, indeed, represent contemplative geometrical figures, like stars in the sky, guiding man to a higher space of reality, one based on imaginative perception. The space formed by the squinch is the space of qualified geometry echoing theoretical conceptions of individuals who found themselves between the earthy and heavenly worlds. The squinch is an intermediary that transforms these worlds into one another. As the Persian master architect would look "up" and see completeness of the heavenly being in the perfectness of the circle, he desired to bring that heaven to the earth, an act of squaring the circle. This spiritual will, however, started with practicing from "down," the earth. "Squaring the circle" is the intellectual drive that generates the practical solution of circling the square. The squinch, the mediator, manifests the mirror-like relationship of this transformation.

Notes

1. Greek and Hellenistic thought influenced Islamic Persian sciences, mathematics, and architecture as early as the eighth century, but most significantly since the tenth century of Abbasid dynasty in Baghdad. With the inception of the *Dar al-Hikma* (lit. House of Wisdom), a scholarly institution and movement for translating Greek texts into Arabic language, the early Islamic courts became acquainted with the Pythagorean's transcendental approach to the geometry and semantic dimensions of Platonic solids (for example, the association of the cube to the terrestrial world, and the sphere to heaven). It was in such an atmosphere that such early Persian and Muslim scientist and mathematicians as al-Būzjānī, Ibn al-Haytham, and Al-Karaji emerged. The first wrote a treatise on practical geometry to be used by architects, and the other two wrote treatises on building and construction.
2. Many masons and architects believed that architecture started with the arch and reached its zenith with the dome. This quote is attributed to *Ghiyath al-din Jamshid Kashani*, a Persian mathematician and astronomer of the fourteenth century [Ashrafi and Ahmadi 2005].
3. Al-Farabi was among the first to provide a classification of sciences for the Islamic world in the tenth century. In his classification, architecture and mechanical devices, namely *ilm al-hiyal* (lit. science of deception), were classified as a subcategory of the practical geometry. Ikhwan al-Safa also following al-Farabi, considered architecture as a subcategory of practical geometry.
4. *Iwan* is a half-vault entry structure that connects the courtyard to the interior spaces. This threshold space, often high enough to elaborate the façade and the building, is located on the central axis of the courtyard. The Friday Mosque in Isfahan, according to [Pirniya 2007], is considered to be the first four-*iwan* typology of mosques introduced from Persia to other Islamic lands.
5. *Shabistan* is an arcade-vaulted space usually surrounding the courtyard of the mosque. The structure of this space is based on squared grid plan that defines the location of the columns at the lower level and vaults sitting on the columns. The etymology of the word is also revealing in regard to the star-like patterns appearing under the vaulted structures. *Shabistan* is comprised of two words; *shab* (lit. night) and *stan* (lit. house), meaning "night house". Historic sources, such as Nazim al-Atibba, have mentioned *shabistan* as a place for Dervish and others to pray and sleep there in cold nights. Therefore, with sharp contrast to the courtyard in terms

of access to the light on the one hand, and a place to be used during the night, on the other hand, it would make sense that star-like patterns became semantically relevant to that space.

6. Safavid architecture contributed in taking squinch design to another level of ornamentation, introducing the use of glazed tiles in squinches, which became a foundation for *rasmi-badi,* a practice in which the transformation was reiterated at a decoration level and not necessary structural.

7. Haji Ghasemi suggested that "late in the [tenth century], this building contained 262 vaults and 55 circular bases, which formed 18 aisles along the length of the courtyard and 15 aisles along its breadth, the central aisle on the [Qibla] axis being broader than the others. At this time, the *shabistans* of the mosque had flat timber roofs. A 420-meter-long raw brick wall encircled the mosque" [2001: 121].

8. There is no direct evidence that al-Būzjānī's treatise was used in Isfahan at the time. However, the role of treatises on practical geometry in communicating theoretical geometric truths to the architects and artisans on the one hand, and the popularity of such treatises in that era on the other hand, indicate that such geometrical investigations were ongoing at the time of construction of the Friday mosque.

9. Translation from Farsi by Hooman Koliji from a Farsi edition by A. Jazbi [2005].

10. This is the northern dome of the Friday Mosque, built in 1098, one year after completion of the south dome. Grabar [1990] explains that that patron of the North dome wished to accomplish something more significant than that previous individual, therefore, the dome was built as a competitive act to the earlier one.

11. *Muqarnas* is a stalactite-like ornamental structure often appeared underneath vaults or half-vaults granting visual sophistication to the transition from the lower rectangular space to the upper area. Muqarnas is non-structural and is a second layer with bricks, glazed tiles on plaster, or paint on plaster. Muqarnas is hung beneath the main structure. Its sophisticated three-dimensional sub-volumes calls for mastery in the practical geometry and imagination, as the muqarnas drawing tradition had neither section or elevation drawings as far as we know. Therefore, such intricate structures required the master builder's presence to be completed while construction.

12. Translation from Farsi to English by Hooman Koliji from [Jazbi 2005]. Persian Jazbi provided a Farsi translation of al-Būzjānī's treatise based on historical manuscripts found in Iran's libraries. Other versions include an Arabic edition [Al-Būzjānī 1971].

13. *Miftah al-hisab,* originally written in the fifteenth century, was translated into Russian in 1954 and several Arabic editions of the book exist. Gülru Necipoğlu [1995] notes that al-Kashi's treatise was addressed to members of the state who where involved in supervising construction for taxing purposes, and not necessarily used by architects. However, such a level of precision in arch and vault computation must have come from the hitherto well-established existing knowledge, either in form of written/drawn documents or from the actual practice by architects of the time. This infers that such treatises must have existed during the time of the Friday Mosque construction. Thabit ibn al-Qurra's treatise, *On Mensuration of Parabolic Bodies,* from the ninth century, is an obvious indication of the use of such treatises. Additionally lost architectural treatises of Ibn al-Haytham and Al-Karaji might have contained relevant information similar to that of al-Kashi. It is also, nevertheless, quite reasonable to imagine that such treatises as al-Kashi's were used by masons and architects. *Miftah al-hisab* is comprised of five main sections, each with several chapters. The fourth section, "On Area," includes nine chapters, the last of which, "On Volume of Buildings and Edifices," discusses vaults and cradle vaults, dome, and muqarnas. Here I used the Farsi translations of the book given in [Jazbi 1987].

14. Translation from Farsi by the author, from [Ashrafi and Ahmadi 2005]. The authors of this reference consulted Yvonne Dold-Samplonius's writings, a mathematical historian of Heidelberg University, Germany, who has done extensive research on al-Kashi; see, for example, [Dold-Samplonius 2002].

15. It is not clear why al-Kashi suggests that from points T and S one should draw perpendicular lines (SN and ON) to find the external point of the arch, N. Considering the minimal length of SN and ON, they could be the continuation of the arcs KS and JO accordingly. The

difference in the height of point N would be minimal and negligible. However, his insistence on drawing perpendicular lines in all types of arches must have been related to construction practices at his time.

16. Farsi translation of [Galdieri 1984] by Jabal Ameli [1995].

17. What Grabar observes as "ahistorical vernacular technique" could also suggest the use of the practical geometry treatises (for example, al-Būzjānī, tenth century) and dome computations (Al-Kashi, fifteenth century) across time and not specific to their own period. Extant pages of treatise on parabolic dome calculations attributed to Thabit ibn al_Qurra (ninth century) are similar to al-Kashi's attempts to determine a method for computing the surface areas of domes.

18. Another term that is used for *rasmi-bandi* is *kār-bandi*. While these two terms have been used interchangeably, *rasmi-bandi* suggests a structural role for the ribs, while *kār-bandi* suggests a decorative role.

References

AL-BŪZJĀNĪ, Abū'l-Wafā Muhammad. 1971. The Arithmetic of *Abu Al-Wafa' al-Buzjani.* Introduction and Commentary by A. S. Saidan. Amman: Jamiyat Umal al-Matabi al-Taawinia. (In Arabic)

ARDALAN, N. and L. BAKHTIAR. 1973. *The Sense of Unity: The Sufi Tradition in Persian Architecture.* Chicago: University of Chicago Press.

ASHRAFI, A. and M. R. AHMADI, M. R. 2005. Al-Kashi's Method for Calculations of Arches. *Ayeneh Miras* 3: 61-77.

BLUNT, W. 1966. *Isfahan: Pearl of Persia.* New York: Paul Elck Productions.

BUZURGMIHRI, Z. 1992. *Hindisa dar Mimari* (Geometry in Persian Architecture). Tehran: Iranian Cultural Heritage Organization. (In Farsi)

DOLD-SAMPLONIUS, Yvonne. 2002. Calculation of Arches and Domes in 15th Century Samarkand. *Nexus II: Architecture and Mathematics,* Kim Williams, ed. Pisa: Pacini Editore.

GALDIERI, E. 1984. *Masgid-i Gum'a.* Vol 3, Research and Restoration Activites, 1973-1978, New Observations, 1979-1982. Rome: IsMeo.

GRABAR, O. 1990. *The Great Mosque of Isfahan.* London: I B Tauris & Co. Ltd.

HAJI GHASEMI, K. 2001. *Ganjnameh, Masajid-i Isfahan.* Tehran: Shahid Beheshti University Press and Rowzaneh Press.

JABAL AMELI, A. 1995. *Esfehan Masgid-I Gum'a.* Isfahan: Iranian Cultural Heritage Organization.

JAZBI, A. 1987. *Risāleh Tāq va Ajaz.* Tehran: Soroush Publications. (Partial Translation of *Miftah al-hisab).*

————. 2005. *Persian Geometry: Applied Geometry Abul-Wafa Muhammad Buzjani.* Tehran: Soroush Publications. (Persian translation with additions)

NECIPOĞLU, G. 1995. *The Topkapi Scroll. Geometry and Ornament in Islamic Architecture.* Los Angeles: Getty Center Publication.

PIRNIYA, K. 2007. *Memari Irani* (Iranian Architecture). Tehran: Soroush-i Danesh Publications.

SHARBAF, A. 2006. *Sharbaf and his Works.* Tehran: Iranain Cultural Heritage Organization. (In Farsi)

About the author

Hooman Koliji is an assistant professor of architecture at the University of Maryland. His research includes theories and history of architectural representation. He completed his Ph.D. at Virginia Tech. Koliji has lectured nationally and internationally on the subject of architectural representation and imagination.

B. Lynn Bodner

Mathematics Department
Monmouth University
Cedar Avenue
West Long Branch, NJ 07764
USA
bodner@monmouth.edu

Keywords: Architectural
ornament, Arabic geometric
design, star polygons, Tashkent
Scrolls, Topkapı Scroll,
Euclidean construction, Islamic
star polygon designs

Research

From Sultaniyeh to Tashkent Scrolls: Euclidean Constructions of Two Nine- and Twelve-Pointed Interlocking Star Polygon Designs

Abstract. In this paper we will explore two nine- and twelve-pointed Islamic star polygon patterns consisting of "nearly regular" nine-pointed, regular twelve-pointed and irregularly-shaped pentagonal star polygons. The two designs are similar in that they may both be classified mathematically as being p6m patterns with the major star polygons placed in identical locations within each layout; however, the structure of the major stars is quite different. Both of the patterns considered here are of Persian origin. The first design may be found as a repeat unit sketch of the *Tashkent Scrolls*, and exists as a Timurid-style stone inlay and mosaic tiling in India. The second pattern may be found as Plate 120 of Bourgoin's *Arabic Geometrical Pattern and Design* and exists as a stucco/plasterwork ceiling in the Mausoleum of Sultan Oljaytu in Sultaniyeh, Iran, as well as numerous other locations across the Islamic world. Both patterns may be recreated via plausible Euclidean "point-joining" constructions (that is, using only the methods available to medieval artisans) in an attempt to ascertain how the original designers of these patterns may have determined the proportion and placement of the stars.

Introduction

Islamic art developed over a period of a thousand years, as Islamic rule expanded to encompass regions previously under the influence of other empires. As the cultures intermingled, the styles and techniques of the conquered craftsmen and master builders were assimilated into the art. Roman, Byzantine, Persian and Central Asian art styles – such as the Roman and Byzantine use of geometric patterns, especially the "heavenly stars," as well as Persian arches, domes and squinches from the Sassanid dynasty – were incorporated and refashioned to create motifs, shared themes and unifying elements in the Islamic art and architecture found from Spain to Central Asia.

Attributes that make Islamic ornament readily recognizable, regardless of the locales or times from which it originates, include the covering of surfaces with calligraphy and endlessly repeating geometric or highly-stylized vegetal patterns. Some of the design principles and aesthetic choices of a particular region, and their subsequent resulting patterns, were perpetuated down through the centuries and also disseminated widely from one region to another by exchanges of drawings and the movement of artisans [Necipoğlu 1992: 48]. Gülru Necipoğlu, the author of *The Topkapı Scroll – Geometry and Ornament in Islamic Architecture: Topkapı Palace Museum Library MS H. 1956* [1995], has written:

[the] Maghribi tradition was originally inspired by architectural developments in the eastern Islamic world that had traveled westward between the eleventh and thirteen centuries all the way to Spain [Necipoğlu 1995: 23].

That being said,

[t]he diffusionist explanation is, however, incomplete. If certain forms or techniques spread throughout different provinces of the Muslim world, it was also because they reflected the values proper to Islam, this term being taken in its broadest sense to designate not only a religion but also a model of society, a way of thinking and even a philosophical system [Clévenot 2000: 21].

One of the two star polygon designs to be discussed in this paper is an example of a pattern that may be found rather ubiquitously across the Islamic world in a wide variety of media such as stucco, wood, masonry and ceramic tiling (and whose creation also spans a few hundred years). Consisting mainly of twelve-pointed stars each surrounded by six nine-pointed and twelve pentagonal stars, it was cataloged by Jules Bourgoin as Plate 120 of his *Arabic Geometrical Pattern and Design* [1973], a rich source of over 200 Islamic patterns, first published in 1879 and based upon drawings, with analyses, of Islamic monuments in Cairo and Damascus. Instances of this pattern, found as decorative ornamentation on monuments dating to medieval times in Iran, Egypt, Turkey, and Spain, may be discovered in the *Pattern in Islamic Art: The Wade Photo Archive*, a collection of over 4000 images of Islamic patterns, available online [Wade]. More specifically, this layout may be found in a stucco/plasterwork ceiling in the Mausoleum of Sultan Oljaytu in Sultaniyeh, Iran, dated 1313, from the Ilkhanid dynasty [Wade: Ira 2701] (fig. 1a). This mausoleum, considered a structural masterpiece and protected by the World Heritage Convention of the United Nations Educational, Scientific and Cultural Organization (UNESCO), "represents an outstanding achievement in the development of Persian architecture" and is "characterized by its innovative engineering structure, spatial proportions, architectural forms and the decorative patterns and techniques" (see http://whc.unesco.org/en/list/1188).

This prevalent pattern may also be found in a panel of a wooden *minbar* (pulpit) of the Mosque of al-Mu'ayyad in Cairo, Egypt, dated 1420, from the Mamluk dynasty [Wade: Egy 1216] (fig. 1b); a carved masonry stone relief in the Medrese of Dunbar Bek in Egridin, Turkey, dated 1302, from the Seljuk dynasty [Wade: Tur 0926] (fig. 1c); and, a thirteenth- to fifteenth-century century Nasrid dynasty ceramic tiling of the Alhambra in Granada, Spain [Wade: Spa 1008] (fig. 1d).

Nonetheless, variations in construction techniques and distinctly different decorative styles within Islamic art may be perceived, and thus may be designated as belonging to particular regions or dynastic traditions. For example, the Islamic architecture of Northern India, which from the sixteenth century onwards was ruled by the Mughals, originated in Persia [Volwahsen 1994: 3] and combined both Persian and Hindu traditions.

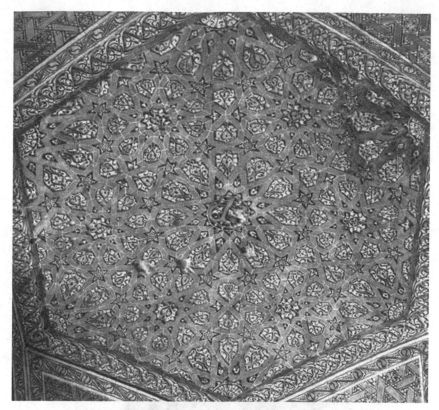

Fig. 1a. A portion of a stucco/plasterwork ceiling in the Mausoleum of Sultan Oljaytu in Sultaniyeh, Iran, dated 1313, from the Ilkhanid dynasty [Wade: Ira 2701] (photograph cropped by this author)

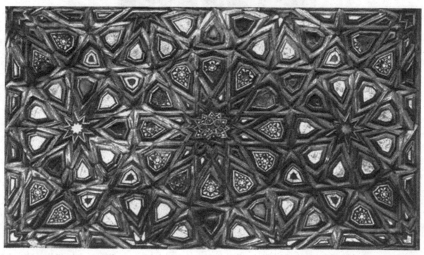

Fig. 1b. A portion of a wooden minbar panel of the Mosque of al-Mu'ayyad in Cairo, Egypt, dated 1420, from the Mamluk dynasty [Wade: Egy 1216] (photograph cropped by this author)

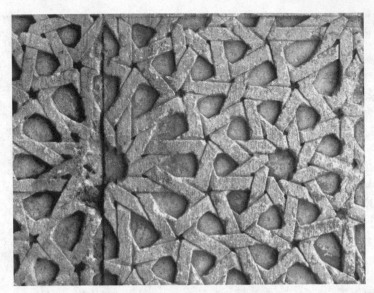

Fig. 1c. A portion of a carved masonry/stone relief in the Medrese of Dunbar Bek in Egridin, Turkey, dated 1302, from the Seljuk dynasty [Wade: Tur 0926] (photograph cropped by this author)

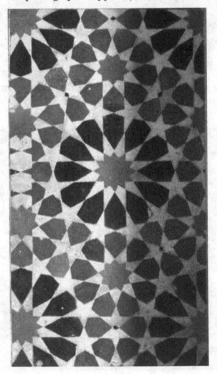

Fig. 1d. A portion of a thirteenth-fifteenth century Nasrid dynasty tiling of the Alhambra in Granada, Spain [Wade: Spa 1008] (photograph cropped by this author)

The second pattern to be discussed in this paper may be found at the Masjid-i Jami in Fatehpur Sikri, India which was constructed by Sheikh Salim from 1571-1574 and whose architecture was based on Timurid forms and styles. It appears as an extant stone inlay and mosaic tiling, illustrated in [Wade: Ind 0729] (fig. 2). In fact, this design may be generated from a *repeat unit* sketch belonging to a collection of fragmentary design drawings known as the *Tashkent Scrolls,* which "almost certainly reflect the sophisticated Timurid drafting methods of the fifteenth century, if not earlier" [Necipoğlu 1992: 50]. The scrolls, so named because they are now housed in Tashkent at the Institute of Oriental Studies at the Academy of Sciences of the Uzbek SSR, are attributed to an Uzbek master builder or a guild of architects practicing in sixteenth-century Bukhara, a city located in the Greater Khurasan of Sassanid and medieval Persian periods [Necipoğlu 1995: 7].

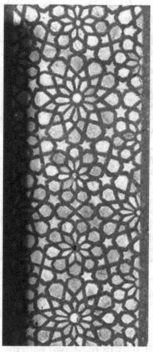

Fig. 2. A portion of a stone inlay and mosaic tiling of the Masjid-i Jami in Fatehpur Sikri, India, dated 1571, Mughal dynasty [Wade: Ind 0729] (photograph cropped by this author)

Many of the drawings of the *Tashkent Scrolls* are similar to those found in the much older, larger and better preserved fifteenth-century *Topkapı Scroll,* a 96-foot-long architectural scroll now housed at the Topkapı Palace Museum Library in Istanbul. Both the *Topkapı Scroll* and the *Tashkent Scrolls* contain geometric design sketches with no measurements or accompanying explanations for how to create them. In addition, they "belong to the same region, extending from Iraq and Iran to Central Asia" [Necipoğlu 1995: 23]. The drawings in these scrolls are also similar to sketches found in the collection of design scrolls and working drawings (now in the Victoria and Albert Museum in London) that belonged to Mirza Akbar, an official state architect of nineteenth-century Iran.

Comparing the Victoria and Albert scrolls with the earlier ones in Tashkent demonstrates the amazing continuity of architectural drafting methods in Iran up to the modern era, a continuity reflecting the absence of radical changes in style and building technology [Necipoğlu 1992: 52].

It is interesting to note that neither of the two nine- and twelve-pointed Islamic star polygon designs to be discussed in this paper may be found in the *Topkapı Scroll*.

To highlight the similar placement of the major 12-pointed and 9-pointed stars, as well as the other polygons filling the interstitial spaces, portions of these two patterns (in skeletal form without additional embellishments) have been recreated and colored by the author using the Geometer's Sketchpad® software program (the electronic equivalent of a compass and straightedge). Fig. 3a shows the design that appears as Plate 120 of Bourgoin, hereafter referred to as *B120*; fig. 3b shows the design hereafter referred to as *TS*, which may be generated from a *Tashkent Scroll repeat unit* drawing.

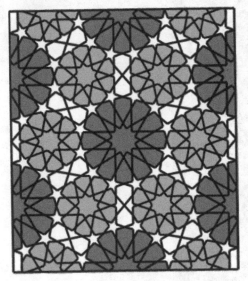

Fig. 3a. Author's reconstruction of the B120 design

Fig. 3b. Author's reconstruction of the TS design

The placement of the major stars in these two patterns is identical and so (in skeletal form) they may both be mathematically classified as belonging to the same crystallographic group; that is, they are both p6m designs, whereby the design elements exhibit six-fold rotational symmetry and mirror reflections. The reflection and rotational symmetry is explicitly denoted in fig. 24 at the end of this present paper. Notice, however, that although the major stars have the same number of points, they are structurally quite different, as explained more fully in a later section.

Creating geometric Islamic patterns

How did artisans and master builders centuries ago create elaborate Islamic star polygon designs? There are few written records to answer this question definitively and it is quite likely that several different methods were actually employed. It most likely did involve "a considerable amount of geometrical knowledge," suggesting that some degree of mathematical literacy may have existed among artisans, or at least among the master

builders, architects and master engineers [Berggren 1986]. For initially creating new designs, the traditional tools of the medieval period – a compass, straightedge, and set square – may well have been used by those master builders versed in construction techniques.

Theoretical mathematicians (al-Sijzī, Abū Nasr al-Farabī, Abū'l-Wafā al-Buzjani, Al-Kashi, Umar al-Khayyami, and Abu Bakr al-Khalid al-Tajir al-Rasadi, among others) developed and wrote about construction techniques useful to artisans interested in creating geometric ornamentation [Özdural 1995; 2000]. Manuals were written as a result of the meetings between these two groups, including one by al-Buzjani entitled, *Kitāb fīmā yahtā ju ilayhi al-sāni' min a'māl al-handasa* (*A book on those geometric constructions which are necessary for a craftsman*) which provided simplified instructions on how to perform basic Euclidean constructions using these traditional tools for:

> ... the construction of a right angle; the bisection of a square or circle; the division of a right angle into equal parts; the trisection of an angle; drawing a line parallel to, perpendicular to, or at a certain angle to a given line; determining the center of a circle or its arc; dividing the circumference of a circle into equal arcs; dropping a tangent to a circle from a given point; drawing a tangent to a circle through a point on it; and trisecting the arc of a circle. ... From these general problems al-Buzjani moved on to the construction of regular polygons inscribed in circles, other constructions involving circles and arcs, and the constructions of polygonal figures inscribed in various figures. The circle is used in al-Buzjani's treatise to generate all of the regular polygons in a plane [Necipoğlu 1995:138].

These geometric constructions could have formed the basis for creating many of the geometric Islamic patterns of the time.

Appended to a copy of a Persian translation of al-Buzjani's manuscript in the Bibliothèque Nationale in Paris, is an anonymous, twenty-page Persian manuscript, *Fī tadākhul al-ashkāl al-mutashābiha aw al-mutawāfiqa* (On Interlocking Similar and Congruent Figures) usually referred to by its shorter title, *A 'māl wa ashkāl* (Constructions and Figures). Believed to have been prepared by an artisan sometime during the eleventh to thirteenth centuries, it is the only known practical manual that provides "how to" instructions for drawing the repeat units of 61 planar geometric patterns. The instructions in Persian usually start with the standard phrase: 'The way of drawing and the ratio or proportion of this construction is as follows' [Necipoğlu 1995]. Abu Bakr al-Khalid al-Tajir al-Rasadi, an otherwise unknown mathematician, is mentioned twice in the *A 'māl wa ashkāl*: "Master craftsmen had questioned [Abu Bakr al-Khalid] about the different ways in which a particular geometric construction could be drawn; one of his solutions is explained in an accompanying diagram" [Necipoğlu 1995: 168]. *A 'māl wa ashkāl* also contains a second geometric construction by Abu Bakr al-Khalid, which shows how to draw a pentagon inscribed with a five-pointed star by using the chord of an arc as the module [Necipoğlu 1995]. Even though the *A 'māl wa ashkāl* provided very complicated, scientifically correct geometric constructions, it also provided simpler methods for constructing the same patterns [Necipoğlu 1995].

In addition, the use of memorized grids may also have been used for recreating familiar and well-established patterns already known to the artisans. Architectural scrolls provide evidence that polygonal and radial grids composed of concentric circles may have been used by master builders in Persia between the tenth and sixteenth centuries. These

grids consisted of black and/or red inked construction lines along with uninked "dead" lines lightly scratched on the paper with a sharp metal tool (such as the pointed end of a compass). According to a note written on one of Akbar's nineteenth-century scrolls, "The uninked drypoint tracing indicates the basis of the formation of figures" [Necipoğlu 1995: 14].

Since meetings were held between mathematicians and craftsmen starting in the tenth century, and "practical geometry" manuals instructing artisans how to perform basic geometry constructions were written, it seems plausible that some master builders were capable of using geometric construction techniques to generate patterns. With this in mind, we propose the following plausible Euclidean "point-joining" compass-and-straightedge reconstructions for each of the two designs in an attempt to discover how the original designer of these patterns may have determined, without mensuration, the proportion and placement of the star polygons. We start first with the construction of the regular polygons, or circles partitioned into congruent arcs, in which the stars will be situated.

Constructing star polygon designs inscribed within regular (or approximately regular) polygons

One of the most straightforward techniques for creating geometric "heavenly star" patterns found throughout the Islamic world is to initially construct a p-gon (a polygon with p sides) inscribed in a circle and then draw in the corresponding regular p-pointed regular star polygon by methodically joining the qth vertices of the p-gon with line segments (diagonals) or by methodically joining midpoints of the p-gon's edges. (Recall that a regular polygon is one in which all the sides have the same length and all the internal angles formed by two adjacent edges have the same measure.) A figure formed in this way is mathematically designated as a $\{p/q\}$ star polygon, where p and q are relatively prime positive integers, with $q < p/2$. If p and q are not relatively prime the star polygon is considered *improper*, or a *star figure* instead. For example, to form the regular $\{5/2\}$ star polygon, every second vertex of a regular pentagon is connected with line segments as shown in fig. 4a. By connecting alternate midpoints of edges of the same regular pentagon, a smaller regular pentagonal star figure may be formed, as shown in fig. 4b. Hence, star polygons or star figures with n points may be created within any n-gon, where every second (or third or fourth or k^{th}, where $2 \le k \le n/2$) vertex (or midpoint) is connected. (Note that portions of the segments have been highlighted to form the more decorative stars).

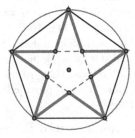 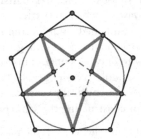

Fig. 4a. A {5/2} star Fig. 4b. A {5/2} star

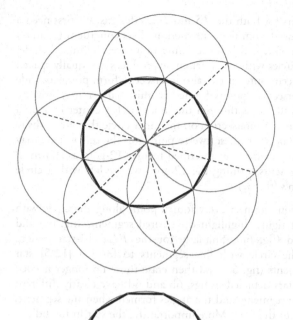

Fig. 5a. Construction of a 12-gon from seven congruent circles

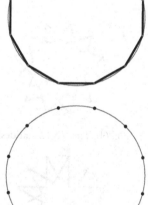

Fig. 5b. The 12-gon inscribed in a circle

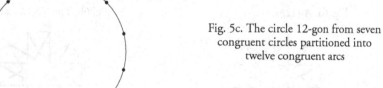

Fig. 5c. The circle 12-gon from seven congruent circles partitioned into twelve congruent arcs

The most common regular star polygon designs have *n* points, where *n* is 4, 5, 6, 8, 10, 12, 15, 16, 20, 24, and so on. It should be noted that these regular *n*-gons are *constructible* in the Euclidean sense; that is, they may be constructed using only a compass and straightedge. For *n* = 7, 9, 11, 13, 14, 18..., the regular *n*-gons (and likewise, the corresponding regular *n*-star polygons) may only be constructed approximately using these tools (for more about this, see the Wikipedia page at http://en.wikipedia.org/wiki/Constructible_polygon and [Sarhangi 2007]). Of these *non-constructible* star polygons, master builders in the eastern regions of the Islamic world often created star patterns with *n* = 7, 9, 14 and 18.

To create the twelve-pointed stars for both the *TS* and *B120* designs, we first need a regular 12-gon, which may be produced from the construction of six congruent ("outer") circles passing through a common point, which is the center of a seventh "inner" circle. The intersection of these six outer circles with the inner circle produces six equally spaced points on the inner circle. Two adjacent outer circles also intersect to form points outside the inner circle. The six outer intersection points formed in this manner may now be connected with three line segments that pass through the inner circle's center in such a way as to produce six additional points of intersection on the inner circle that are midway between the already extant points. Together, these twelve points on the inner circle may now be connected with line segments to form an inscribed regular 12-gon, as shown in figs. 5a and 5b. If we erase the segments forming the 12-gon, we are left with a circle partitioned into twelve congruent arcs (fig. 5c).

To produce the *TS* 12-star design, connect every fourth point along the circle with line segments to form a {12/4} star figure, highlight the desired segments (fig. 6a) and then erase those no longer needed (fig. 6b). Similarly for the *B120* 12-star design, connect every fifth point along the circle with line segments to form a {12/5} star polygon, highlight the desired segments (fig. 6c) and then erase those no longer needed (fig. 6d). It is evident that the 12-stars depicted in figs. 6b and 6d have clearly different structures; that is, the length of line segments and the angles formed when the segments meet differ markedly from one star to the next. More importantly, the star in fig. 6d is a {12/5} star polygon but the one in fig. 6b is a {12/4} star figure resulting from four overlapping equilateral triangles.

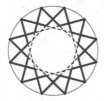

Fig. 6a. A {12/4} star

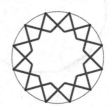

Fig. 6b. The *TS* 12-star design

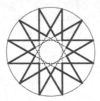

Fig. 6c. A {12/5} star

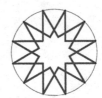

Fig. 6d. The *B120* 12-star design

Likewise, to create the nine-pointed stars of the *B120* and *TS* designs, we first need to construct an approximately regular 9-gon, or a circle partitioned into nine congruent arcs. As previously mentioned, it is impossible to construct a regular 9-gon using only a compass and straightedge. The actual construction of the two 9-gons – one for each design – will be shown in their upcoming sections, respectively. However, if given a 9-gon, one could partition a circumscribing circle into nine congruent arcs and then create the *TS* 9-star design by connecting every third point of nine along the perimeter with line segments to form a {9/3} star figure, highlight the desired segments (fig. 7a) and then erase those no longer needed (fig. 7b).

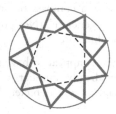
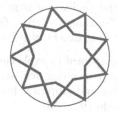

Fig. 7a. A {9/3} star Fig. 7b. The *TS* 9-star design

To create the *B120* 9-star design within a given 9-gon, partition a circle into eighteen congruent arcs and connect every seventh point with line segments, thereby creating a {18/7} star (fig. 8a). By highlighting every other star point, as shown in fig. 8b and erasing the remaining dashed line segments yields the 9-pointed star polygon with the same proportions as those found in the *B120* design (fig. 8c). It is also apparent that the 9-stars depicted in figs. 7b and 8c have clearly dissimilar structures; that is, the length of line segments and the angles formed when the segments meet differ noticeably from one star to the next. More importantly, the star in fig. 7b is a {9/3} star figure but the one in fig. 8c is the result of highlighting half of the line segments comprising an {18/7} star.

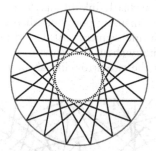
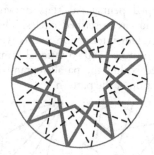
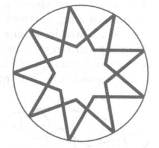

Fig. 8a. A {18/7} star design Fig. 8b. Half of the {18/7} star Fig. 8c. The *B120* 9-star
 highlighted design

Note also that the line segments comprising the *B120* 12-star image (fig. 6d) and those of the *B120* 9-star image (fig. 8c) have sets of parallel segments. This is not the case for the line segments comprising the *TS* 12-star image (fig. 6b) and the *TS* 9-star image (fig. 7b). Before we continue with the construction of the designs – one of which may be generated from a *repeat unit* which is then replicated using symmetry operations, and the other which will be constructed without regard to a repeat unit – let's first consider the source of each design.

The Tashkent Scrolls (TS) design

The source of the *TS* design, as previously mentioned, is a sketch belonging to the collection of post-Timurid design scrolls known as the *Tashkent Scrolls*, which "appear to have been a catalogue of ideal two- and three-dimensional designs ... identified by practicing Persian builders as *girih*" [Necipoğlu 1992: 50]. Some of the drawings, contained within rectangular or square regions, represent only a small portion, or *repeat unit*, of an overall geometric pattern that may be produced by the symmetry operation of reflection, across the edges of the rectangle or square, or rotation, about a corner of the square. Beneath some of the illustrations drawn in black ink are also "dead" construction

lines, arcs and circles that were scratched on the paper with a compass or other sharp implement "so as not to detract from the inked patterns they generate" [Necipoğlu 1995: 31]. As is also the case for the *Topkapı Scroll*, the sketches which are

> [u]naccompanied by explanatory texts or measurements ... appear to have served as an *aide-mémoire* for master builders who were already familiar through experience and empirical knowledge with the language of the depicted forms. [Necipoğlu 1992: 50].

Here I have created a facsimile of the *TS* sketch by tracing the image and producing its copy using the Geometer's Sketchpad® software (fig. 9a). The repeat unit contains two halves of nine-pointed star polygons along its horizontal edges and two quarters of twelve-pointed star polygons in the upper left and the lower right corners of the rectangle. Between the 9- and 12-star polygons (which include the petals) there are six irregularly-shaped pentagonal stars, two non-regular hexagons (similar in size and shape to the star petals) and two overlapping arrow-like polygons that produce a parallelogram in the overlapping region they share at the center of the rectangle. Fig. 9b shows a second facsimile (also created by me) of the *TS* design's overlay where the inked pattern (as dashed line segments) is superimposed on the uninked "dead" construction line segments, circles and arcs (in bold). Note that the "nearly regular" 9-stars, the regular 12-stars and the irregularly shaped pentagonal stars drawn in black ink in fig. 9 are constructed using inscribed and circumscribed circles. The remaining polygonal shapes may be achieved by joining certain intersection points with line segments. Also, notice that the pattern in the repeat unit has 180° rotational symmetry about the center of the repeat unit's rectangle (located within the parallelogram of the two arrow-like shapes), which is useful in the construction of the pattern.

Fig. 9a. Author's reconstruction of the TS design produced using Geometer's Sketchpad®

Fig. 9b. Author's construction of an overlay of the TS design produced using the Geometer's Sketchpad®

The *TS* design's repeat unit is interesting for several reasons. First, the major stars in the vast majority of Islamic star designs usually have an even number of points, and this has major stars with both an even number of points (the twelve-pointed stars) and an odd number of points (the nine-pointed stars). Second, the repeat unit contains 9-star polygons, presumably created from an underlying grid consisting of 9-gons, which are *not constructible* using the traditional drafting tools of straightedge and compass, so most likely an approximation was utilized to create them. Third, the position of the stars in the repeat unit is remarkable as well. Usually the major stars appear centered at either corner vertices (as the twelve-pointed stars are) or at the midpoints of the edges in the repeat units of Islamic star designs. But for the *TS* design, the centers of the major nine-pointed stars are not located in these standard positions.

Construction of the *TS* design repeat unit rectangle

In this section, we outline a method to construct the rectangle containing the polygons that comprise the *TS* design's repeat unit. Starting with a line segment of any length, construct two circles centered about the two endpoints and sharing the same radius. Using one of the points of intersection between these two circles as its center, construct a third circle through the endpoints of the line segment. Connect the centers of these three circles with line segments to form an equilateral triangle (fig. 10a). Extend the horizontal segments until they intersect and terminate on these circles. Also construct a segment that connects two of the points of intersection of two of the circles to form a second equilateral triangle (fig. 10b). Finally, construct two perpendicular line segments through existing points that terminate at the horizontal segments (fig. 10c). Note that the two resulting right triangles at either end of the rectangle are 30-60-90 triangles, halves of equilateral triangles. Erasing the circles and any unneeded segments yields the *TS* design's repeat unit rectangle (fig. 10d).

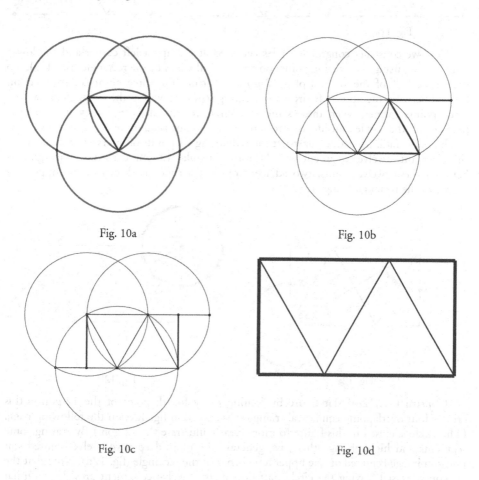

Fig. 10a

Fig. 10b

Fig. 10c

Fig. 10d

Construction of the twelve-pointed star polygons of the *TS* design

Constructing a diagonal line segment between the upper left corner and the lower right corner of the rectangle creates two additional, larger 30°-60°-90° right triangles and four smaller ones (congruent to the first two right triangles formed when the perpendiculars were constructed) from the halving of the equilateral triangles (fig. 11a). Three of the small right triangles share at their 30° angles the upper left corner point of the rectangle. Likewise, the lower right corner point of the rectangle is the vertex that the other three, small right triangles share at their 30° angles. We bisect all six of these 30°angles to produce the grids shown in figs. 11b and 11c.

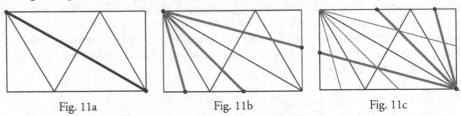

Fig. 11a Fig. 11b Fig. 11c

Next we construct congruent circles centered at the upper left corner and the lower right corner, using the existing points on the vertical edges of the rectangle (fig. 12a). To determine half of the vertices of a 12-gon, construct the three points of intersection formed between the upper left circle and existing segments within the rectangle, as well as three points formed when these same segments are extended until they intersect the portion of the circle outside the rectangle. The construction of six angle bisectors produces the radii needed to construct the remaining six points of intersection that divide this circle into twelve congruent arcs. To form a regular 12-gon, construct line segments between these twelve points, two adjacent ones at a time, as shown in the upper left corner of the rectangle in fig. 12b.

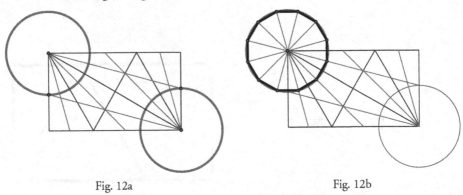

Fig. 12a Fig. 12b

Construct a {12/4} star figure by joining every fourth point of the 12-gon – this creates four overlapping equilateral triangles, as shown in fig. 12c, on the following page. (The circle is erased in this figure to more clearly illustrate the 12-gon.) By erasing some segments and highlighting others, we generate the more decorative twelve-pointed star polygon image centered on the upper left corner of the rectangle (fig. 12d). Note that the 12-gon is erased leaving the circle partitioned into twelve congruent arcs. In a similar manner, a twelve-pointed star may also be constructed, centered on the lower right corner (fig. 12e).

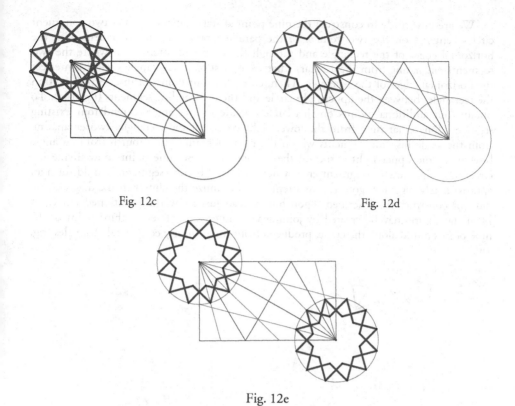

Fig. 12c Fig. 12d

Fig. 12e

Construction of the nine-pointed star polygons of the *TS* design

Before we can construct the nine-pointed star, we need to draw two additional line segments – one in the lower left corner and one in the upper right corner of the rectangle – by connecting existing points on adjacent edges of the rectangle. Next, construct a large parallelogram using points of intersection of the rectangle's diagonal with the circles containing the twelve-pointed stars and existing points on the horizontal edges of the rectangle (fig. 13a). The nine-pointed stars will be centered on the two vertices of the parallelogram that are coincident with the horizontal edges of the rectangle. Finally, we may construct angle bisectors (fig. 13b).

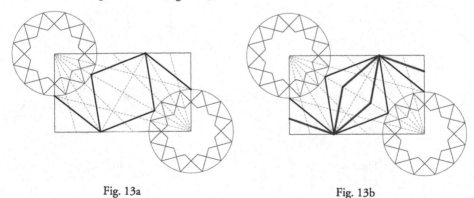

Fig. 13a Fig. 13b

We are now ready to construct the nine-pointed stars. First, construct two congruent circles centered on the two vertices of the parallelogram that are coincident with the horizontal edges of the rectangle and through the points of intersection where the two segments emanating from the 12-stars (that are closest to the rectangle's width) intersect the horizontal edges of the rectangle. Then, construct four points of intersection (within the rectangle) between the upper right circle and the existing line segments (fig. 14a). To obtain four additional points on this circle outside the rectangle, extend four existing segments (one emanating from the lower right corner of the rectangle, two emanating from the angle bisector segments within the parallelogram, and a fourth from an angle bisector in the upper right corner of the rectangle). These nine points now divide the circle into nine nearly congruent arcs, which, if joined by line segments, would form an approximately regular 9-gon. (In an attempt to minimize the clutter in the diagram, we did not construct the inscribed 9-gon but instead just show the partitioned circle.) A {9/3} star figure may be created by joining with line segments every third point of the nine points found along the circle, produced from three "nearly equilateral" triangles (fig. 14b).

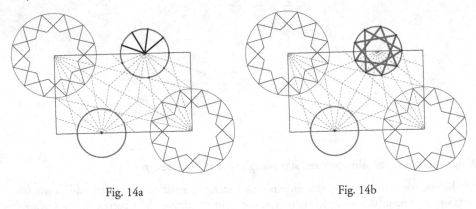

Fig. 14a Fig. 14b

By erasing some segments and highlighting others, we generate the more decorative star image (fig. 14c). We may repeat the same procedure to create a second nine-pointed star in the second circle along the lower horizontal edge of the rectangle (fig. 14d).

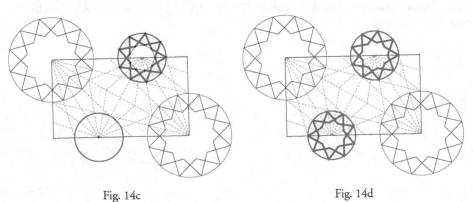

Fig. 14c Fig. 14d

Construction of the polygons found within the interstitial space of the *TS* design

With the construction of the major 12- and 9-stars completed, we only need now to fill in the interstitial space with the irregularly-shaped pentagonal stars, hexagons and arrow-like shapes. By extending some of the line segments of the major stars until they meet existing segments (their points of intersection are denoted in fig. 15a by the dots), we can construct large circular arcs centered on these stars and through these points to determine additional segments also obtained by extending existing line segments, also shown in fig. 15a (these points of intersection are drawn without the dots). Note that the original circular arcs circumscribing the major stars were erased for clarity. Line segments may now be drawn between these points, as shown in fig. 15b.

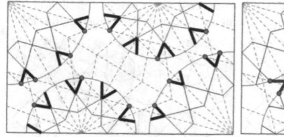
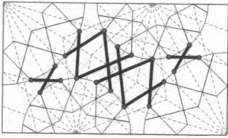

Fig. 15a Fig. 15b

Additional points of intersection, which were constructed from some of these segments, may now be used to determine the radius of two new circular arcs drawn in the upper left and lower right corners of the rectangle, about the 12-stars. (The previously used arcs were erased for clarity.) The points of intersection between these new arcs and the edges of the rectangle yield a few additional points and hence line segments (fig. 15c). Similarly, two more circular arcs may now be drawn about the centers of the 9-stars to also determine additional points and line segments (fig. 15d).

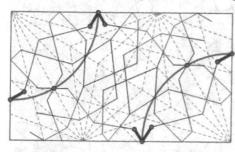
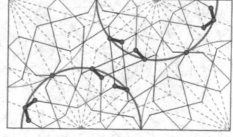

Fig. 15c Fig. 15d

Extending some of the segments constructed in the previous step allows for the completion of the pentagonal stars and hexagons (fig. 15e). Lastly, short line segments in bold are drawn through the existing points on the vertical edges and parallel to the non-bold segments of the 9-stars (fig. 15f).

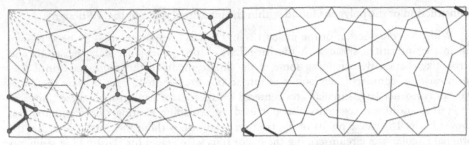

Fig. 15e Fig. 15f

Erasing the unneeded segments yields the completed repeat unit in skeletal form (fig. 15g) and a colorized version can be created using the Microsoft Paint program (fig. 15h).

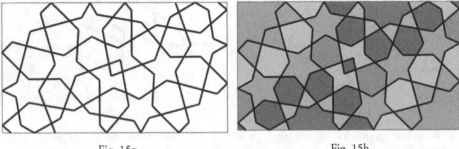

Fig. 15g Fig. 15h

Sixteen copies of the colorized repeat unit, replicated by reflection across the edges of the rectangle, are shown in fig. 16.

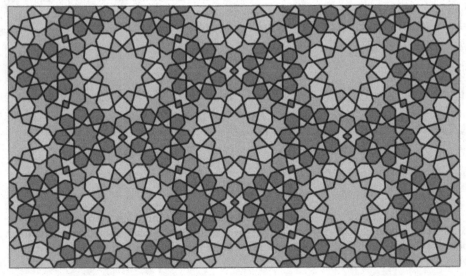

Fig. 16. Sixteen copies of the *TS* repeat unit, colored and replicated by reflection across the rectangle's edges

The left side of fig. 17 shows a portion of the photograph reproduced in fig. 2 above [Wade: Ind 0729], cropped and rotated so that it has the same orientation as my reconstructed *TS* design. The interior of the stars in the Ind 0729 pattern contain additional embellishment, and the arrow-shapes do not overlap to form a parallelogram, as is the case for the *TS* repeat unit, but otherwise the skeletal patterns are identical.

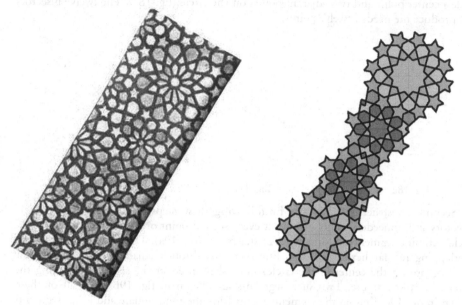

Fig. 17. left) A portion of the Masjid-i Jami in Fatehpur Sikri, India [Wade: Ind 0729] (photograph cropped and rotated by this author); right) the author's cropped reconstruction

Construction of the B120 design

One source for the next nine- and twelve-pointed star design is Plate 120 of Bourgoin's *Arabic Geometrical Pattern and Design*. Bourgoin copied these designs from Islamic monuments in Cairo and Damascus and lightly sketched some circles and lines that underlie his constructions. But this is after the fact, an analysis of a completed design. He does not indicate at all how the design might have been achieved. So in this section, I will outline a plausible Euclidean construction that produces the *B120* design without regard to a repeat unit, as was the case for the *TS* design. Instead the focus is on the completed design and how to properly position the major stars within it.

Construction of the twelve-pointed star polygons of the B120 design

First, divide a circle of any size into twelve arcs of equal measure using the following method. Construct a square, and then using the diagonals to determine the center, inscribe it within a circle. Construct three additional, smaller squares, using the midpoints of each larger square as the vertices of the next smaller square (fig. 18a). Erase the segments comprising the three outer squares, reserving the smallest innermost square and then construct six ("outer") circles all congruent to the original ("inner") circle. The outer circles are all coincident with the center of the inner circle and their intersections with the inner circle define six of the twelve points needed. Two adjacent outer circles also intersect at points outside the inner circle, and altogether there are 6 of these outer intersection points. Connect the opposite outer points with three line segments that pass

through the inner circle's center point. These segments will intersect the inner circle forming the six additional points needed to divide the inner circle into twelve arcs of equal measure, as shown in fig. 18b. Erase the six unneeded outer circles and the three line segments. To construct twelve additional points midway between the twelve existing points already on the circle, bisect the angles formed by rays emanating from the inner circle's center point and two adjacent points on the circle (fig. 18c). The twelve bisectors will produce the needed twelve points.

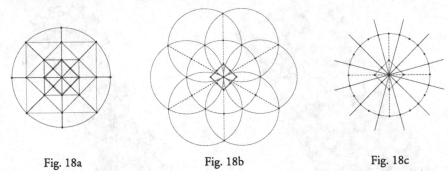

| Fig. 18a | Fig. 18b | Fig. 18c |

Second, construct a {12/5} star by following these steps. Erase the twelve angle bisectors and unneeded points. Connect every second point of the 12 remaining on the circle with line segments to form a {12/2} star figure (fig. 19a). These segments form two overlapping regular hexagons. Draw line segments through adjacent midpoints of the small square (at the center of the circle) until they intersect the segments forming the outer {24/2} star figure. Two such segments are shown in fig. 19b, with all of them shown in fig. 19c. Erasing the segments comprising the inner square and other segments now no longer needed, while highlighting others, yields the more decorative star shown in fig. 19d. Highlighting segments that complete the petals of the star and erasing some unneeded segments yields the image in fig. 19e. Erase the original circle to yield the motif we will call the completed 12-star, which includes the hexagonal petals (fig. 19f).

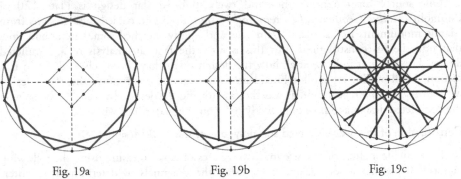

| Fig. 19a | Fig. 19b | Fig. 19c |

Fig. 19d Fig. 19e Fig. 19f

Construction of the nine-pointed star polygon of the *B120* design

To construct a nearly regular 9-gon, and within it an {18/7} star (which in turn will produce the requisite 9-star), follow these steps. Starting with a 12-star (fig. 19f), construct a circumscribing circle about it. (Note that this is **not** the same circle that was used to create the 12-star in the original construction and that is shown in fig. 19e). Then construct an equilateral triangle whose edges must measure three times the length of the radius of this circumscribing circle (fig. 20a). Centered on each of the remaining two vertices of the triangle, construct two additional 12-stars in the manner previously described and erase the circles (fig. 20b).

Fig. 20a Fig. 20b

We may now create an approximately regular 9-gon in the interstitial space by constructing the nine line segments between extant points (fig. 21a). Six of the interior angles of the 9-gon shown in fig. 21b measure approximately 140.10° (as measured by the Geometer's Sketchpad® software program) and the remaining three interior angles measure 139.79°. The theoretical angle measure of a regular 9-gon would be exactly 140°. Hence the measure of these constructed angles differs by approximately .10 to .21 of a degree from the exact (theoretical) angle measure.

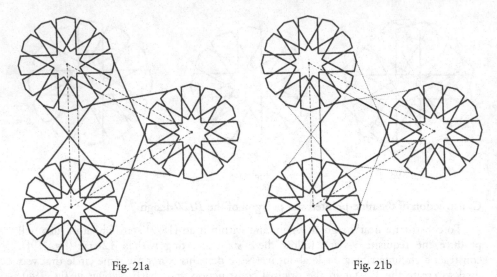

Fig. 21a Fig. 21b

It is within this 9-gon that we will now construct the 9-star. Extend three line segments emanating from the centers of the three 12-stars, parallel to existing segments, until they intersect at the midpoints of the segments joining the centers of these 12-stars. These segments intersect at the center of the 9-gon. Also extend six line segments parallel to these three line segments until they intersect each other near the center of the 9-gon (fig. 22a). Construct two additional segments through existing points and construct a circle centered within the 9-gon and through the point of intersection of these two segments (fig. 22b). Twelve of the eighteen needed points of intersection may now be constructed on the circle where the line segments cross.

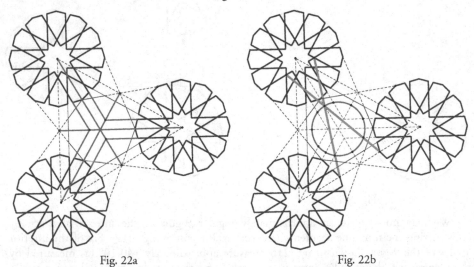

Fig. 22a Fig. 22b

Just six additional points on the circle are needed to construct the 9-star. To obtain these, construct segments from the center of the 9-gon to the vertices of the 9-gon. These segments and the requisite eighteen points on the circle are shown in fig. 22c. Erase unneeded segments. Construct an {18/7} star now by connecting with line segments every seventh point of the eighteen along the circle, as shown in fig. 22d.

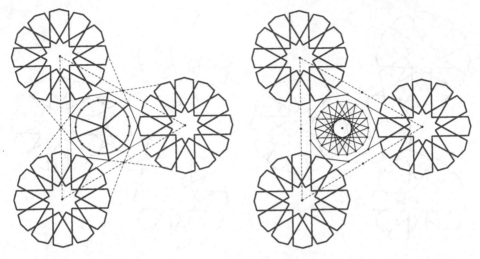

Fig. 22c Fig. 22d

Erase the unneeded line segments (half of the segments comprising the {18/7} star) to form the 9-star shown in fig. 22e. Extend existing line segments that form the 9-star until they meet the 9-gon and highlight other existing segments to enclose the hexagonal petals of the star (fig. 22f).

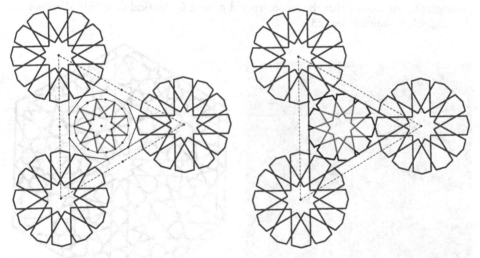

Fig. 22e Fig. 22f

Erase unneeded line segments and the circle circumscribing the 9-star, and connect existing points to form the six pentagonal stars (fig. 22g). Erasing some line segments and highlighting others will produce more decorative pentagonal stars. Lastly, the three "arrow" shapes may be constructed by connecting existing points on the 9-gon with the midpoints of the segments joining the three 12-stars (fig. 22h). Having found a way to construct the requisite polygons in the interstice between the three 12-stars, the rest of the design (shown in fig. 3a at the beginning of this paper) can be completed by using symmetry and repetition.

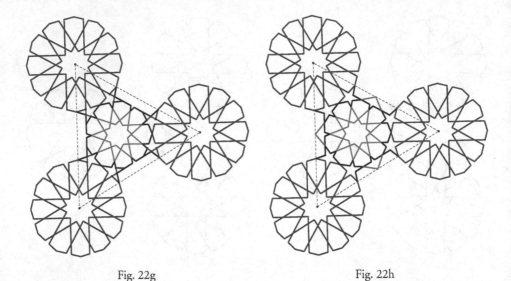

Fig. 22g Fig. 22h

Since the Sultaniyeh example of the *B120* design (the [Wade: Ira 2701] photograph) is contained within a hexagon, we have created a copy of the reconstructed design also within a hexagonal frame for comparison purposes. Aside from the embellishments evident in the photograph, which is also slightly distorted due to the perspective of the photograph, one can see that the reconstructed pattern is identical to a skeletal version of the original, as shown in fig. 23.

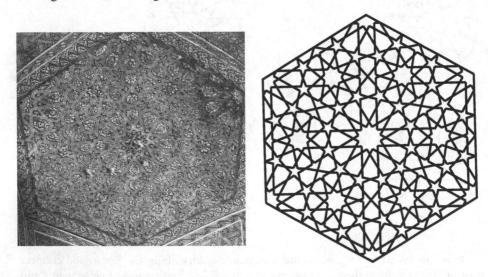

Fig. 23. left) A portion of a ceiling in the Mausoleum of Sultan Oljaytu in Sultaniyeh, Iran, dated 1313, from the Ilkhanid dynasty [Wade: Ira 2701] (photograph cropped by this author); right) the author's reconstruction

Discussion

In this paper we have described two plausible Euclidean "point-joining" compass-and-straightedge constructions for the two different nine- and twelve-pointed Islamic star

polygon designs. The first design, designated as the *TS* design, was completed by recreating to the exact design proportion and placement, the polygons within a repeat unit of a sketch from the *Tashkent Scrolls*. The other design, designated as the *B120* design, was completed by first constructing three copies of the appropriate regular 12-star and then finding a way to construct a nearly regular 9-gon and then a 9-star in the interstitial space. Both methods were relatively straightforward and easy to accomplish, showing that they are plausible constructions of the designs. Although we found only one extant example of the *TS* design [Wade: Ind 0729], the *B120* design may be found rather ubiquitously in monuments across the Islamic world, from Spain to Egypt to Turkey and to India. Ironically, neither of these two nine- and twelve-pointed star polygon patterns may be found in the *Topkapi Scroll*.

The designs were very similar in overall structure; that is, the number and placement of the major stars were identical and so (in skeletal form) they may both be mathematically classified as belonging to the same crystallographic group – both are p6m designs, whereby the design elements exhibit six-fold rotational symmetry and mirror reflections, as shown for the *B120* design in fig. 24. (The analysis would be the same for the *TS* design shown in fig. 3b.) The completed pattern more clearly shows the six-fold nature of the design's rotational symmetry. Notice the six 9-stars that are equispaced at 60° angles about the center point of the central 12-star. These, in turn, are surrounded by two groups of six 9-stars and six 12-stars. A few mirror axes are also indicated on the design by the dashed line segments.

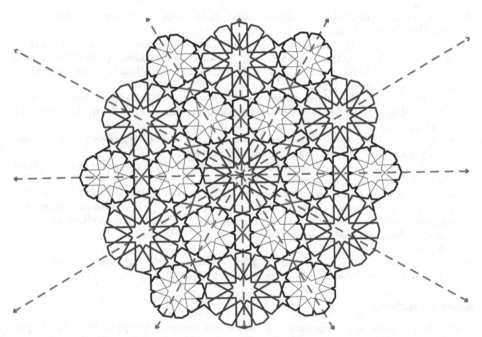

Fig. 24. The completed design, showing the p6m symmetry

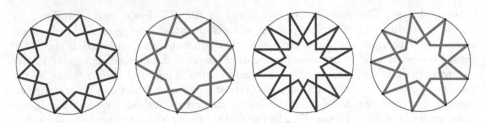

Fig. 25. The TS stars on the left ({12/4} and {9/3} star figures), and the B120 stars on the right ({12/5} and (derived from) {18/7} star polygons

It was, however, the major stars themselves that were structurally quite different despite having the same number of points, and so on, as is most evident by comparing the stars in fig. 25. Reconciling their differences was the most interesting aspect of this study.

Acknowledgment

I am indebted to the reviewers for their useful comments and suggestions for improvement.

References

BERGGREN, J. L. 1986. *Episodes in the Mathematics of Medieval Islam*. New York: Springer-Verlag.

BOURGOIN, Jules. 1973. *Arabic Geometrical Pattern and Design* (1879). New York: Dover Publications.

CLÉVENOT, Dominique. 2000. *Splendors of Islam: Architecture, Decoration and Design*, New York: The Vendome Press.

NECIPOĞLU, Gülru. 1992. Geometric Design in Timurid/Turkmen Architectural Practice: Thoughts on a Recently Discovered Scroll and Its Late Gothic Parallels. Pp. 48-67 in *Timurid Art and Culture: Iran and Central Asia in the Fifteenth Century*, Lisa Golombek and Maria Subtelny, eds. Leiden: E. J. Brill.

———. 1995. *The Topkapı Scroll: Geometry and Ornament in Islamic Architecture: Topkapı Palace Museum Library MS H. 1956*. Santa Monica: The Getty Center for the History of Art and Humanities.

ÖZDURAL, Alpay. 1995. Omar Khayyam, Mathematicians, and *Conversazioni* with Artisans, *Journal of the Society of Architectural Historians* **54**: 54-71.

———. 2000. Mathematics and Art: Connections between Theory and Practice in the Medieval Islamic World, *Historia Mathematica* **27**: 171-201.

SARHANGI, Reza. 2007. Geometric Constructions and their Arts in Historical Perspective. Pp. 233-240 in *Bridges Donostia, Conference Proceedings*, The University of the Basque County, San Sebastian, Spain, Reza Sarhangi and Javier Barrallo, eds. London: Tarquin Publications.

VOLWAHSEN, Andreas. 1994. *Islamic India*, Vol. 8. Henri Stierlin, ed. New York: Sterling Publishing.

[WADE] *Pattern in Islamic Art: The Wade Photo Archive*, available at http://www.patterninislamicart.com. Last accessed 11 April 2012.

About the author

B. Lynn Bodner has taught a wide variety of mathematics courses to college students over the past thirty years. For the last twenty-two of these, she has especially enjoyed teaching an interdisciplinary course at her university entitled the Mathematics of Artistic Design. Of the many topics considered in that course, geometric Islamic patterns have held the most fascination and appeal for her, in addition to being a source of limitless geometric investigation.

Carl Bovill

School of Architecture
Planning and Preservation
University of Maryland
USA
College Park, MD 20742
bovill@umd.edu

Keywords: Tessellations,
design theory, Persian
architecture, patterns,
measurement, Christopher
Alexander

Research

Using Christopher Alexander's Fifteen Properties of Art and Nature to Visually Compare and Contrast the Tessellations of Mirza Akbar

Abstract. When one looks closely at the tessellations designed by Mirza Akbar in the early nineteenth century there are many overlapping structures interacting with one another. The complex structure of these tessellations results from the horizontal, diagonal, and radial grids that were used to construct the tessellations. This paper will discuss how Mirza Akbar constructed two of his tessellations and why star shapes embedded in complex symmetrical patterns are important in Islamic culture, and will then test the usefulness of Christopher Alexander's fifteen properties of art and nature as an additional method of comparing and contrasting the visual characteristics of these tessellations. The fifteen properties are levels of scale, strong centers, boundaries, alternating repetition, positive space, good shape, local symmetries, deep interlock and ambiguity, contrast, gradients, roughness, echoes, the void, simplicity and inner calm, and not separateness.

The tessellations of Mirza Akbar

Mirza Akbar, a master builder in early nineteenth-century Persia, documented the tessellations shown in figs. 1 and 2 [Gombrich 1979: 85; Necipoglu 1995: 19]. Looking closely at the tessellations, one can see overlapping structures that surround and reinforce the star shapes that are the most prominent features of the tessellations. Tessellation A (fig. 1) has ten-pointed stars in a field of diagonal and vertical lines formed from four-sided kite-like tiles, and pentagon-shaped tiles, with some hourglass-shaped tiles to complete the tessellation. There are also pentagon shapes that oscillate up the vertical line of tiles between the vertical lines of star shapes. Tessellation B (fig. 2) is dominated by twelve-pointed stars surrounded symmetrically by four-sided kite-shaped tiles and hexagon-shaped tiles, with some arrow shaped tiles to complete the tessellation. The twelve-pointed star shapes are separated by triangle shapes. There is also a six-sided line of tiles that overlaps the stars and triangles and surrounds the large star shapes.

Mirza Akbar codified in a set of drawings how the complex tile patterns of Tessellation A and Tessellation B were developed. Fig. 3 shows how Tessellation A was developed. Fig. 4 shows how Tessellation B was developed. The light lines are construction lines that were lightly scratched on the paper. The dark lines were set in ink to mark the shapes of the tiles. Both constructions were prepared with compass and straightedge and it is clear from the constructions that the procedure started with the laying out of the centers of the stars and drawing concentric circles that were used to organize the lines that outline the tiles. Note how the lines that define the tile shapes have their origins and intersections where the concentric circles intersect the radial lines [Christie 1969: 252-258].

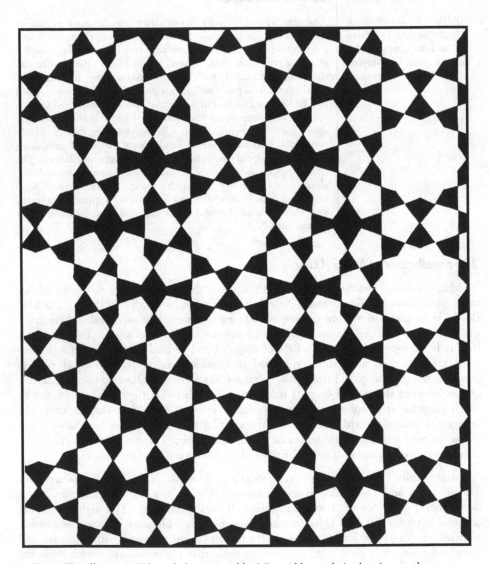

Fig. 1. Tessellation A. Tilework documented by Mirza Akbar early in the nineteenth century.
[Dowlatshahi 1979: 58; Christie 1969: 157]

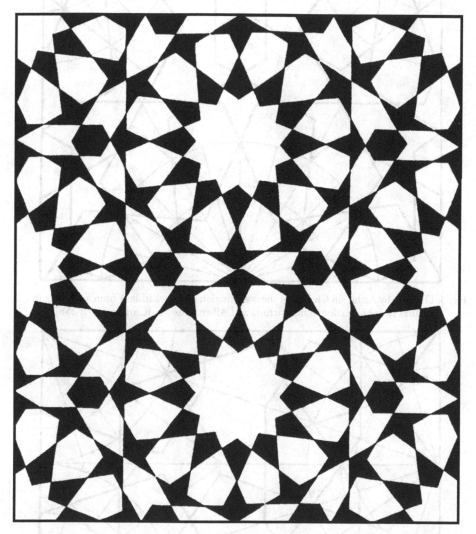

Fig. 2. Tessellation B. Tilework documented by Mirza Akbar early in the nineteenth century.
[Dowlatshahi 1979: 58; Christie 1969: 154]

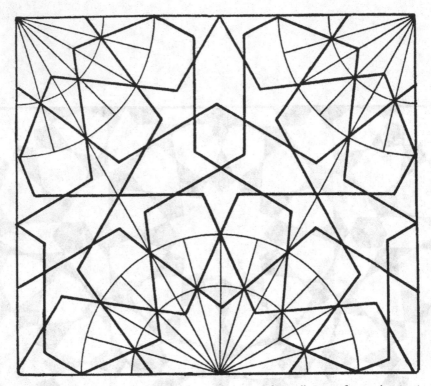

Fig. 3. Diagram by Archibald Christie of the construction of Tessellation A from a drawing in the Mirza Akbar collection at the Victoria and Albert Museum [Christie 1969: 258]

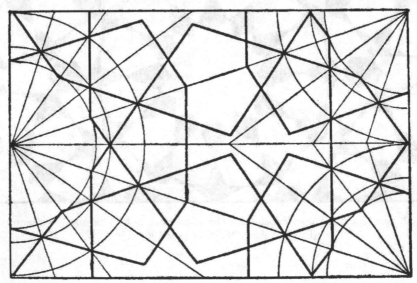

Fig. 4. Diagram by Archibald Christie of the construction of Tessellation B from a drawing in the Mirza Akbar collection at the Victoria and Albert Museum [Christie 1969: 255]

Syed Jan Abas, in a paper on symmetries [2001], addresses the prominence of star shapes embedded in the complex geometrical patterns of Islamic tessellations through four features of Islamic culture. One, the concept of God in Islam is abstract but can be described as light. Two, wandering over deserts and oceans required an understanding of the complexities and symmetries of the night sky for navigation. Three, a long tradition with carpet weaving reinforced covering surfaces with complex symmetrical patterns, and four, combining all of these was the concept that geometry connected the material and spiritual worlds [Abas 2001: 61-62]. Abas, in his book *Symmetries of Islamic Geometrical Patterns* [Abas and Salman 1995], discusses how symmetry plays an important part in human understanding and perception of the physical world around us. Gravity is radially symmetric. Animals are bilaterally symmetric. Our thought processes look for symmetries to understand what is before us and to project into the future [Abas and Salman 1995: 32-35]. Both of the tessellations and their construction drawings shown in figs. 1 through 4 demonstrate complex symmetry defined as patterns that, when rotated, translated, and or reflected, reproduce the same image [Abas and Salman 1995: 57; Loeb 1993: 14-27; Weil 1952]. Tessellation B has rotational symmetries of 60°, 120° and 180°. It also has translational symmetries vertically, horizontally, and along the diagonal lines. Tessellation B has a 180° rotational symmetry but no others. It has translational symmetries vertically, horizontally, and along both the diagonal lines that run through the tessellation. These multiple overlapping symmetries create a pleasant mix of order and surprise that holds the observer's visual attention. The connection, well presented by Abas, between symmetries and our perception of the world and our ability to project from past observation to future consequences, reinforces the Islamic concept that complex symmetries in geometric patterns connect the material and spiritual worlds.

As demonstrated in the previous paragraphs, the two tessellations can be described by discussing the star centers and the interlocking and overlapping symmetrical shapes that frame the stars. The two tessellations can also be described by exploring the method used to construct them. The use of stars as a central motif embedded in complex symmetrical patterns can be related to Islamic culture. However none of these methods provides a detailed multi-dimensional method of discussing the strongly different visual characteristics of the two tessellations. It would be helpful if there were a structured method to describe the visual differences between the tessellations, thus providing another method to compare and contrast the complex interlocking and overlapping geometrical patterns of Islamic design.

Christopher Alexander's fifteen properties of art and nature

Christopher Alexander, in book one *The Nature of Order* of his four book set *The Phenomenon of Life*, discusses at length how art and nature are given life by collections of centers that interact with each other. "My aim in this book is to create a scientific view of the world in which this concept – the idea that everything has a degree of life – is well defined" [Alexander 2002: 32]. He goes on to develop fifteen properties that can be used to compare and contrast works of art and works of nature. The fifteen properties are levels of scale, strong centers, boundaries, alternating repetition, positive space, good shape, local symmetries, deep interlock and ambiguity, contrast, gradients, roughness, echoes, the void, simplicity and inner calm, and not separateness. Alexander does not create formal definitions of these properties, but rather defines each of the fifteen properties through a discussion of examples from art and nature that illustrates the property [Alexander 2002: 243]. The following paragraphs are a test of the ability of Alexander's fifteen properties to provide a multi-dimensional comparison of the visual characteristics of the tessellations.

Levels of scale

The appearance of scale is widespread throughout natural systems. The tree: trunk, limbs, branches, twigs. The cell: cell walls, organelles, nucleus, chromosomes. The river: bends in the river, tributaries, eddies, pools at the edge [Alexander 2002: 246].

This is a verbal description of a fractal view of nature.

Both tessellations have large star structures made from smaller tiles. However Tessellation A has more overlapping shapes. There are diagonal lines running across the tessellation. There are vertical lines running up and down the tessellation. There are pentagons embedded in these vertical lines that oscillate their orientation as they run up the line of tiles. There are four-sided diamond shapes that appear where the pentagons overlap,

Strong centers

We certainly see strong centers throughout the physical world. Many natural processes have centers of action. The action, or development, or force-field radiates outward from some systems of centers. This is implicit in much of physics and biology. In physics, we have the fact that electric, magnetic, gravitational, and nuclear forces are carried by spatially symmetrical fields, thus most often creating centrally and bilaterally symmetrical structures [Alexander 2002: 251].

While both tessellations provide centers in their star shapes, Tessellation B has much stronger centers than Tessellation A. In tessellation B the star centers dominate the formation while in Tessellation A the star shapes are in a visual balance with the diagonal lines running past the star centers.

Boundaries

In nature we see many systems with powerful, thick boundaries. The thick boundaries evolve as a result of the need for functional separations and transitions between different systems. They occur essentially because wherever two very different phenomena interact, there is also a 'zone of interaction' which is a thing in itself, as important as the things which it separates [Alexander 2002: 254].

Examples of boundaries are the sun's corona, the delta of a river, and the foothills of a mountain range.

The boundaries between the star shapes in Tessellation A are stronger than the boundaries in Tessellation B. In Tessellation A there are wide vertical boundaries separating the star shapes. There are also diagonal lines running across the tessellation separating the star shapes, and overlapping both of these linear boundaries is a circular boundary running around each of the stars. In Tessellation B the most important boundary is composed of the kite-shaped and hexagon-shaped tiles that surround the twelve-pointed star at the center. This reinforces the strong center (see "strong centers" above). There is also a line of tiles creating a hexagon boundary that separates the star shapes. This hexagon line of tiles is a fairly weak boundary since the surrounded star shapes create such strong centers.

Alternating repetition

In most of these cases of natural repetition, the repeating units do alternate with a second structure, which also repeats. When atoms repeat, so do the spaces which contain the electron orbits; when waves repeat, so do the troughs between the waves; as mountains repeat, so do the valleys [Alexander 2002: 257].

Both tessellations require alternating repetition of kite shapes, four-sided shapes that resemble kites, with polygons in Tessellation A, and hexagon shapes in Tessellation B. There are a few more complex shaped tiles that are necessary to complete the tessellation (see "roughness" discussed below). At a larger scale, in Tessellation A, there is a repetition of vertical lines with stars in them and vertical lines without stars. In addition there are diagonal lines of various widths. The wider lines contain the stars; the narrow lines run past the stars. Tessellation B is a little simpler. There is a repetition of star shapes and triangle shapes that fill out the plane. There is also a repetition of star shapes and the line of hexagon-shaped tiles that surrounds the star shapes.

Positive space

In the majority of naturally developed wholes, the wholes and spaces between wholes form a continuum. This arises because the wholes form 'from the inside' according to their specific functional organization, thus making each whole positive in its own terms. The positive nature of the space is necessary to preserve the wholeness of the system [Alexander 2002: 261].

This is similar to yin and yang. The shape of the form and the spaces between the forms are equally important.

Tessellation B is a good example of positive space. Each star shape pushes outward toward the other star shapes creating triangle shapes between them. The ratio between the size of the star shapes and the sizes of the hexagon shapes that surround them is pleasing. In Tessellation A the star shapes do not push outward into the field of tiles as strongly as in Tessellation B. However, a form of positive space is created by the interaction of the star shapes with the diagonal lines that run above and below the stars. One might consider this a more nuanced form of positive space.

Good shape

A great many natural systems have a tendency to form closed, beautifully shaped figures: leaves, the curl of a breaking wave, a cowrie shell or a nautilus, a harebell, a bone or a skull, a whirlpool, a volcano, the arch of a waterfall. ... In order to understand the widespread occurrence of the beauty of these shapes in nature, we must remember that good shape in a geometric figure – often curved – has in it some major center that is intensified by various minor centers [Alexander 2002: 264].

Under the above definition, Tessellation B has better shape than Tessellation A. Tessellation B has star centers, surrounded by twelve minor centers created by the kite and hexagon-shaped tiles surrounding the star shape. Tessellation A surrounds its star shapes with ten minor centers but its minor centers are not as strong as the minor centers in Tessellation B. In Tessellation A the surrounding minor centers are overpowered by the strong diagonal lines surrounding the stars.

Local symmetries

In general these symmetries occur in nature because there is no reason for asymmetry; an asymmetry only occurs when it is forced. Thus, for instance, a water drop, falling through the air, is asymmetrical along its length, because the flow field is differentiated in the direction of the fall, but symmetrical around its vertical axis, because there is no differentiation between one horizontal direction and any other [Alexander 2002: 266].

Both tessellations exhibit local symmetries. Tessellation B has very strong local symmetries surrounding the star shapes and in the triangle shapes that separate the star shapes. Tessellation A has a less visually powerful cascade of symmetry around the star shapes but it has other local symmetries. There are overlapping pentagon shapes that are embedded in the vertical boundaries between the star shapes. These pentagon shapes have a bilateral symmetry. Where the pentagons intersect there are diamond shapes that also have bilateral symmetry.

Deep interlock and ambiguity

Deep interlock comes about in many natural systems because neighboring systems interact most easily along extended or enlarged surfaces, where the surface area is large compared with the volume [Alexander 2002: 270].

Tessellation A has a much higher degree of interlock and ambiguity than Tessellation B. Tessellation A has an overlay of diagonal and vertical lines of varying widths running through it. In the wide vertical lines that separate the star shapes there are multiple overlapping shapes. The most dominant are pentagons that oscillate up through the figure. Where the pentagons overlap they create a diamond shape. Finally, each star is surrounded by a circle of tiles that overlays all the shapes just discussed. The main interlock in Tessellation B is the six-sided line of tiles that surrounds the star shapes and overlaps the triangle shapes that separate the star shapes.

Contrast

Many – perhaps all – natural systems obtain their organization and energy from the interaction of opposites. We see this at a fundamental level in the following chart of elementary particles, which contains particles and antiparticles, positive and negative electric charges, charmed and anti-charmed quarks, up and down quarks, and anti-up and anti-down quarks [Alexander 2002: 272].

Both tessellations have good contrast. However, I find it interesting that when viewed up close Tessellation B appears to have a slightly better balance between dark and light tiles, but when viewed at a distance Tessellation A appears to have a better balance. In addition, as in positive and negative electrical charges, both tessellations are mostly constructed with kite-shaped tiles and polygon-shaped tiles.

Gradients

Gradients play a very large role throughout nature. Any time that a quantity varies systematically through space, a gradient is established. For instance, we climb on a mountain, the higher we go, the climate becomes colder, and the air becomes thinner. In these gradually changing conditions, trees become more thinly spaced, finally giving way to grass and then to rocks, and then to rocks and ice [Alexander 2002: 275].

Tessellation B has a strong gradient of shapes surrounding the stars. There are three layers of tiles of varying shapes that surround the star shape in the middle. This is a

gradient and also an example of a boundary, discussed previously. Tessellation A also has a gradient of three layers of tiles surrounding the star shapes, but here the gradient is not as strong as in Tessellation B, and the gradient gets somewhat lost in the overlapping diagonal and vertical lines of tiles around the stars.

Roughness

Roughness, or irregularity, appears pervasively in natural systems. It appears as a result of the interplay between well-defined order and the constraints of three dimensional space [Alexander 2002: 278].

At the level of the design of the tessellation, there are specially shaped tiles that are necessary to complete the tessellation. In Tessellation A, which is mostly kite-shaped and pentagon-shaped tiles, there are hourglass-shaped tiles in the centers of the polygon shapes that cascade up the vertical lines of tiles between the star shapes. This different shape is necessary to complete the tessellation. In Tessellation B, there are arrow-shaped tiles that are necessary to complete the tessellation, which is primarily built from kite-shaped and hexagon-shaped tiles.

Echoes

In all natural systems, deep-lying fundamental processes ultimately give geometric form to the static structure of the system. These processes repeat certain typical angles and proportions over and over again, and it is the statistical character of these angles and proportions which determines the morphological character of the system of parts [Alexander 2002: 281].

The ten-pointed star shape in Tessellation A is echoed in the pentagon shapes that make up much of the tessellation. The pentagon shapes that oscillate up the vertical line of tiles between the stars are also an echo. The twelve-pointed star-shape in Tessellation B is echoed in the hexagon shapes that make up much of the tessellation. The triangle shapes separating the twelve-pointed stars are also echoes in the twelve, six, three sequence.

The void

The void corresponds to the fact that differentiation of minor systems almost always occurs in relation to the 'quiet' of some larger more stable system. Thus smaller structures tend to appear around the edge of larger more homogeneous structures. In Plasma physics, for example, this appears in the form of systems of galaxies which have strongly homogeneous zones, bounded by more intricate zones where the structure is more intense and more densely disturbed [Alexander 2002: 284].

Looking at the tessellations it is clear that without the star shapes – the voids which generate the boundaries of interacting smaller structures – the design would break down into a chaotic collection of small tiles.

Simplicity and inner calm

Simplicity and inner calm is the Occam's razor of any natural system: each configuration occurring in nature is the simplest one consistent with its conditions. For example, Michel's theorem shows that the typical three dimensional form of a leaf, with the particular way the plan and cross section vary from stem to tip, is the least weight structure for a cantilever supporting a uniformly distributed load [Alexander 2002: 287].

Neither of these tessellations demonstrates simplicity and inner calm, however Tessellation B, because of its less overlapping structure, demonstrates more simplicity and inner calm than Tessellation A.

Not separateness

Not separateness corresponds to the fact that there is no perfect isolation of any system, and that each part of every system is always part of the larger systems in the world around it and is connected to them deeply [Alexander 2002: 288].

This last concept simply states that all of the above ways that nature and good design organizes itself are interconnected. They need to smoothly interact with each other.

Both tessellation designs contain characteristics of all of the fifteen properties, with some more prominent than others.

Conclusion

The two tessellations of Mirza Akbar presented in this paper can be studied and classified by the complexity of their construction using compass and straightedge. They can also be studied and classified by their rotational and translational symmetries. Neither of these methods directly addresses their visual differences

However, Christopher Alexander's fifteen properties of art and nature can provide a structured way to compare and contrast the visual characteristics of the two tessellations. Tessellation A has more levels of scale, stronger boundaries between the dominant star shapes, a deeper interlock of shapes, good contrast when viewed at a distance, and a higher level of not separateness. Tessellation B has stronger centers, strong positive space, good shape, strong local symmetries, good contrast when viewed up close, and strong gradients around the star shapes. Both tessellations exhibited roughness, echoes and the void.

Finally, I chose these tessellations because I was fascinated by how long they held my visual attention exploring the multiple overlapping symmetrical patterns they present.

References

ABAS, Syed Jan and Amer Shaker SALMAN. 1995. *Symmetries of Islamic Geometrical Patterns.* Singapore: World Scientific.

ABAS, Syed Jan. 2001. Islamic Geometrical Patterns for the Teaching of Mathematics of Symmetry. *Symmetry in Ethnomathematics* **12** (1-2): 53-65. Budapest: International Symmetry Foundation.

ALEXANDER, Christopher. 2002. *The Nature of Order: An Essay on the Art of Building and the Nature of the Universe, Book 1 - The Phenomenon of Life.* Berkeley: The Center for Environmental Structure.

CHRISTIE, Archibald. 1969. *Pattern Design, An Introduction to the Study of Formal Ornament.* New York: Dover Publications.

DOWLATSHAHI, Ali. 1979. *Persian Designs and Motifs for Artists and Craftsmen.* New York: Dover Publications.

GOMBRICH, E. H. 1979. *The Sense of Order: A Study in the Psychology of Decorative Art.* Ithaca, NY: Cornell University Press

IRWIN, Robert. 1997. *Islamic Art in Context.* New York: Harry N. Abrams, Inc.

LOEB, Arthur. 1993. *Concepts and Images.* Boston: Birkhäuser.

NECIPOĞLU, Gülru. 1995. *The Topkapi Scroll: Geometry and Ornament in Islamic Architecture.* Santa Monica, CA: Getty Center for the History of Art and Humanities.

WEYL, Hermann. 1952. *Symmetry.* Princeton, NJ: Princeton University Press.

About the author

Carl Bovill is an Associate Professor of Architecture at the University of Maryland at College Park. He has a Bachelor's degree and a Master's degree in mechanical engineering from the University of California, and a MArch degree from the University of Hawaii where he was awarded the AIA School Medal for excellence in the study of architecture. In addition to journal and conference papers, he has published two books, *Architectural Design: Integration of Structural and Environmental Systems* (New York: Van Nostrand Reinhold, 1991) and *Fractal Geometry in Architecture and Design* (Boston: Birkhäuser, 1996). He is currently working on a book on sustainability.

Reza Sarhangi

Department of Mathematics
Towson University
8000 York Road
Towson, MD 21252 USA
rsarhangi@towson.edu

Keywords: Persian architecture,
Persian mathematics, star
polygons, decagram, mosaic
designs

Research

Interlocking Star Polygons in Persian Architecture: The Special Case of the Decagram in Mosaic Designs

Abstract. This article analyzes a particular series of Persian mosaic designs illustrated in historical scrolls and appearing on the surfaces of historical monuments. The common element in these designs is a special ten-pointed star polygon, called a decagram for convenience; it is the dominant geometric shape in several polyhedral tessellations. This decagram can be created through the rotation of two concentric congruent regular pentagons with a radial distance of 36° from each others' central angles. To create a decagram-based interlocking pattern, however, a craftsman-mathematician would need to take careful steps to locate a fundamental region. A modular approach to pattern-making seems to be more applicable for this design than compass-straightedge constructions. Such designs include patterns that are sometimes called aperiodic or quasi-periodic tilings in the language of modern mathematics.

1 Introduction

From a few documents left from the past, it is evident that the designers of patterns on the surfaces of medieval structures in Persia and surrounding regions, were well-equipped with a significant level of knowledge of applied geometry. Nevertheless, they never exhibited the same level of effort or interest in providing the pure side of the subject by proving theorems and establishing mathematical facts about such designs. The main concern of a designer or craftsman was to present a visual harmony and balance, not only in deep details, but also as a whole. Nevertheless, the steps taken for creating such designs include techniques that are only acquired and understood by mathematicians. An individual with the knowledge of such detailed techniques is a mathematician, artist or not.

The infrastructures of a large number of patterns are the three regular tessellations of equilateral triangles, squares, and regular hexagons. Square shape tiles are the most popular ones because they are produced more conveniently than the others. Between the other two shapes, since each six equilateral triangles can be presented as a single hexagon, the economy for molding, casting, painting and glazing tiles would have made craftsmen more inclined to create tiles of hexagonal shapes than triangular ones. The following are two examples of patterns that are created on the basis of regular tessellations. Even though the two patterns may appear to be the same to an untrained eye, as both include the same repeating twelve-pointed star polygons, they are very different in construction. Fig. 1a shows a pattern made from a square tile; Figure 1b shows a pattern made from a regular hexagon. Fig. 2 demonstrates the geometric constructions for each tiling illustrated in Fig. 1.

Nexus Netw J 14 (2012) 345–372
DOI 10.1007/s00004-012-0117-5; *published online* 5 June 2012
© 2012 Kim Williams Books, Turin

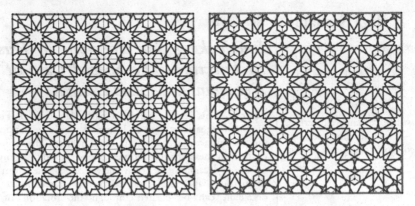

Fig. 1. a, left) Square-based twelve-pointed star tiling; b, right) Hexagonal-based twelve-pointed star tiling

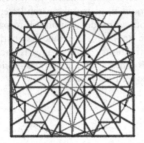
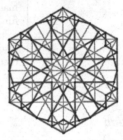

Fig. 2. a, left) Square-based twelve-pointed star tiling; b, right) Hexagonal-based twelve-pointed star tiling

A recent book on this subject illustrates step-by-step compass-straightedge constructions of tile patterns and is dedicated specifically to patterns derived from these two shapes, square and hexagon [Broug 2008].

After studying designs on existing structures of medieval Persia and similar buildings in neighboring regions, one may notice that some patterns cannot be based on either squares or regular hexagons; their underlying structure is based on a different set of angles. Many, if not all, of these patterns are based upon a ten-pointed star that results from the crossing of two regular pentagons.

2 Tiling with the decagram: a special case of the ten-pointed star polygon

Fig. 3 exhibits a method for creating a tiling design that is not based on previously mentioned regular tessellations [El-Said and Parman 1976]. In this method, the starting point is a (10, 3) star polygon – a figure created from connecting every third vertex in a set of ten equally spaced points on a circle in one direction in one stroke (the star inside the circle on the upper left corner of fig. 3). By extending some of the segments that constitute the (10, 3) star polygon and intersecting them with the lines perpendicular to some other segments, one achieves the construction of the rectangular frame and other necessary line segments inside the frame, as is illustrated in fig. 3. This rectangular tile tessellates the plane and creates a pleasing series of stars that are ordered in columns and in rows (fig. 4).

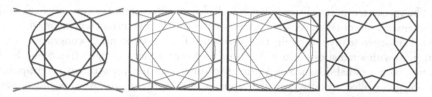

Fig. 3. Compass-straightedge construction of a decagram tile

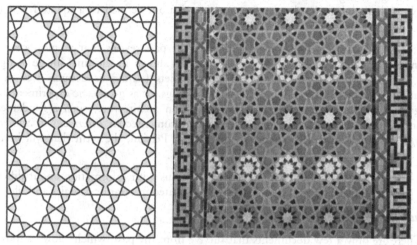

Fig. 4. a, left) A tessellation of the tile in fig. 3; b, right) Example of this tessellation on wall at Masjid-i-Jami, Kerman in Iran, executed in ceramic tile

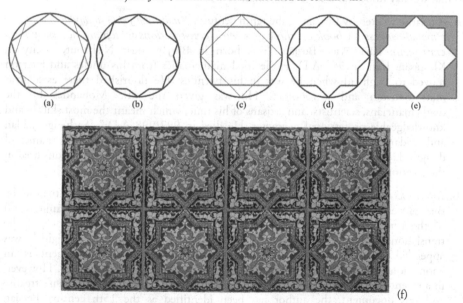

Fig. 5. a) Two concentric pentagons arranged at a 36° rotation from one another; b) the decagram that is thus generated; c) two concentric squares arranged at a 45° rotation from one another; d) the octagram that is thus generated; e) a square tile for the octagram-and-cross tessellation; f) an existing octagram-and-cross tessellation from a wall of Ark Karim Khan Zand in Shiraz, Iran

The special ten-pointed star polygon (called here a decagram for convenience), which is the visually dominant geometric shape of the tessellation presented in fig. 4, can be created independently through the rotation of two concentric congruent regular pentagons with a radial distance of 36° from each others' central angles (fig. 5a-b). Such a rotation with a radial distance of 45° for two squares creates the attractive eight-pointed star polygon (called an octagram) that appears in many geometric designs and tilings as one of the motifs in cross-octagram tessellations (fig. 5c-e). We may assume that creating a tile design using a decagram was a challenge for designers, compared to a less complicated, straightforward cross-octagram tessellation, defined in a square frame (fig. 5f).

Studying documents and monuments from the past reveals that in most cases the rectangular fundamental regions, similar to what is shown in the final image in fig. 3, were shapes recorded in scrolls (*tumār*) and booklets (*daftar*) as designs used in the execution of actual tilings on the surfaces of buildings, or as geometric experimentations using interlocking star-polygon patterns. In Persian architecture, such a fundamental region was called a knot: *aghd*, in Arabic, as is documented in *Interlocks of Similar or Complementary Figures* [Anonymous], or *girih*, in Persian, the term that will be used here.

The following resources from the past provide us with information about different girih patterns and their geometries, which were executed in ceramic mosaics and tiles.

3 Surviving historical documents

There are only a few documents that survive from the past, which allow us today to study the configuration of layouts of many interesting and intriguing ornamental designs so that we may understand their mathematics:

A. A treatise written by Būzjānī in the tenth century, *Kitāb fīmā yahtā ju ilayhi al-sāni' min a'māl al-handasa* (*A book on those geometric constructions which are necessary for a craftsman*): Abū'l-Wafā Būzjānī "was born in Būzjān, near Nishābur, a city in Khorāsān, Iran, in 940 A.D. He learned mathematics from his uncles and later on moved to Baghdad when he was in his twenties. He flourished there as a great mathematician and astronomer. He was given the title Mohandes by the mathematicians, scientists, and artisans of his time, which meant the most skillful and knowledgeable professional geometer. He died in 997/998 A.D." [Sarhangi, Jablan and Sazdanovic 2004: 282]. The treatise by Būzjānī does not include any ornamental designs. However, it presents a number of compass-straightedge constructions used in the creation of such designs [Özdural 2000].

B. *Interlocks of Similar or Complementary Figures* [Anonymous]. The treatise by Būzjānī was originally written in Arabic, the academic language of the Islamic world of the time, and was translated into Persian in several periods. In one of the translations, the aforementioned *Interlocks* treatise in its Persian original, was appended. Some researchers believe that the author of this document is an anonymous thirteenth- century mathematician/craftsman [Özdural 2000]. However, in a recent Persian book that includes a modern translations of both Būzjānī's treatise and this document, the author has been identified as the 15th century Persian mathematician Abūl-Es-hāgh Koobnāni [Jazbi 1997]. It is important to realize that *Interlocks* is the only known practical manual that provides "how-to" instructions for

drawing two-dimensional girih patterns (similar to the right image in fig. 3). According to G. Necipoğlu, "The treatise shows that the girih mode was conceived as a system of proportionally related geometric patterns harmoniously interlocking with one another" [1995: 133-135].

C. The *Topkapi Scroll*, a scroll close to thirty meters long and about a third of a meter high, is a document attributed to Persian artisans and architects, during the reign of Timurid dynasty in the fourteenth or fifteenth century. This scroll is preserved in the collection of the Topkapi Palace Museum in Turkey. The scroll provides a wealth of knowledge for creating designs for wall surfaces and vaults in architecture and ornaments of its time, documenting efforts by architects and craftsmen in the late medieval Persian world. Belonging to a period of tradition of scrolls in which geometric designs and patterns used for various architectural purposes were recorded next to each other without any distinction and explanation of the creation process, it consists of 114 patterns ready for use by architects to create the mosaic patterns in many structures. A book, *The Topkapi Scroll*, documenting this scroll was published in 1995 with general discussion and extensive commentary about each design [Necipoğlu 1995].

D. The *Tashkent Scrolls* (sixteenth-seventeenth century documents that present the works of master masons of the post-Timurid period) were first kept in the Bukhara Museum after their discovery and later transferred to the Institute of Oriental Studies in Tashkent, Uzbekistan. "At the time of their discovery the mode of geometric design codified in these fragmentary scrolls was identified as the girih by traditional Central Asian master builders who still used such scrolls. This term refers to the nodal points or vertices of the web-like geometric grid systems or construction lines used in generating variegated patterns…" [Necipoğlu 1995: 9]

E. The Mirza Akbar Collection held at the Victoria & Albert Museum, London. This collection consists of two architectural scrolls along with more than fifty designs that are mounted on cardboard. The collection was originally purchased in Tehran, Iran, in 1876 for the South Kensington Museum (the precursor of the Victoria & Albert Museum) by Sir Caspar Purdon Clarke, who was Director of the Art Museum (Division of the Victoria and Albert Museum) from 1896 to 1905. Purdon Clarke purchased them after the death of Mirza Akbar who had been the Persian state architect of his period. Although not as old as the *Topkapi Scroll*, they do show a continuation of the drafting scroll tradition that continued into the modern era. [Necipoğlu 1995]

To have a significant grasp of the ideas behind a large number of designs in the above scrolls, to see some of them on the walls of existing monumental buildings of the past, and deeply understand the process of creating such designs in a traditional approach, we need to refer to a useful five-volume book in Persian, *Construction and Execution of Design in Persian Mosaics* written and illustrated by M. Maheroannagsh [1984]:

Perhaps the most comprehensive and elegant recent book about Persian mosaics that includes geometric constructions of designs presented along with colorful images of their executions performed on different mediums on the wall, floor, interior and exterior of domes, doors and windows, and many more, is Construction and Execution of Design in Persian Mosaics. The author, who was a professional artisan, inherited his profession from his ancestors of several centuries, had the most access to original artisans' repertories of the past. The

ornamental qualities of these geometric constructions and their executions provide a joyful journey to the past for readers [Sarhangi, Jablan and Sazdanovic 2004: 282].

4 An interlocking decagram-polygon mosaic design

The existing tessellation on the wall of a Persian structure shown in fig. 6a includes a decagram motif as in the tiling shown in fig. 4. There are tiles of other shapes that constitute the tiling. In fact there are exactly five motifs (modules). fig. 6b presents these modules, which in Iran are called *muarraq*, an Arabic word. The Arabian-Andalusian word for these hand-cut pieces of glazed ceramic tiles is *zellij*. In this article they are called sāzeh (operative in Persian) module tiles.

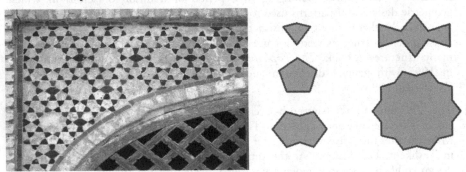

Fig. 6. a, left) Imamzeda Darb-i Islam, Isfahan in Iran; b, right) The five sāzeh module tiles.

These modules have their own specific Persian names: *Torange* (the quadrilateral tile), *Pange* (the pentagonal tile), *Shesh Band* (the concave octagonal tile), *Sormeh Dān* (the bow tie tile), and *Tabl* (decagram tile).

Comparing the two tessellations in figs. 4 and 6, one can see that, despite the fact that the individual sāzeh modules used in both tessellations are identical, they are very different tessellations.

The following solution for the geometric construction of the tiling in fig. 6, with a few minor revisions in the process, comes from the mosaic designer M. Maheroannaqsh [1984]. Please note that the division of a right angle into five congruent angles is not a part of the instructions provided, because it is considered an elementary step for designers. Interested readers who wish to learn about this division may read the construction technique for a regular decagon in [Sarhangi 1999] or search online.

Divide the right angle ∠A into five congruent angles by creating four rays that emanate from A. Choose an arbitrary point C on the second ray, counter-clockwise, and drop perpendiculars from C to the sides of angle ∠A. This results in the rectangle ABCD along with four segments inside this rectangle, each having one endpoint at A and whose other endpoints are the intersections of the four rays with the two sides of CB and CD of rectangle ABCD. Find E, the midpoint of the fourth segment created from the fourth ray. Construct an arc with center A and radius AE to meet AB on F and the second ray on G (the second segment is now part of the diagonal of the rectangle). Make a line, parallel to AD, passing through G, that intersects the first ray at H and the third ray at I. Line FH passes through point E and meets the third ray at L and line AD at J. Construct a line, passing through J, that parallels the third ray. Also construct line EI

and find M, the intersection of this line with AD. From F make a parallel line to the third ray to meet the first ray at K. Construct segments GK, GL, and EM. Find N such that GI = IN by constructing a circle with center I and radius IG. Construct the line DN (which happens to be parallel to GK), to intersect the line emanate from J, to find P to complete the regular pentagon EINPJ. Line DN meets the perpendicular bisector of AB at Q. From Q construct a line parallel to FK to intersect ray MI at R and then complete the figure (fig. 7a). Using O, the center of the rectangle ABCD, as a center of rotation for 180°, one can make the fundamental region for the tiling in fig. 6 (fig. 7b). Figs. 7c, d show the motif and its tessellation for this girih.

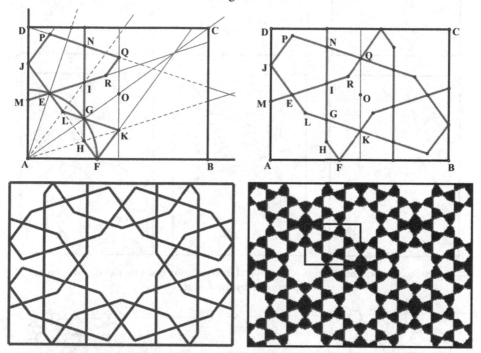

Fig. 7. Compass-straightedge construction of the mosaic design in fig. 6

5 Three compass-straightedge related interlocking pattern construction methods

5.1. The radial grid method

The construction method in fig. 7, which uses a radial grid approach, as a method used in medieval times, is supported by some images along with their construction details and instructions, recorded in the *Interlocks of Similar or Complementary Figures* [Anonymous].

Fig. 8, created by the author, shows another example for radial grid method. It shows a step-by-step construction of a girih for a ten-pointed star design and its tessellation. To follow the construction comfortably the points are labeled in alphabetic order according to their appearance in the construction. The first step, as in the previous construction in section 4, is the division of a right angle into five and then the selection of an arbitrary point C on a ray (now on the third ray). The first few points are found as intersections of the rays emanating from the right angle ∠A, the rays emanating from the opposite right angle ∠C, and the diagonal BD.

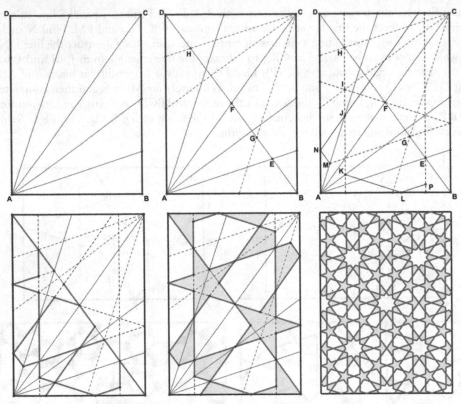

Fig. 8. Step-by-step construction of a girih and its tessellation based on radial grid approach performed by the author

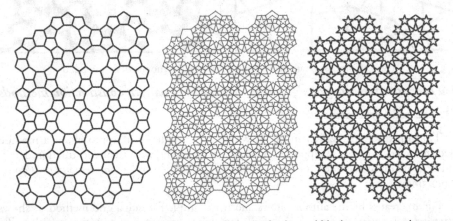

Fig. 9. a, left) A pattern created from laying three types of polygonal blocks, pentagons, hexagons, and decagons, edge-to-edge; b, center) using the midpoints of the sides of the polygons to create segments and properly decorate the tiles; c, right) discarding the block lines to exhibit the final pattern

5.2. The polygons in contact method

E. H. Hankin [1925] introduced another technique called "polygons in contact" (PIC), which is explained in recent articles [Bonner 2003; Kaplan 2005; Cromwell 2009; Bodner 2009]. This is another system for which there is evidence of historical use by designers [Bonner 2003]. Fig. 9 from left to right, exhibits this technique starting from the underlying polygonal network and ending in the final pattern, which is the same pattern in shown in fig. 8.

5.3. A method based on the (n, k) star polygons

Following [El-Said and Parman 1976] one may construct the same pattern using the technique introduced in fig. 3, which is based on the use of (10, 3) star polygon and extensions of some of its sides (fig. 10).

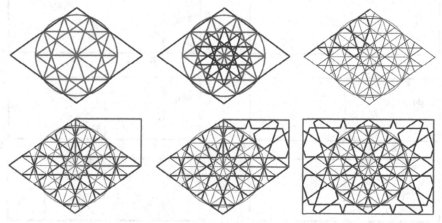

Fig. 10. The construction of girih for the tessellation in figs. 8 and 9 using the extensions of the lines that constitute the (10, 3) star polygon

6 A tessellation from Mirza Akbar architectural scrolls and its construction

The two different tessellations in figs. 4 and 6, each made from the same set of sāzeh modules, raise the question: Are there other tessellations that can be made from the same decagram and its interlocking polygons?

The image in fig. 11 is an exact rendering of a design illustrated in the Mirza Akbar collection [also see Bovill, 2012]. In this tessellation, the decagrams are farther apart from each other. Using the steps involved in the construction of the design in section 4, we can find a traditional radial solution for the tessellation in fig. 11.

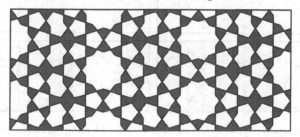

Fig. 11. A tessellation from the Mirza Akbar collection

It is not difficult to discover that the fundamental rectangle for this tilling has a longer length compared to the rectangle in fig. 7. So, starting with the radials that divide the right angle into five congruent angles, the arbitrary point P was selected on the first ray counterclockwise (rather the second ray in the previous problem). For the radius of the circle inscribed in the decagram one half of the segment created from the third ray, segment AM, was selected (unlike the fourth ray in the previous construction). Then a similar approach was taken to create the tiling in fig. 12. The following figure illustrates a step-by-step compass-straightedge visual solution to the problem by the author. Fig. 13 illustrates another approach, which is presented by El-Said and Parman [1976], for creating the same tiling as in fig. 12. The starting point is again a (10, 3) star polygon but with new extensions as illustrated in this figure.

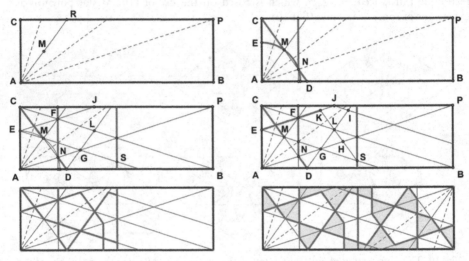

Fig. 12. Step-by-step compass-straightedge construction of the tessellation in fig. 11 as a visual solution to the problem solved by the author

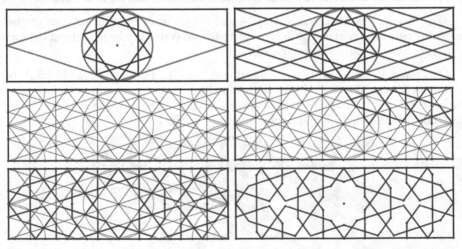

Fig. 13. The construction of girih for the tessellation in fig. 11 using the extensions of the lines that constitute the (10, 3) star polygon

7 Square girih for constructing an interlocking tessellation

Selecting an arbitrary point on any of the rays that divide the right angle into five congruent angles and dropping perpendiculars to the sides of the right angle from that point results in only two types of rectangles of different proportions:

- Selecting the arbitrary point C on the first ray and dropping the two perpendiculars BC and CD to the sides of right angle $\angle A$ results in the rectangle ABCD (fig. 14a), where the relationship between its diagonal AC and side BC is $AC/BC = 2\phi = 1+\sqrt{5}$, where ϕ is the Golden Ratio. Therefore, $AB/BC = \sqrt{5+2\sqrt{5}}$.

- Selecting the arbitrary point F on the second ray will result in the rectangle AEFG (fig. 14a), which is the Golden Rectangle: $AE/EF = \phi$.

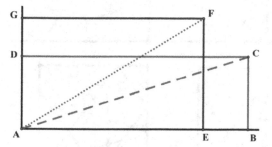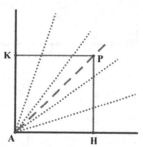

Fig. 14. The possible rectangles and square for girih construction based on the radial grid created from the division of a right angle into five

Now the question is whether using the same technique as mentioned above, are we able to come up with a new pattern composed from all five sāzeh modules in fig. 6b but now based on a square shape girih?

Obviously, none of the rays that divide $\angle A$ into five congruent angles helps directly. Choosing P as an arbitrary point on the angle bisector of $\angle A$ and constructing square AHPK cannot help us either (fig. 14b). Nevertheless, we are able to obtain a solution if we start with an arc with center A and an arbitrary radius. This arc cuts the sides of the right angle and the four rays at certain points that are used to find a solution. Following images in fig. 15, starting from the upper left and ending at the lower right, demonstrates a step-by-step solution by the author to this problem.

Fig. 16 is a tessellation that is created from the five sāzeh modules using the square girih in fig. 15. This artwork was exhibited at the 2012 Bridges Mathematical Art Exhibition at Towson University, Maryland, USA [Fathauer and Selikoff 2012].

Adding the tiling girih in fig. 15 to the previously mentioned girihs that are illustrated in figs. 4, 7, and 11, makes a set of four different mosaic patterns, each made from the aforementioned five sāzeh modules.

A curious reader may want to know whether more tessellations can be formed from this set of modules. The same curiosity may prompted the craftsmen-mathematicians of the past to look for new solutions that are not necessarily, at least in part, based on the compass-straightedge constructions.

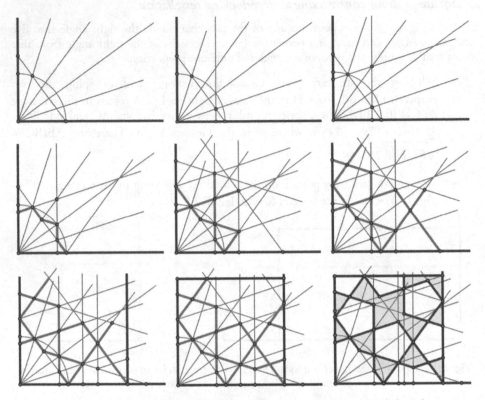

Fig. 15. Step-by-step compass-straightedge construction of a square shape girih for a decagram interlocking pattern as a visual solution to the problem solved by the author

Fig.16. *Dah Par I* (September 2011) by the author, Bridges Mathematical Art Exhibition, Towson University, Maryland, USA, 2012 [Fathauer and Selikoff 2012]

8 A modularity approach to mosaic designs

Figs. 5d-e present the way the design for a cross-octagram tessellation can be constructed. However, to tessellate the plane using actual tiles there are two different approaches:

- Use fig. 5e as an actual tile and tessellate the plane using this tile (fig. 5f). We call such a tile a girih tile (that is, one decorated with lines that form the layout of a tessellation). The expression "girih tiles" was used in [Lu and Steinhardt, 2007]. to indicate the tiles that create the layout of a decagram interlocking pattern. Here it is adopted to generalize the idea to include more cases;

- Make two separate modules of the cross and octagram. Then cut the tiles based on these two modules (fig. 17). This is what we call the sāzeh modules for this tessellation.

Fig. 17. Two individual sāzeh modules, cross and octagram, and photograph from a tiling in the Istanbul Archaeological Museum (photograph by author, August 2010)

This means it is possible (and indeed it has been a common practice) to find the layout of a tessellation using some tiles (girih tiles) but then use individual cut sāzeh tiles that are not necessarily the same as the girih tiles to tessellate. Fig. 18 shows the hand-cut pieces of glazed ceramic tiles, *zellij*, that are ready to be used for different tiling patterns in a market in Morocco. Each individual sāzeh tile (called "tesserae" in some literature) is cut and shaped from larger square-shaped colored and glazed tiles.

Fig. 18. Bags of individually cut sāzeh tiles(zellij in Arabian-Andalusian), Fez, Morocco. Source: Peter Sanders] Saudi Aramco World/SAWDIA

Modularity offers a method for creating the layout of a tessellation (that is, for conceptualizing but not necessarily making the individual actual tiles that compose the final tiling). The following sections demonstrate two ways the modularity technique has been employed to create the layout of mosaic patterns in contrast to the classical compass-straightedge method.

The modularity approach has been suggested as the means used in ancient cultures as old as the Paleolithic period as proposed by Slavik Jablan in his paper "Modularity in Art" [1980], which also appears as the last chapter of his book *Symmetry, Ornament and Modularity* [2002]. The possible use of modular tiles for creating the layouts of patterns in medieval Persia and surrounding areas was discussed in [Sarhangi, Jablan and Sazdanovic 2004 and Sarhangi 2008], where the authors also introduced gaps and overlaps as a tool for creating modular patterns. In recent years, several interesting and informative articles have appeared with more complex systems of modules discussed below.

8.1 Modularity based on color contrast

Fig. 19 shows *Kharragan I* (January 2011) an artwork based on a design from one of the eleventh-century tomb towers in Kharraqan, western Iran [Sarhangi 2010; Bier 2002; Bier 2012]. The artwork demonstrates two different approaches that are assumed to have been utilized centuries ago to create the layout of the pattern that appears in the center of the artwork. From left to right, the artwork exhibits the construction of the design based on a compass-straightedge construction (fig. 20). From right to left, we see another approach, the modularity method based on color contrast, to construct the same design using cutting and pasting of tiles in two colors (fig. 21). These two methods of constructions were presented at "A Workshop in Geometric Constructions of Mosaic Designs" during the 2010 Bridges Conference, Pécs, Hungary [Sarhangi 2010].

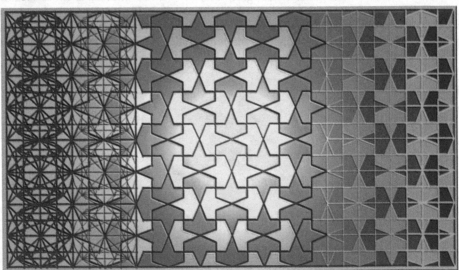

Fig. 19. *Kharragan I* (January 2011) by the author, Bridges Mathematical Art Exhibition, Coimbra University, Portugal, 2011 [Fathauer and Selikoff 2011]

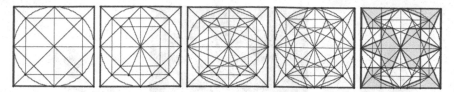

Fig. 20. Polygon construction approach for generating the grid for the "hat" tiling

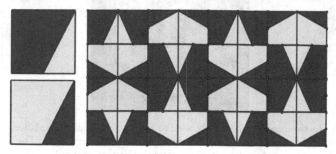

Fig. 21. Modularity approach for the "hat" tiling

The photograph shown in fig. 22 was taken by the author from an actual tiling in the entrance floor of the Enderun Library in the Topkapi Palace Museum. From the actual tile it is not possible to discover whether the layout has been formed by a compass-straightedge method (fig. 20) or the modularity approach (fig. 21). However, the color contrast in the actual tiling suggests the latter.

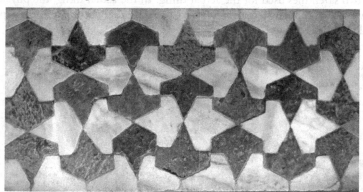

Fig. 22. A photograph of entrance floor of the Enderun Library in Topkapi Palace, Istanbul, Turkey

8.2. Modularity based on motifs formed from the combination of polygons

Fig. 23b shows *Hope* (December 2008), an artwork by the author [Akleman 2009], based on the modularity concept using two triangles, each composed from smaller triangles and rhombuses in three colors. The actual tiling adorns a wall of Bibi Zinab Mausoleum in Isfahan, Iran [Maheroannagsh 1984]. Notice that in fig. 23a, except for the diamonds in outermost vertices, the two compound triangles (girih modules) are in opposite colors. Using these two girih modules in a rotational fashion, results in the pattern in this artwork (fig. 23b). To make an actual tiling for this pattern a craftsman might use the cut sāzeh tiles illustrated in fig. 23c.

Fig. 23. a, left) The two modules that can be used to find the layout of a tessellation; b, center) The tessellation *Hope* (December 2008), made from these two modules; c, right) The sāzeh tiles that may have been used to create this pattern on a wall

Fig. 24b shows *Together* (November 2008) [Akleman 2009], another artwork based on the modularity concept using one single triangle, formed from smaller triangles and rhombuses in three colors; however, the number of required colors to make the tiling is two. The actual tiling of this pattern appears on a wall of Jāme Mosque in Natanz, Iran [Maheroannagsh 1984]. Fig. 24a is the girih module for finding the design. Fig. 24c shows the two sāzeh tiles used for the actual tiling. In the actual tiling, the physical copies of these two sāzeh modules have been set next to each other with a uniform gap between them filled by mortar.

Fig. 24. a, left) The girih module used to find the layout of a tessellation; b, center) "Together" (November 2008); c, right) The sāzeh tiles that were used to execute this pattern

9 Modularity in interlocking star polygon mosaic designs

Jay Bonner [2003] has described several polygonal systems that generate Islamic geometric patterns using the polygons in contact technique]. The polygonal elements

within these systems have associated patterns with lines that Bonner describes as having historical precedent. The variety of five-fold design represented in the mosaic patterns described herein uses the decagram and have 72°, 108°, 72°, 108° angles at each pattern vertex. This has been identified by Bonner as the medium pattern family. Within the five-fold System, medium patterns have 72° crossing pattern lines placed upon the midpoints of each edge of the repetitive module. fig. 25a illustrates the ten polygonal modules that form the five-fold system.

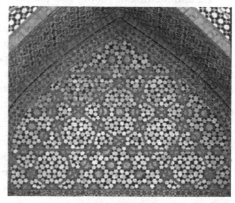

Fig. 25. a, above) The five-fold system;
b, right) Darb-i Imam, Isfahan

Looking at fig. 25b (Darb-i Imam, Isfahan) Bonner noticed a set of lines that connect the centers of decagrams to form other tessellations with larger composite tiles (For the readers of this article these lines have been made bold to be more visible). Bonner used this figure to introduce self-similarity and introduced the term "sub-grid" to explain medieval Persian mosaic designs.

An informative book that appeared in recent years about mosaic designs in their historical context is *The Topkapi Scroll* [Necipoğlu 1995], which reproduces in facsimile at half-scale all of the images illustrated on the scroll. Bonner used image no. 28 from the scroll (fig. 26) as another example for the five-fold self-similar Type A:

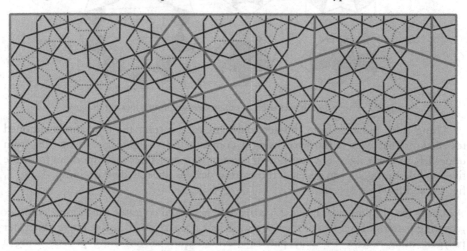

Fig. 26. A rendering of image no. 28 in the Topkapi Scroll

Pattern 28 in the Topkapi scroll is a 5-fold self-similar Type A design that also depicts the underlying polygonal sub-grid used in the creation of the secondary design.... That this very particular technique was used historically is confirmed in the Topkapi scroll. Pattern no. 28 from this scroll makes use of small red dots to distinguish the underlying polygonal sub-grid of the secondary pattern [Bonner 2003].

Lu and Steinhardt [2007] also noticed these red dotted lines and proposed that they illustrate a new set of tiles, where the black solid lines decorate these new tiles (fig. 27). They realized that this new set could be used as a set of modules, similar to the modules that were presented in the previous section, but now in more complex and fascinating forms, for finding new interlocking star polygon patterns. This would eliminate the difficulties involved in compass-straightedge constructions and, in fact, opens the door to creating many more interesting mosaic patterns. Lu and Steinhardt named this new set girih tiles, the name adopted in this paper for the modules that form the layout of a mosaic tiling.

The edge-to-edge modular methodology that Lu and Steinhardt propose corresponds to five of the medium family design modules from the five-fold system presented in [Bonner 2003] that are illustrated in an earlier work, an unpublished manuscript by Bonner [2000]. Lu and Steinhardt posit that,

... by 1200 C.E. there was an important breakthrough in Islamic mathematics and design; the discovery of an entirely new way to conceptualize and construct girih line patterns as decorated tessellations using a set of five tile types, which we call 'girih tiles'. Each girih tile is decorated with lines and is sufficiently simple to be drawn using only mathematical tools documented in medieval Islamic sources. By laying the tiles edge-to-edge, the decorating lines connect to form a continuous network across the entire tiling [Lu and Steinhardt 2007: 1106].

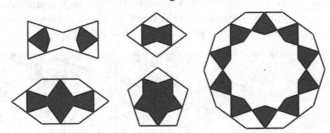

Fig. 27. The five girih tiles used to create decagram interlocking designs

Using three modules from this set enable us to construct the four aforementioned tessellations that were constructed using a compass and straightedge. In fig. 28, from upper left to lower right, one sees how the composition of three girih modules from the five modules in fig. 27 can generate the pattern designs illustrated above in fig. 4, fig. 7, fig. 11, and fig. 15, respectively.

Using the girih modules in fig. 27, a tile designer could compose much more complex repeating patterns. Even two of them are sufficient to make an attractive interlocking star polygon tiling, where the same pattern would require a very long process using a compass-straightedge construction (fig. 29).

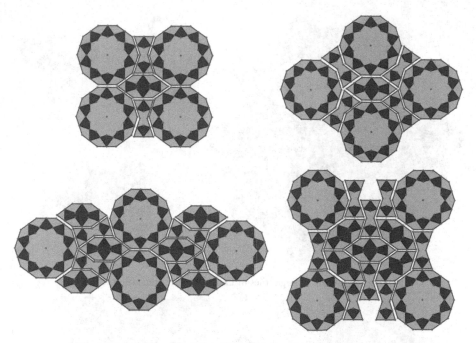

Fig. 28. A modular approach to constructing aforementioned patterns

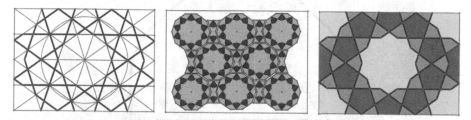

Fig. 29. Compass-straightedge method (a, left) and modular approach (b, center) for creating a pattern (c)

The design in fig. 25b is highly complex and much more complicated than the four tessellations in fig. 28. However, using the girih tiles set, one can construct it much more conveniently and quickly than by employing a compass and straightedge. Fig. 30 shows how one can construct the larger tessellation tiles on the Darb-i Imam using the three girih tiles used in fig. 28. Then the execution of the entire tessellation on a wall using hand-cut sāzeh tiles would be only a matter of time.

It is interesting to note that the larger tessellation on the Darb-i Imam in fig. 25b is indeed a part of the tiling created from the two girih modules of decagon and non-convex hexagon used in the tilling image in fig. 29. Fig. 31 illustrates this tessellation and the part that has been used in Darb-i Imam.

Fig. 30. Details of larger tiles in Darb-i Imam using girih tiles

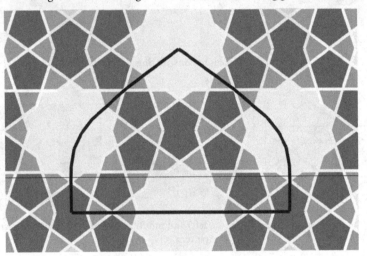

Fig. 31. The larger tessellation at Darb-i Imam in relation to the pattern in fig. 29

10 Quasi-periodic interlocking star polygon designs

A periodic tiling is one in which the image of the tiling under an appropriate translation based on some vectors coincides with the original one without using rotational or reflective symmetries (the tiling should be invariant under translations by vectors in a two-dimensional lattice). Fig. 32a is the hat tiling that is formed from the two modules in fig. 21. If the tessellation translates so that the image of A under this translation coincides with B, then the entire image of this tessellation will coincide with the original. The same property exists if the tessellation translates under vector AC. Therefore, fig. 32a demonstrates a periodic tiling.

A non-periodic tiling is a tiling that does not follow the rule of periodicity. Consider, for example, the same two hat modules shown in fig. 21 arranged randomly to tile the plane. This simple rule, as stated above, generates a tiling that is non-periodic (fig. 32b).

Fig. 32. A periodic tiling (a, left) and a non-periodic tilling (b, right) obtained from the hat modules

The four tessellations in fig. 28 offer further examples. Each is a periodic pattern, which may be compared to the decagon in fig. 30 that can be expanded in all directions as a non-periodic tiling. Note that each of these tilings, the four illustrated in fig. 28 and the expanded decagon shown in fig. 30, are made using the same three girih modules, comprising the decagon and two hexagons in fig. 27.

An interesting question in this regard that appeared in mathematics literature of 1960s was: "Are there sets of tiles that tessellate the plane only non-periodically?" [Gardner 1977].

A quasi-periodic, or aperiodic, tiling is one generated from a quasi-periodic set of tiles, a set that tessellate the plane only non-periodically. Mathematically speaking, a tiling of the plane is aperiodic if and only if it consists of copies of a finite set of tiles that only produce non-periodic tilings. So the above question can be rephrased as: "Does a set of aperiodic tiles exist?"

In 1961 the logician and mathematician Hao Wang claimed that any set of tiles that can tile the plane non-periodically can tile it periodically as well (that is, a set of quasi-periodic tiles does not exist). Robert Berge, a student of Wang, using Wang dominos, the tiles that were invented by Wang, showed that Wang's conjecture is not correct. He discovered that there is a set of Wang dominoes that tiles only non-periodically. Berger constructed such a set, using more than 20,000 dominoes. Later he found a much smaller set of 104; Donald Knuth was able to reduce the number to 92. Karel Culik discovered a set of 13 tiles that can tile the plane, but only non-periodically. Robinson constructed six tiles that force non-periodicity. In 1977 Robert Ammann found a different set of six tiles that also force non-periodicity [Gardner 1977].

In 1973 the mathematical physicist Roger Penrose found a quasi-periodic set of six tiles: "In 1974 he found a way to reduce them to four. Soon afterward he lowered them to two" [Gardner 1977]. The two tiles that he discovered, called "kite" and "dart," can only tessellate non-periodically (fig. 33b). These two tiles form a rhombus that is the wing of a five-folded star that can be constructed using the (10, 3) star polygon (fig. 33a). In order to tile aperiodically using kites and darts one should also connect the arcs of the same color printed on the tiles properly to create continuous curves (closed or open). The

curves prevent the two tiles from forming a rhombus. John H. Conway found that a set of aperiodic tiles (Ace, Short bow tie, and Long bow tie) that are made from the Penrose tiles, can tessellate the plane in a faster and more stable fashion (fig. 33c) [Gardner 1977].

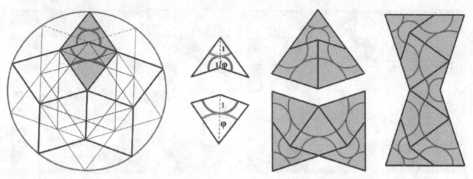

Fig. 33. a, left) The kite and dart in a five-pointed star; b, center) The tiles with printed curves that are in the proportions of $1/\phi$, 1, and ϕ, where ϕ is the Golden ratio;
c, right) The new set of non-periodic tiles suggested by Conway

It can be proven that one needs ϕ times as many kites as darts in an infinite Penrose tiling. But ϕ as the ratio of the number of kites over the number of darts is an irrational number. This irrationality is the basis for a proof by Penrose that the tiling is nonperiodic: If the Penrose tiling were periodic, then the ratio of kites to darts would have to be rational.

Fig. 34a shows a Penrose tiling created from kites and darts of a certain size. Fig. 34b shows how one can use the vertices of the previous tiling to generate a new tiling with larger darts and kites, a phenomenon called inflation. One can continue forming new tilings using inflation with each new generation of tiles larger than the previous iteration. Deflation is the reverse process of inflation. Using inflation one can prove that the number of Penrose tiling is uncountable.

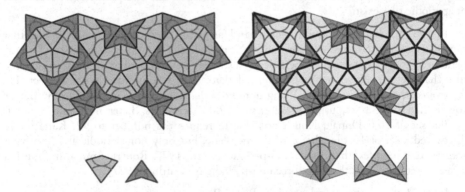

Fig. 34. a, left) A Penrose tiling; b, right) The inflation

A Penrose tiling has many remarkable properties, most notably:

- It is non-periodic, which means that it lacks any translational symmetry. Stated more informally, a shifted copy will never match the original;

- It is self-similar, so the same patterns occur at larger and larger scales. Thus, the tiling can be obtained through "inflation" (or "deflation") and any finite patch from the tiling occurs infinitely many times;

- It is a quasi-crystal: implemented as a physical structure a Penrose tiling will produce Bragg diffraction and its diffractogram reveals both the fivefold symmetry and the underlying long range order [Wikipedia].

The five-pointed star in fig. 33 has been used in Persian architectural designs on the wall and on the dome interiors [Sarhangi 1999]. Fig. 35a shows this star as an actual tiling. Fig. 35b shows the compass-straightedge details of the construction that exhibits a subdivision rule for creating self-similar smaller generation of stars [Sarhangi 1999].

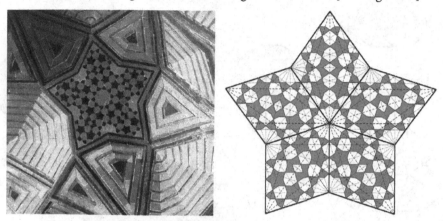

Fig. 35. An actual tiling for star in fig. 33a and the details of its construction

Emil Makovicky, a crystallographer, was among the earliest individuals who studied mosaic designs on Persian architecture to recognize the existence of quasi-crystalline patterns [Makovicky 1992]. He studied the Gonbad-e Qabud in Maragha, Iran [Bier 2012]. This decagonal Seljuk building of the late twelfth century has attracted the attention of many mathematicians and designers in recent years. For his course of study, Makovicky considered three tiles that he named "Maragha-type" tiles: pentagons, butterflies, and rhombuses with marked acute vertices.

To study the quasi-crystalline properties of some Persian structures based on the set of compounded tiles created by Conway shown in fig. 33c, Lu and Steinhardt proposed three new tiles that resemble the three aforementioned girih tiles in fig. 27 (fig. 36a). These new three tiles generate aperiodic tilings; nevertheless, considering the decorations on each tile, which are Penrose curves, they are different in nature from the three girih tiles in fig. 27, as they possess fewer symmetries. For this set (and not the set that constitute the Penrose kite and dart) we can tessellate the plane using ten-fold rotational symmetry (fig. 36b). In this fashion it is reasonable to accept that we are able to expand the cartwheel in fig. 36 to a bigger structure to construct the decagon in fig. 30 (without considering the decorations on the individual tiles) and continue to infinity. We may also choose an opposite approach in this regard: we start with a decagon and subdivide it based on the rules exhibited visually in fig. 30 and then replace the small girih tiles inside of the decagon in fig. 30 with the tiles in fig. 36a and continue this process indefinitely. This pattern that is generated from the quasi-periodic tiles in fig. 36a is a quasi-crystalline

pattern with respect to the original Penrose kites and darts. Lu and Steinhardt showed that considering the tiles in fig. 36a as units, this subdivision process, using the matrix notation, can be expressed as a matrix that exhibits the frequencies of appearance of the three tiles in each step of subdivision. The eigenvalues of this matrix, which represent the ratio of tile frequencies in the limit of an infinite subdivision process, are irrational, indicating that the pattern is not periodic. Therefore the pattern generated from this subdivision is quasi-periodic if we use the three tiles in fig. 36a, and is non-periodic if we exchange these three tiles with their correspondence girih tiles in fig. 27.

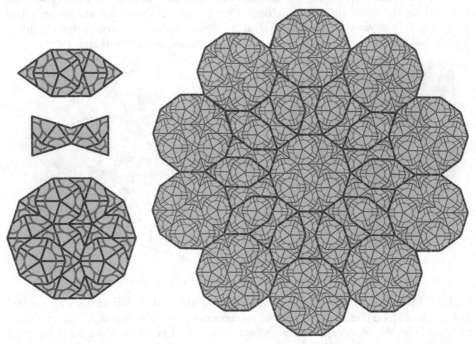

Fig. 36. a, left) The three tiles made from kites and darts that resemble the three girih tiles; b, right) The start of edge-to-edge construction of a cartwheel that resembles the decagon in fig. 30

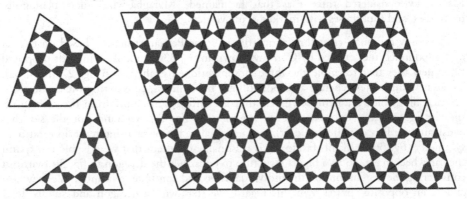

Fig. 37. a, left) Rigby kite and dart; b, right) A periodic pattern formed by Rigby tiles

To generate non-periodic mosaic patterns, Jean-Marc Castera created a set of four decorated module tiles [Castera 2003], and later introduced more decorated tiles in this regard.

In 2006, in an independent effort for making Penrose interlocking star polygons, John Rigby [2006] proposed a way to cover the surface of kites and darts with appropriate patterns to obtain a set of sāzeh tiles to generate various interlocking patterns (fig. 37a). The patterns that decorate these two tiles are not in an equivalent class of symmetries with the Penrose curves. This is due to the fact that the Rigby tiles can tessellate the plane periodically because the kites and darts can form rhombuses (fig. 37b). Nevertheless if we avoid forming any rhombuses in a Rigby tiling then the pattern will be non-periodic.

As described above, it is important to emphasize that the Penrose tiles cannot produce either global or local ten-fold rotational symmetry. They only yield five-fold symmetries. There are uncountably many Penrose tilings. Even though a Penrose tile has infinite centers of local five-fold rotational symmetry, none has global five -fold rotational symmetry, with two exceptions. The two tessellations that have perfect global five -fold rotational symmetry are called "Sun" and "Star" (fig. 38). These two tessellations are the dual of each other in the sense that one is the inflation of the other.

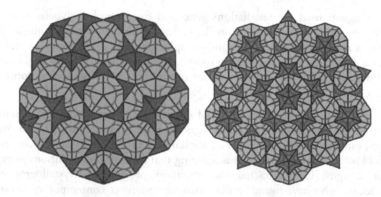

Fig. 38. left) Penrose Sun; right) Penrose Star

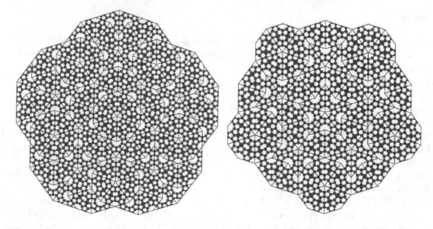

Fig. 39. Penrose Sun and Star with Rigby kites and darts

Fig. 39 shows the Penrose Sun and Star where we use Rigby kites and darts for their formations. Looking at the Sun in fig. 39a, an observer notices a striking similarities between the center of the cartwheel in fig. 30a that can be expanded as a perfect non-periodic (but not quasi-periodic) pattern holding a ten-fold rotational symmetry, and the center of the Sun in fig. 39a, which is modeled based on a quasi-crystalline pattern with perfect five-fold rotational symmetry.

Conclusion

Medieval Persian artisans, architects, and mathematicians must have had a relatively strong background in geometry to manifest their findings not only in the structures of domes and buildings, but also in the designs and patterns that adorn the walls of these structures.

It seems that some of the earlier geometric designs found in ancient times have been created through trial and error combinations of cut-tile pieces. This technique is called modularity in some literature including this article.

Later, as the center of knowledge moved from Greece and Byzantine to the East, Persians used compass-straightedge extensively to create geometric patterns. The few treatises and scrolls that have come down from the past exhibit this point clearly.

Later, designers used the tessellations generated from simple polygons as a base for constructing exquisite mosaic designs on them. Soon after that, the combination of their knowledge in modularity and in creating complex patterns using compass-straightedge resulted in a new level of the modularity method, which generated many highly complex and elegant designs that are difficult, if not impossible, to execute using compass and straightedge alone.

Looking at these designs on the walls of existing structures and historical scrolls one may come to the conclusion that the designers of the past were looking to maximize symmetries, especially local and global rotational symmetries, and in particular, five-fold and ten-fold rotational symmetries. It is amazing that some of their solutions as expressed in mosaic designs, have attracted the attention of modern crystallographers and mathematicians, who have found similar patterns to answer contemporary questions in modern mathematics.

References

AKLEMAN, E. 2009. *Bridges Banff Art Exhibition Catalog*. Phoenix: Tessellations Publishing.

ANONYMOUS. *Interlocks of Similar or Complementary Figures*. Ms. ancien fonds. Persan 169, ff. 180r-199v. Paris: Bibliothéque Nationale.

BIER, C. 2002. Geometric Patterns and the Interpretation of Meaning: Two Monuments in Iran. Pp. 67-78 in *2002 Bridges Proceedings*. Kansas: Central Plains Book Manufacturing.

———. 2012. The Decagonal Tomb Tower at Maragha and Its Architectural Context: Along the Lines of Mathematical Thought, *Nexus Network Journal* 14, 2.

BODNER, B. L. 2009. The Unique Eleven-Pointed Star Polygon Design of the Topkapı Scroll. Pp. 147-154 in *Bridges International Conference Proceedings*, G. Kaplan and R. Sarhangi, eds, London: Tarquin.

BONNER, J. 2000. *Islamic Geometric Patterns: Their Historical Development and Traditional Methods of Derivation*. Unpublished.

———. 2003. Three traditions of self-similarity in fourteenth and fifteenth century Islamic geometric ornament. Pp. 1-12 in *Proceedings of the ISMA/Bridges: Mathematical Connections in Art, Music, and Science*, R. Sarhangi and N. Friedman, eds. Granada, Spain.

BOVILL, C. 2012. Using Christopher Alexander's Fifteen Properties of Art and Nature to Visually Compare and Contrast the Tessellations of Mirza Akbar. *Nexus Network Journal* 14, 2.

BROUG, Eric. 2008. *Islamic Geometric Patterns*. London: Thames and Hudson.

CASTERA, Jean-Marc. 2003. Play with Infinity. Pp. 189-196 in *Proceedings of the ISAMA/Bridges: Mathematical Connections in Art, Music, and Science*, R. Sarhangi and N. Friedman, eds. Granada, Spain.

CROMWELL, P.R. 2009. The search for quasi-periodicity in Islamic 5-fold ornament. *The Mathematical Intelligencer* 31, 1: 36-56.

EL-SAID I. and A. PARMAN. 1976. *Geometric Concepts in Islamic Art*. London: World of Islam Festival Publishing Company.

FATHAUER R. and Nathan SELIKOFF, eds. 2012. *Bridges International Conference Art Exhibition Catalog 2012*. Tessellations Publishing.

FATHAUER R. and Nathan Selikoff, eds. 2011. *Bridges International Conference Art Exhibition Catalog 2011*. Tessellations Publishing.

GARDNER, M. 1977. *Pentose Tiles to Trapdoor Ciphers*. Washington, D.C.: Mathematical Association of America.

HANKIN, E. H. 1925. *The Drawing of Geometric Patterns in Saracenic Art*. Memoires of the Archaeological Society of India, vVol. 15. Calcutta: Government of India.

JABLAN, S. V. 2002. *Symmetry, Ornament and Modularity*. Singapore: World Scientific.

———. 1980. Modularity in Art. http://modularity.tripodcom/osn.htm.

JAZBI, S. A., trans. and ed. 1997. *Abul-Wafa Muhammad Buzjani: Applied Geometry*. Tehran: Soroush Publications. (Translation with additions)

KAPLAN, C. S. 2005. Islamic star patterns from polygons in contact. Pp. 177-186 in *Graphics Interface 2005*. ACM International Conference Proceedings Series 112.

LU, P. J. and STEINHARDT, P. J. 2007. Decagonal and quasi-crystalline tilings in medieval Islamic architecture. *Science* 315: 1106-1110.

MAHERONNAQSH, M. 1984. *Design and Execution in Persian Ceramics*. Tehran: Reza Abbasi Museum Press.

MAKOVICKY, E. 1992. 800-Year-Old Pentagonal Tiling from Maragha, Iran, and The New Varieties of Aperiodic Tiling It Inspired. Pp. 67-86 in *Fivefold Symmetry*, I. Hargittai, ed. Singapore: World Scientific.

NECIPOĞLU, G., *The Topkapi Scroll: Geometry and Ornament in Islamic Architecture*. Santa Monica, CA: Getty Center Publications.

ÖZDURAL, A. 2000. Mathematics and Arts: Connections between Theory and Practice in the Medieval Islamic World. *Historia Mathematica* 27: 171-301.

RIGBY, J. 2006. Creating Penrose-type Islamic Interlacing Patterns. Pp. 41-48 in *Bridges International Conference Proceedings*, Reza Sarhangi and John Sharp, eds. London.

SARHANGI, R. 2010. A Workshop in Geometric Constructions of Mosaic Design. Pp. 533-540 in *Bridges Proceedings*. Tessellations Publishing.

———. 2008. Modules and Modularity in Mosaic Patterns. *Journal of the Symmetrion* 19, 2-3: 153-163.

———. 1999. The Sky Within: Mathematical Aesthetics of Persian Dome Interiors. *Nexus Network Journal* 1: 87-97.

SARHANGI, R., S. JABLAN, and R. SAZDANOVIC. 2004. Modularity in Medieval Persian Mosaics: Textual, Empirical, Analytical, and Theoretical Considerations. Pp. 281-292 in *Bridges International Conference Proceedings*, R. Sarhangi, ed. Winfield, KS.

[Wikipedia] Penrose tiling. http://en.wikipedia.org/wiki/Penrose_tiling.

About the author

Reza Sarhangi is a professor of mathematics at Towson University, Maryland, USA. He teaches graduate courses in the study of patterns and mathematical designs, and supervises student research projects in this field. He is the founder and president of the Bridges Organization, which oversees the annual international conference series "Bridges: Mathematical Connections in Art, Music, and Science" (www.BridgesMathArt.Org). Sarhangi was a mathematics educator, graphic art designer,

drama teacher, playwright, theater director, and scene designer in Iran before moving to the US in 1986. After completing a doctoral degree in mathematics he taught at Southwestern College in Winfield, Kansas (1994-2000), before moving to Towson University. In addition to writing many articles in mathematics and design, Sarhangi is the editor/coeditor of fourteen Bridges peer-reviewed proceedings books. He is an associate editor of the *Journal of Mathematics and the Arts*, published by Taylor & Francis in London.

Giampiero Mele

Facoltà di Lettere Università
Telematica e-Campus
Via Isimbardi, 1022060
Novedrate (Como) ITALY
giampiero.mele@uniecampus.it

Keywords: Acaya, Segine,
Charles I of Anjou, Gian
Giacomo dell'Acaya, metrology,
surveying, geometry, geometrical
layouts, arithmetic, area
calculations, Plato, ideal
numbers

Research

A Geometrical Analysis of the Layout of Acaya, Italy

Abstract. The analysis of the urban fabric contained within the city walls of the town of Acaya, made possible by a new integrated survey involving manual, topographical, photogrammetric and 3D laserscan techniques, has cast doubts on the conventional attribution of the city layout to Gian Giacomo dell'Acaya. A rectangular layout consisting of six blocks divided by six longitudinal streets and three lateral streets is indicative of a medieval date. The geometrical analysis shows how the site of the ancient town of Salappya was transformed by Charles I d'Anjou in 1273, renaming it Segine, and how, in about 1500, Alfonso dell'Acaya enlarged the city and its walls according to the same proportional criteria. In 1536 Gian Giacomo dell'Acaya succeeded his father as Baron, redesigning the city walls in order to make them suitable lines of defense against firearms, renaming the city Acaya.

And he that talked with me had a golden reed to measure the city, and the gates thereof, and the wall thereof. And the city lieth foursquare, and the length is as large as the breadth: and he measured the city with the reed, twelve thousand furlongs. The length and the breadth and the height of it are equal. And he measured the wall thereof, a hundred and forty and four cubits, according to the measure of a man, that is, of the angel. And the building of the wall of it was of jasper: and the city was pure gold, like unto clear glass [Revelations 21: 15-18].

Preliminary remarks

The construction of a town creates a perimeter, a shape, attributing to these actions the religious mystic value of separating the land. The internal and the external part of a town are defined by the functional meaning of the urban enclosure, which creates an order: a conceptual work of the architect which skillfully contains a great quantity of meanings and theoretical and functional codes. The surrounding walls, having always been part of the development of towns, constitute the main point of reference for comprehending the consistency of the value of what they delimit. From the time of picket fences, people have viewed the enclosures as both a protection and the mark of gaving achieved political and cultural order. In the region of Puglia such meanings have been preserved since the fortified towns of the Messapi people (as early as the eighth century B.C.) and of later Roman and medieval towns. In particular, medieval Acaya was part of a network of villages and castles that resulted from a political and administrative reorganization of the territory. In many cases the walls show recognizable signs of the changes occurred over the centuries, caused not only by administrative arrangements but also by their adaptations to be a proper defense against firearms. The legacy of knowledge contained in this perimeter has to be emphasized. The walls of a town are not only of monumental and historical value, but cultural as well, perceived as their own by the inhabitants who lived and live within that territory and enclosure.

Nexus Netw J 14 (2012) 373–389
DOI 10.1007/s00004-012-0110-z; *published online* 26 May 2012
© 2012 Kim Williams Books, Turin

The richness of Italy's cultural heritage is remarkable. Many towns have a notable architectural, artistic, and archaeological heritage, a great quantity of cultural assets that deserve to be known, exploited and preserved in the best way, starting with a careful documentation and ending with a range of conservation and restoration interventions where necessary. The essential requirement for the valorization of our cultural heritage is to know it. Survey has always been the privileged means of documenting the natural and manmade reality, but, both in theory and in practice, but only in the last few decades has the survey process turned into a scientific discipline, officially becoming the first step and essential operation for any new research on architectural heritage. In recent years the science of surveying has been deeply renewed. Now, although still strongly rooted in already consolidated scientific knowledge, surveying offers new perspectives of analysis in an increasingly wide range of situations and applications. The scientific survey is the instrument and means for documenting, investigating and understanding shape and historical events directly from the object surveyed, considered the principal "self-document". With a renewed confidence in the undeniable results obtained from an accurate survey, studies on historical architecture based on the analysis of the built environment are emerging, deserving the attention of the scientific community. Experts in this field have been recognized as capable of critical investigations in the meaning of what has been surveyed, since they have the possibility to compare drawings with parallel studies, checking and validating any hypothesis.

The considerations that follow arise from the precise measurement of the walls of the town of Acaya, a small fortified village near Lecce. The analysis of the survey has unveiled the signs of the different authors involved in the building. This research clarifies, by means of hypotheses and confirmations, the meaning of the shape, and shows how arithmetic, geometry and astronomy (three of the four disciplines of the *quadrivium*, which, together with those of the *trivium*, constituted the basis of liberal arts education in antiquity, propaedeutical to the knowledge of theology and philosophy) act as the generating instruments for the design of the walls and the urban grid of the city of Acaya.

The integrated survey of the town walls of the village of Acaya

In 2009 the city of Vernole launched a plan to collect funds from the Region of Apulia (Puglia) for a project aiming at the recovery and restoration of the town walls of the village of Acaya, one of the five outlying villages of Vernole.[1] That was the first step of a long process of recovery to be done in the immediate future, an important step that led this small town to use all its resources to organize a workshop for the knowledge of the town walls. At the city's invitation, the present author organized a survey class for the students of the Universities of Ferrara Bari, Milan and the Faculty of Arts of the Telematic University Ecampus. This experience has had different outcomes: training in knowledge and critical analysis, knowledge of the built environment as a prerequisite for its optimal preservation and use by both the administration and the inhabitants. The inhabitants of the town have gained awareness of the presence of the town walls as part of their heritage and have also rediscovered the symbolic value of a civic memory.

The student teams who conducted the survey operations directly in situ throughout the different steps, analyzing the collected data, came to understand the value of scientific integration between operators and the need to bring to a good end a process subtended by a scientifically and technically correct methodology.

In a way similar to what happened with drawing (where digital drawing having almost completely substituted hand drawing) computer and information sciences have

moved on. Thus new, technologically advanced instruments have substituted the traditional ones. These changes have altered the meaning of the survey intended as a model and have even prompted the development of new methodologies to acquire and manage data,[2] which represents an improvement with respect to the traditional methods. Therefore, the new survey is the result of a combination of different methods aiming at a scientific description and knowledge of the architecture and producing an image embedding its value as an image.[3]

The survey of the town walls of Acaya is a significant case study of an integrated survey, oriented towards management, conservation and restoration. The administrative requirement to have a complete digital survey of the entire complex of the town walls arose from the necessity of having scientific documentation in order to begin an iter for future restoration interventions characterized by respect for those unwritten rules that every architect should know. The city technical office realized that a survey on digital support is not a static database, but can be implemented and provides valuable support for the one who maintains it, who will be able to integrate it with all future information pertaining to this object. The reading of a document of this kind, accurate and detailed, could provide answers and raise questions both for the restorers and for all the scholars willing to investigate and increase the knowledge of the architecture.[4] The remarkable dimensions of the building to be surveyed and its morphological features required a great effort of organization and a notable quantity of working force.[5]

The integration of the different survey systems (manual, topographical, photogrammetric and 3D laserscan) has been fundamental for setting up a database that had would encompass characteristics just described. The measurements were conducted following two methods. The topographic survey was used to fix points of first kind and to identify the shape of the plan enclosed by the entire circuit of town walls; this grid was implemented with pieces of information obtained by measurements made with laser meters and traditional instruments. The principal elevations and the cross sections have been obtained by integrating topographic, traditional (where possible), photogrammetric surveys with a 3D laserscan survey.

The result is a survey model that guarantees an elevated degree of metric precision, with a series of detailed cross sections along the town walls. The wall stretches are more than sixteen. The drawing of the elevations of each stretch has been obtained using the photogrammetric technique. The photos mapped in the vectorial model (obtained by integrating different survey systems and methods) make it possible to have a functional document for specific estimations: in particular, to check the state of deterioration of the masonry and to draft some thematic maps useful for the evaluation of the extent of the intervention. The survey with a 3D laser scanner has been realized in those streches where there are partial collapses, in particular in some areas on the east side where the walls are connected to the rock mountain. The survey operations have been extended to the dyke. The survey of the thickness of the walls and that of the internal elevations has been partial, as the main part of the walls are included in private houses or in private properties. The topographer created a closed polygon that included all of the external perimeter, putting it into relation to some fixed station points, determined by the present author, to create a valid support for the measurements of important points for the plan drawing of the urban blocks. The survey of the town walls of Acaya is the result of the integration of different methods and instruments. The computerized drawing in a database of vectorial drawings has produced a document useful for the knowledge of the town walls and for a future restoration, both in terms of management and of analysis.

Sezione 22-22

Sezione 23-23

Sezione 20-20

Sezione 21-21

Fotopiano Tratto Y-Z

Prospetto Tratto Y-Z

Pianta Tratto X-Y-Z

Fotopiano Tratto X-Y

Prospetto Tratto X-Y

0 5 25m

Fig. 1. Integrated survey of some of the stretches of the city walls of Acaya

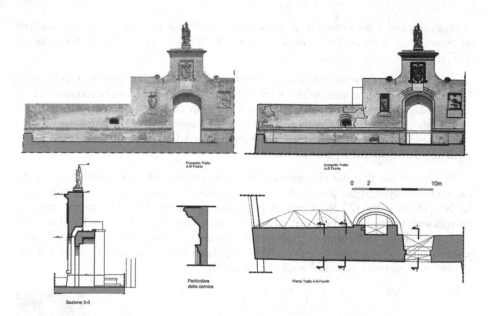

Fig. 2. Integrated survey of the stretch of the city walls of Acaya with the entrance portal

The metric analysis of the survey: from Segine to Acaya

Through the metric analysis of the survey (which is in itself an instrument of knowledge) we have the chance to reveal, on the basis of hypotheses and confirmations, the meaning (theoretical or not) of the shape and stratification of the artifact. The actual state of a historical compound often reveals morphological elements as well as those technical and scientific aspects of the original design which even highly esteemed historiographical criticism would neglect. The most important works of architecture have been mainly studied from the points of view of aesthetical/artistic criteria, and thus finding the practical 'reason' for an architectural shape, through the generating elements and the geometric constructions which are revealed by this kind of analysis, allows a researcher to complete the historical and documentary reading of the project with the detection of the original pattern. This procedure, which seems to be very simple in theory, in practice proves to be very complex, especially, when the work to be analysed is the result of a complex project and belongs to a remote past. Analysing a survey with the aim of unveiling the original project of the designer, means starting from the metric measures and converting them into the ancient metrological system used for the construction of the building. From this conjecture, we obtain some numerical quantities about which, however, we need to guess[6] the geometrical meaning to be explained according to a logical scientific reasoning starting from an hypothesis (going through some major postulates) and arriving at defining and explaining the detailed calculation of the quantities involved, through a series of theorems and corollaries. To guess the geometrical meaning means to formulate a hypothesis of work depending on the specific knowledge of the researcher.

The village of Segine

In the case of Acaya, the careful observation of the walls' shape led me to detect the urban structure enclosed within them. A first measurement of the block showed some

incongruities and a discontinuity of the scheme commonly attributed to Gian Giacomo dell'Acaya, a military architect, who, as Jacopo Antonio Ferrari wrote in his *Apologia* [1977],

> …in his time, not only planned the fortification of Acaya, but also the Castle of Lecce, providing the walls of this City with many bulwarks and walls you can still see today; he was also involved in the edification of the Neapolitan Castle of S.Eremo, the Castles of Capua and Cosenza and many fortresses in the Kingdom; for the edification of these fortresses he was employed by the Imperator Carlo V, as he was considered a gifted architect.

The hypothesis that this discontinuity had some precise historical reasons takes shape. The metric analysis of the plan leads to logical results if we consider as a unit of measure the Neapolitan palm (26.3670 cm). A particular use of the historical metric structure emerges with multiples and submultiples and in particular the unit of length called *canna per le stoffe* (equal to 8 palms or 2.109360 m), linked to the square measure called *canna quadra* (equal to 64 square palms = 4.4494 m²). Each block measures 16.89 m x 84.44 m,[7] which in Neapolitan palms[8] would be 64 x 320.[9]

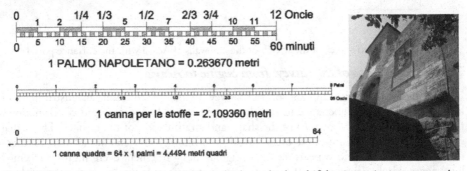

Fig. 3. Historic units of measurement, with multiples and submultifples, in use in Acaya up to the second half of the nineteenth century

If you consider that a canna quadra is given by 64 x 1palms, it becomes quite easy to calculate the block surface, which proves to be 32 canne quadre. The street is 16 palms wide and 320 long; consequently, the (square) surface is 80 canne quadre.[10] The number of the lots for each block is 40 (16 x 32 palms =8 canne quadre[11] each). Given this basic model of 8 canne quadre, it becomes easy to calculate accordingly the lots and the surface occupied by the solids and the voids.

Counting the number of the city blocks and streets that make the city, one can see that the pattern proves unstable and the city so far described is actually older. A rectangular scheme composed of six blocks (1/2+5+1/2=6), broken up respectively by six streets lengthwise and three streets vertically, seems to be a medieval scheme.

From a careful reading of the historical written sources, which prove hard to interpret without this kind of background information, it turns out that the ancient village of Salappya was transformed by Charles I of Anjou[12] into a new land renamed Segine around 1268. Only later, in 1294, Charles II of Anjou[13] gave Gervasio of Acaya (Gian Giacomo's ancestor) the village of Segine. It was probably already a city surrounded by walls with a central church and a central square, measuring 480 x 752 Neapolitan palms or 5640 *canne quadre*.

Segine, according to the archaeologist Giacomo Arditi,[14] was given in 1269 to the monastery of San Giovanni Evangelista di Lecce, in 1271 moved to Filippo de Tunzico Ammirato del Regno, in 1283 to Raimondo Gubaldo and in 1285, the year of Charles I's death, to Gervasio dell'Acaya, "valiant captain, *as a reward for his service to Charles I of Anjou, having already been given by him Galugnano and part of Cesareo*". It is difficult to establish the exact year of the foundation of Segine.

No doubt that, if the hypothesis of the foundation of a new land is justified, then the beginning of its construction can be traced back to between 1288, when Charles became king of Naples, and 1269, the year in which Segine was made over to the monastery of San Giovanni. The city would have had the shape of some French bastides and in particular, those founded by Alphonse of Poitier (between 1250 and 1271)[15] and by King Louis IX of France.[16] The reasons for the foundation of the bastides were political,[17] economic,[18] demographic[19] or of security,[20] whereas Segine was certainly founded for political reasons. Charles I's organisation of the State was meant to consolidate his monarchy. He distributed among his knights what he had taken away from his feudatories (lieges). That is why Segine is given to Gervasio dell'Acaya.

Once we have made clear why a city was founded in that place, in that precise historical moment and with those dimensions, we have to clarify all the arithmetical and geometrical steps which led to its final shape. The starting module/unit is a square whose side is 160 palms producing an area of 400 canne quadre. Six square units form a rectangle of proportions 2:3 (320 x 480 palms = 2400 square canne), the value of the diagonal line of this rectangle is $160\sqrt{13}$ palms; if we invert this value, we obtain a new rectangle of proportions $3:\sqrt{13}$ (480: 160 $\sqrt{13}$ palms).

The length of this new diagonal is equivalent to $160\sqrt{22}$. If we repeat the operation, we get a new rectangle of proportions equivalent to $3:\sqrt{22}$ (480:160$\sqrt{22}$ palms). The general dimensions of the city, then, are 480 palms widthwise and 160 x 4.6904157 = 750.4665, or approximately 752 palms.[21]

The calculation of the city area gives an natural integer of canne quadre (5640) which, if transformed into metric units of superior surfaces, does not produce an integer value. In fact, given that a *quarta* is equivalent to 4840 square palms the surface of the rectangle that originates the city is 74.578512 *quarte*, equivalent to 7.4578512 *moggi*; if we consider that Segine had to have a moat all around, then the total starting surface may be 8 *moggi*.

The project of Segine shows a strong arithmetic-geometrical coherence. The area dimensions are defined in order to divide its precise geometrical shape into a given number of blocks. In this way the calculation of both the area and the number of lots becomes easy. Indeed, if we consider that each lot measures 16 x 32 palms = 8 canne and that each block contains 40 lots, the computation of the total number of lots can be given by the following count: 10 blocks (5+5) for 40 lots make 400 lots to which we must add those lots contained in the four half blocks (20 lots x 4). We finally have 480 lots. We still must add the 60 lots distributed along the short sides of the triangle (480 palms : 16 palms = 30 lots which will be multiplied by two) giving a total of 540 lots.

This computation still lacks the 4 lots that occupy the space of the length of the two vertical peripheral streets, thus we have a total of 544 lots. From this number we must subtract the twelve lots attributed to the Piazza and the twelve lots occupied by the church. The number of taxable lots is 520. This kind of calculation is very useful for managing the local taxes paid by property owners.

Let us compute the street area, a very useful datum. When paving the streets, the City needs to know how much material is required. Segine's rational layout allows us to easily calculate this surface. Knowing the width of the streets (16 palms) and the length of the blocks (320 palms) the area of the longitudinal streets can be easily computed by multiplying the number of streets by the area inbetween each block.

The value of the surface of a street between the blocks is 80 square canne (16p x 320p = 5150 square palms : 64 square palms[22]) and the number of these ones is 12. Their area is 960 canne quadre (80 x 12). This value must be added to the one of the transversal streets, which are three. Each width is equal to 16 palms and their length is 480 – (2 x 32) = 416 palms. The surface of each of them is 104 canne quadre (416p x 16p = 6656 square palms : 64 square palms) that multiplied by 3 is 312 canne quadre, which added to the previous 960 gives 1272 canne quadre. To obtain the area of the urban void we have to add the last value to the surfaces of the lots of the piazza and the streets which are tangent to the church and have not been counted.

The number of the lots is 15. We have to add 120 (15 x 8) to the 1272 canne quadre. So we get the total surface of the urban void that is equivalent to 1392 canne quadre corresponding to 1.840666 moggi. The proportion between solid and void is 1.8406666 : 5.6171852.

The above calculation makes it clear that the project of the village has been thought in canne quadre compared to the units of length. This full demonstration about the shape of the city desired by Charles I, shows how arithmetics and geometry (numbers, measures and shape) are used to solve not only formal problems but also problems of economy and computation.

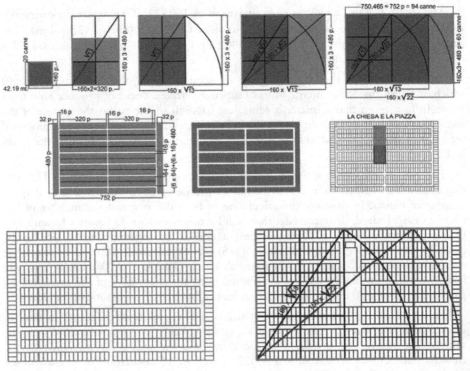

Fig. 4. Geometric schemes relative to the city founded by Charles I d'Anjou

The orientation

A first hypothesis about the orientation based on the measurement of the main axis (from Google Earth) shows that the eastwest axis has an azimuth equivalent to 72. 94°. This value reported in the hypothetical year of the foundation can be identified with 15 August, the day on which according to the Neapolitan Marmoreo calendar (ninth century)[23] the feast of the Assumption is celebrated. In Acaya, the cult of the Assumption is still alive and well. During restoration works in the castle, a fresco was recovered in a wall interstice: the *Dormitio Virginis*, or sleeping Virgin, measuring 4 x 3 meters, traceable to the second half of 1300. The picture is perfectly preserved, and represents the Apostles witnessing the death of the Virgin and Jesus picking her soul and presenting it to the Father, according to the iconographic tradition referring to the apocryphal Gospels. What is certain is that it is difficult to establish whether the city was really devoted to the sleeping Virgin.

Fig. 5. Orientation of the city plan

Fig. 6. Orientation of the city of Acaya

The value of 72.94° is relatively close to 75°. If we consider Vitruvius's indications on the orientation of the city in relation to the wind – that the wind should not be allowed into alleys[24] – another conjecture can be made: the orientation of 72.5° does not allow the wind named Carbas (see [Vitruvius 2009: I.vi.10, p. 30]) to enter Segine's alleys. If we consider Vitruvius's wind rose, it can be seen that Carbas blows in direction of 75°.

Carbas is a wind that blows in a direction that is between the Grecale and the East wind. In winter it is a cold wind associated with freezing temperatures, blowing with a moderate to strong intensity. To protect oneself from cold implies to protect oneself from both the Grecale and the Eastern wind. Astronomy, the fourth liberal art, turns out to be here very useful to find out a precise orientation whose meaning can be both symbolic and practical (to avoid cold winds).

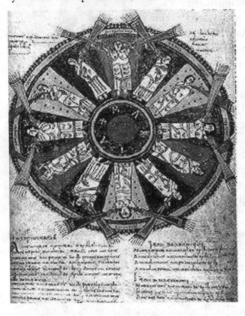

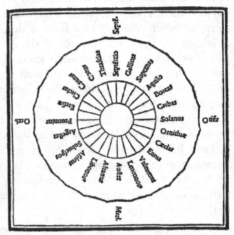

Fig. 7. left) Wind rose, Codex Vigilanus, Spain, tenth century; above after Vitruvius

Enlarging the city

Let us now return to Acaya's plan. The question is: how did the present drawing come to be and when was the city expanded? The actual situation is certainly the result of an enlargement of Segine. In the light of what is described about Segine, a rereading of the historical documents clarifies that which was, in Arditi's words,[25] "the third transformation". Alfonso dell'Acaya, father of Gian Giacomo, in 1506 "restored (the town) and gave it, as legend has it, walls of marble" [Arditi 1879: 4]. Arditi here uses the expression "restored it", but what does this mean? Again Foscarini in an article on Gian Giacomo writes about his father Alfonso "in the following year [1510] he was charged with the safety of Otranto as, in those seas, the Venetian navy had appeared, and restored the family castle, the keeps and all that remained of the defense of 1506". Again the verb "restored" is used. Therefore, a fortified city with a castle already existed and the discovered fresco of a sleeping Virgin, dated 1300, is a testimonial. Proof of our hypothesis is another inscription on the south face of the bastion. It reads as follows: "This fortress, begun by his forefathers and enlarged by his father, to hold it faithfully for Charles V, invincible emperor, was completed by Gian Giacomo dell'Acaya with great efforts in the year of grace 1536". This epigraph demonstrates that an old fortification existed in that place, was enlarged by Alfonso, and was completed with further modifications by Gian Giacomo dell'Acaya.

Hereafter we will attempt to explain, starting from measurements, Alfonso's "enlarged" city. The restorations were necessary since Segine, less than four kilometers

from the sea, was exposed to attacks by Turks who raided along the Salento coast. Alfonso's *caput magister operis* has the same criteria regarding proportions. He added two blocks of the same size as those already extant on the long side to the eEast and to the west, bringing the general dimensions of the city to (731 x 794.52 palms, exactly 12 *moggi* (12 x 48.400 = 580.800 square palms; 580.080 : 731 = 794.5280 palms). The enlarged city was recentered and maintains its original orientation. The cross axis remains the same and the longitudinal axis is moved one block. From the drawing we can see that the enlargement of the center is done in only one direction. This allows the city to economize resources, reinforcing the extant walls on the short side, extending them and using the demolished materials of the long side of the first *enceinte* to build the second. The southwest corner of the city has always had a fortification, certainly reorganized on this occasion. From the documents it is evident that the first circular tower, the one with the smallest diameter, is from 1500 and the other, with a larger diameter, is from 1506. The castle is located exactly on the diagonal of the new city walls and one of the two towers, the one with the hexagonal hall, has its center of basic circumference on the same oblique line. In 1521, Gian Giacomo inherited the barony of Segine from his father and decided to improve the manor by surrounding it with strong bastions, suitable as defense against firearms. Three lanceolated bastions were used here for the first time. The construction of the new walls was concluded in 1536. The three bastions show involuted walls that were less vulnerable to the cannons used at the time. The defenses ensured flanking for the curtain walls and the defense of the facades, guaranteeing a perfect defense of the town. The medieval city was giving way to the Renaissance city.

The plan of the walls begins with a rectangle built by Alfonso (8731 x 794.52 palms), which are given a double rotation to define the most useful directions for setting the lanceolated bastions.

To locate these directions it is necessary to draw a circumference which has its center at the crossing of the axes of the Alfonsine city and a radius equal to 625 palms (55.5 pertiche), dividing the circumference into sixty equal parts (360° : 60 = 6°) with the principal diameters oriented to the cardinal points. The direction of the first side rotated by the new rectangle can be obtained by joining two points of the circumference, A and B, the first extending the diagonal to the point of touching the circle (point A is from north to 24° northeast = 6 x 3) and the second, chosen conveniently in function of the length that the bastion will require (point B is south to 39° southeast = 8.5 x 3). The median point of the distance between A and B is thus found, using the half-distance of the long side (794.52/2) of the rectangle, and a rectangle is then drawn of the same dimensions. The second rotational direction is obtained by joining two more points of the circumference. The first is always A and the second is chosen conveniently on the circumference (point C is at north to 63° northwest = 10.5 x 6).

The median point of the distance AC is determined, referred to the half-distance of the short side of the original rectangle (731/2) and a rectangle is drawn of the same dimensions. Extending the sides of the two rectangles thus determined, we obtain the directions to contain the bastions. The iconography of the lanceolated bastions varies from bastion to bastion, the dimensions of the sides go from 280 palms to 330 palms, increasing in a counterclockwise cycle. In summary, the proportioning of the medieval city is arithmetic-geometric, that of the Renaissance city enlarged by Alfonso is arithmetic and the redrawing of the walls of Gian Giacomo is geometric. The subsequent layering of these three phases creates the design of the city, symbol of the Salentine Renaissance.

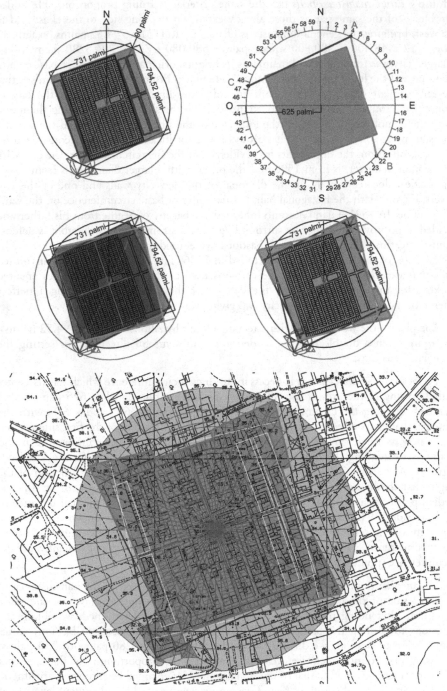

Fig. 8. Geometric schemes for identifying the shape of the city plans laid out by Alfonso and Gian Giacomo dell'Acaya

Conclusions

In the thirteenth century there was a vigorous philosophical debate about institutions that had the responsibility of educating citizens, and organizing and building cities. This debate is documented in the entire western area. During the Classical period the philosophical debate on cities and citizenship gained new vigour. Knowledge of Greek literature was revived and considered useful for the purpose of reorganizing the local territory, creating new ideologies and consequently new formal interpretations of cities. Religious philosophers wrote about the differences between celestial cities and earthly cities. As with the Greek *polis*, the medieval city was supposed to be the educational instrument for strengthening citizenship, and therefore had to show harmony, geometric rigor, symmetry, numerical order, measure as the symbolic reference. All these qualities were present in Segine. The founders of the new cities borrowed from classical Greek literature the concept of city, both in its physical dimensions, easily manageable from an administrative point of view, and in its educational task towards the citizens. The example of Segine (Acaya) immediately shows affinities with Plato's ideal city: its size is that of a typical agricultural village, the street plan is an octagonal network creating rectangular blocks. No part of the city is far from view. From one end of the city, the other can always be seen. The image of the city that fascinated Plato was absolutely geometric. The principal characteristics were smallness, isolation, autonomy, enclosure within a well-protected valley, living in Puritan rigor on the fruits of one's own soil. He declared:

> ...if men must have a wall of sorts, they should construct their own dwellings from the outset in such a fashion that he whole town forms one unbroken wall, every dwelling house being reandered readily defensible by the uniformity and regularity with which all face the streets. Such a town, with its resemblance to one great house, would be no unpleasing spectacle, and the ease with which it could be guarded would give it an unqualified advantage over any other in point of security [Plato 1961: Laws VI.778e, p. 1355].

Nonetheless, in this description Plato stands aside from the concrete image of the traditional Hellenic city. In the Laws, the ideal number of citizens was limited to 5040: the maximum number that allowed for direct participation and democratic elections. The number 5040 indicated by Plato is obtained multiplying the first seven natural numbers, that is, it is equal to 7! ($7!=1\times2\times3\times4\times5\times6\times7=5.040$). For the founders of the Ideal City, the number 5040 was supposed to be divisible by the first ten numbers, allowing for the redistribution, at least theoretically, of lots to each newcomer.

1	12	35	72	168	504
2	14	36	80	180	560
3	15	40	84	210	630
4	16	42	90	240	720
5	18	45	105	252	840
6	20	48	112	280	1000
7	21	56	120	315	1200
8	24	60	126	336	1260
9	28	63	140	360	2520
10	30	70	144	420	3040

Fig. 9. List of the sixty divisors of 5040, the number of Plato's ideal city

The table in fig. 9 shows the 60 divisors of 5.040. Some of these numbers can also be found in general architectural dimensions, both civil and religious, of the medieval period. Suffice it to mention the example of 144 as the dimensions of the Celestial

Jerusalem. From the metric analysis of certain information about churches of the medieval period, one notes that many of them are modulated on numbers which are divisors of 5.040. The reasoning of the medieval architects is, probably, to a reference to an ideal network. Choosing as size a divisor of 5.040, one is aware of operating within a certain number of integer divisors.

The other interesting number indicated by Plato in the *Republic* is 12,960,000, also called the nuptial number, equal to $60^4 = 3^4 + 4^4 + 5^4$. 12,960,000 also has a large number of integer divisors (225), from which one may choose to select notable numbers which themselves contain a series of divisors that help in the redistribution of whole quantities. In the table of its 225 divisors, many numbers can be found which were used in Segine. 16, 32, 40, 64, 80, 320, 480, 540, are all numbers that were used to define shape and assign dimensions.

$$3^4 \times 4^4 \times 5^4 = 12\,960\,000$$
[1]

2	100	540	2 000	6 912	27 000	144 000
3	108	576	2 025	7 200	28 800	160 000
4	120	600	2 160	7 500	30 000	162 000
5	125	625	2 250	8 000	32 000	172 800
6	128	640	2 304	8 100	32 400	180 000
8	135	648	2 400	8 640	33 750	202 500
9	144	675	2 500	9 000	34 560	216 000
10	150	720	2 592	9 600	36 000	240 000
12	160	750	2 700	10 000	40 000	259 200
15	162	768	2 880	10 125	40 500	270 000
16	180	800	3 000	10 368	43 200	288 000
18	192	810	3 200	10 800	45 000	324 000
20	200	864	3 240	11 250	48 000	360 000
24	216	900	3 375	11 520	50 625	405 000
25	225	960	3 456	12 000	51 840	432 000
27	240	1 000	3 600	12 960	54 000	480 000
30	250	1 080	3 750	13 500	57 600	518 400
32	256	1 125	3 840	14 400	60 000	540 000
36	270	1 152	4 000	15 000	64 800	648 000
40	288	1 200	4 050	16 000	67 500	720 000
45	300	1 250	4 320	16 200	72 000	810 000
48	320	1 280	4 500	16 875	80 000	864 000
50	324	1 296	4 800	17 280	81 000	1 080 000
54	360	1 350	5 000	18 000	86 400	1 296 000
60	375	1 440	5 184	19 200	90 000	1 440 000
64	384	1 500	5 400	20 000	96 000	1 620 000
72	400	1 600	5 625	20 250	101 250	2 160 000
75	405	1 620	5 760	20 736	103 680	2 592 000
80	432	1 728	6 000	21 600	108 000	3 240 000
81	450	1 800	6 400	22 500	120 000	4 320 000
90	480	1 875	6 480	24 000	129 600	6 480 000
96	500	1 920	6 750	25 920	135 000	12 960 000

Fig. 10. List of the divisors of Plato's nuptual number

Plato states that,

> ...for divine begettings there is a period comprehended by a perfect number, and for mortal by the first in which augmentations dominating and dominated when they have attained to three distances and four limits of the assimilating and the dissimilating, the waxing and the waning, render all things conversable and commensurable with one another, whereof a basal four thirds wedded to the pempad yields two harmonies at the third augmentation, the one the product of equal factors taken one hundred times, the other of equal length one way but oblong – one dimension of a hundred numbers determined by the rational diameters of the pempad lacking one in each case, or of the irrational lacking two; the other dimension of a hundred cubes of the triad. And this entire geometric number is determinative of this thing, of better and inferior births [Plato 1961: Republic VIII.546b-c].

The geometric number, indicated by Plato, expresses a law of growth which was useful to medieval planners, a sort of mental abacus that rationalized arithmetic. The medieval city of Acaya (Segine) is its emblem.

Acknowledgment

I wish to thank Prof. Paolo Pepe of the Facoltà di Lettere, Uniecampus, for the English translation.

Notes

1. The more recent population data of Vernole and its outlying villages (the census of 20 October 2001) attribute to Vernole 3,031 inhabitants; Strudà 1,704; Pisignano 1,058; Acquarica 1,047; Acaya 494; Vanze 306. In total Vernole and its fractions reach 7,640 inhabitants.
2. Viewed as the complex of the investigations and operations aimed at identifying the significant qualities under the morphological, dimensional, figurative and technological aspect. See [Cundari and Carnevali 2005].
3. For Le Goff "image" or "representation" includes every possible mental translation of an external reality perceived: "Representation is related to the process of abstraction. The representation of a cathedral is our idea of it" [1992: 1].
4. The perimeter of the walls measures approximately 950 meters and encloses an area of about 55,300 square meters.
5. More than thirty people have worked at the survey: Dr Giampiero Mele was coordinator of the project; the Longo and Spongano architectural firm, with the contribution of three collaborators, provided a detailed topographical survey; Federico Cortese offered his valuable contribution as an expert in the field of GPS survey; Prof. Vincenzo De Simone of the Politecnico di Bari contributed as an expert in the field of photogrammetry; students from more than thirty faculties in the 2009-10 academic year were involved in the project. Special thanks go to the students of the Faculty of Architecture of the University of Ferrara.
6. The intuition depends on the researcher's idea and capacity to formulate a hypothesis to demonstrate.
7. The measure is obtained to work out an average of all the lengths obtained from the measures that vary for the short side from 16.85 to 16.92 and for the long side from 84.33 to 84.52.
8. 64 x 0.263670 = 16.87488 m.; 320 x 0.263670 = 84.3744 m.
9. 16 x 0.263670 = 4.21872 m, the measure relieved from the lengths of the streets varies from 4.18 to 4.23.
10. 16 x 320 = 5120; 5120:64 = 80 square canne.
11. 320 square canne : 8 square canne = 40 lots.
12. Charles I of Anjou, brother of Louis IX of France (Saint Louis), conquered the kingdom of Naples in 1266, defeating in Benevento the last Swabian king, Manfredi of Sicily, illegitimate son of Frederick II. Charles died in Foggia on 7 January 1285.
13. Son of Charles I and King of Naples from 1285 to 1309.
14. In *La corografia fisica e storica della provincia di Terra d'Otranto*, Stabilimento tipografico Scipione Ammirato, Lecce 1879.
15. Alfonso, brother both of Charles I of Anjou and of Louis IX king of France, founded about fifty cities during these years. They were: Verfeil sur Seye (1250); Calmont (1252); Monflanquin (1252); Montclar (1252); Villefranche de Rouergue (1252); Villeneuve sur Lot (1253); Montpezat (1255); Villefranche de Lauragais (1254); Ste Foy la Grande (1255); St Sulpice sur Léze (1255); Montréal du Gers (1255); Palaminy (1255); Ste Gemme (1256); Carbonne (1256); Tournon d'Agenais (1257); Montjoie en Couserans (1256); St Pastour (1259); Castillonnés (1259); Labastide du Temple (1260); Villefranche du Périgord (1261); Labastide Castel Amouroux (1264); Donzac (1265); Gimont (1266); Cordes Tolosannes (1267); Labastide St Pierre (1267); Lavelanet de Comminges (1267); Laparade (1267); Mirabel (1267); Monclar de Quercy (1267); Montalzat (1267); Lavelanet de Comminges (1267); Villebrumier (1267); Villenouvelle (1267); Villeréal (1267); Montjoi du Quercy (1268); Gaillac Toulza (1268); Lavardac (1268); Angeville (1269); Castelsagrat (1269); Dunes (1269); Damazan (1269); Septfonds (1270); Alan (1270); Salles sur Garonne (1270); Eymet (1270);

Castelnau de Gratecombe (1270); Castelsarrazin(1270); Caumont (1270); Molières du Quercy (1270); Najac (1270); Le Fousseret (1270); Puylagarde (1270).

16. Aigues Mortes
17. The settlement of the French royal power on the annexed county is also the reason for a foundation, as well as the need for autonomy of some lords.
18. The rent and value of the uncultivated land or woods not exploited is one of the economic reasons.
19. The grouping of scattered habitat motivated the foundation, as well as the displacement of the population following the destruction of a castelnau.
20. Providing protection of the population and the liege lord from brigands and wars was a complementary cause of some constructions.
21. Integer value multiple of 8 which approximates the one individuated multiplying 160 for $\sqrt{22}$.
22. The value of the square canna.
23. The Marble Calendar of Naples, an important historical/hagiographic/liturgical monument and among the most ancient ones recovered so far (the visigotic monument of Carmona, near Siviglia is antecedent (sixth century), was probably carved between 847 and 877, on the base of a Latin and Greek calendar, as not only the problematic and crowded santorale shows, but also the mention of the four feasts of the Virgin Mary deriving from the Byzantine religion: the Purification of Mary (February 2nd); the Assumption (August 15); the birth of Mary (September 8); and, above all, the Immaculate Conception (December 8).
24. Vitruvius, *On Architecture*: "When the walls have been built around the city, the lots for housing inside them must be allocated and the main avenues and narrow cross-streets oriented so that they take account of climactic conditions: if the winds are cold they damage the health, if hot, they are infectious, and if humid, they are noxious" [Vitruvius 2009: I. iv.1, p. 27].
25. "... *qui però debbo soffermarmi sulle persone di Alfonso e di Gian Giacomo, padre e figlio Acaja, perché furono essi i rigeneratori ed i punti di partenza della terza trasformazione di questa Terricciuola*" ("... here however I would like to examine in greater depth the figures of Alfonso and Gian Giacomo, Acaja father and son, because they were the regenerators and point of departure for the third transformation of this land'"); see [Arditi 1879: 4].

References

ARDITI, G. 1879. *Corografia fisica e storica della provincia di terra d'Otranto*. Lecce: Stabilimento Tipografico "Scipione Ammirato".

BACILE DI CASTIGLIONE, G. 1927. *Castelli Pugliesi*, Rome: A. Forni. (Rpt. Rome: A. Forni, 2005).

CAZZATO, M. and A. COSTANTINI. 1990. *Guida di Acaya. Città, campagna Cesine*. Galatina (Lecce): Congeda Editore.

CUNDARI, C. and L. CARNEVALI, eds. 2005. *Atti del Convegno, Verso la Dichiarazione sul Rilevamento architettonico* (Rome, 16-18 Novembre 2000). Rome: Kappa.

DIVORNE, F., B. GENDRE, B. LAVERGNE and P. PANERAI. 1985. *Les bastides d'Aquitaine, du Bas Languedoc et du Béarn. Essai sur la régularité*. Brussels: Aux Archives d'architecture moderne.

DIVORNE, Françoise. 1993. *Bern und die Zähringerstädte im 12. Jahrhundert. Mittelalterliche Stadtkultur und Gegenwart*. Bern: Benteli.

FERRARI, Jacopo Antonio Ferrari. 1977. *Apologia paradossica della città di Lecce* (1576). A. Laporta, ed. Lecce: Cavallino.

FOSCARINI, A. 1934. Giov. Giacomo dell'Acaia e i suoi ultimi anni. *Rinascenza salentina, rivista bimestrale di arti lettere e scienze*, II, 5-6 (Sept-Dec 1934): 241-255.

INCERTI, M. 2010. Geometrie celesti nel disegno della forma urbana. In *Atti del Convegno Disegnare il tempo e l'armonia: il disegno di architettura osservatorio nell'universo*, E. Mandelli and G. Lavoratti, eds. (Florence, 17-19 September 2009). Università degli Studi di Firenze, Dipartimento di Architettura: DisegnoStoriaProgetto. Collana Materia e Geometria 19/2010, 2 vols.

———. 2008. Il cosmo nelle fonti. Pp. 17-33 in *Mensura Caeli, Territorio, Città, Architettura, Strumenti*. Proceedings of "Ferrara Castello estense, 17-18 October 2008. Ferrara: UnifePress.

LE GOFF, J. 1992. *The Medieval Imagination*. A. Goldhammer, trans. Chicago: University of Chicago Press.

LIUZZI D. 1994. *La rosa dei venti nell'antichità grecoromana*. Galatina (Lecce): Congedo Editore.

MARTINI, A., 1883. *Manuale di metrologia, ossia misure, pesi e monete in uso attualmente e anticamente presso tutti i popoli*. Torino: Loescher.

MELE G. 2004. Dalla geometria una regola per il disegno delle chiese medievali tra XII e XIV secolo. Doctoral thesis, University of Florence.

————. 2007. Architettura gotica e disegno urbano. La piazza e fronti verso il centro antico. In *Musso e non quadro, la strana figura di palazzo vecchio dal suo rilievo*, M.T. Bartoli, ed. Florence: Edifir.

MONTE, A. 1996. *Acaya, Una città fortezza del Rinascimento meridionale*. Lecce: Edizioni del Grifo.

PLATO. 1961. *The Collected Dialogues*. Bollingen Series LXXI. Edith Hamilton and Huntington Cairns, eds. Princeton: Princeton University Press.

VITRUVIUS. 2009. *On Architecture*. Richard Schofield, trans. London: Penguin Classics.

About the author

Architect Giampiero Mele received his Ph.D. in "Survey and Representation of architecture and the environment" at the University of Florence in 2000, and a Ph.D. in "Architectural and Urban Design" from the Universitè di Paris 8 in 2004. Since 2010 he has been a researcher at the Università Telematica Uniecampus, and professor of descriptive geometry at the University of Ferrara. His fields of research are the relationships between geometry and arithmetic in historic architecture, and drawing in architecture and design. He has given talks at various conferences in these fields, and is the author of numerous papers, the most important of which are: "Mesure et proportion dans la Loge de la Signoria à Florence" (*Revue XYZ*, Association Française de Topographie, no. 98, 2004); "Dalla geometria una regola per il disegno delle chiese medievali tra XIII e XIV secolo" (self-published, Florence, 2004); "Architettura gotica e disegno urbano: la piazza e i fronti verso il centro antico" in *Musso e non quadro: la strana figura di Palazzo Vecchio dal suo rilievo*, M.T. Bartoli, E. Fossi and G. Mele, eds. (Florence: Edifir, 2007).

Mojtaba Pour Ahmadi

Department of Architecture
Roudsar and Amlash Branch
Islamic Azad University
Roudsar, IRAN
mojtaba.pourahmadi@yahoo.com

Keywords: Mausoleum of Sheikh
Zāhed-e Gīlāni, design analysis, Iran,
Lahijan city, dome, Timurid
architecture, circles, diagonals,
Euclidean geometry, geometric
analysis, harmonic proportions, lines,
patterns, cube, pyramid, octagonal
pyramid, proportion, proportional
analysis, ratio, square, symmetry

Research

A Geometrical Analysis of the Mausoleum of Sheikh Zāhed-e Gīlāni

Abstract. This article aims to explore some geometrical schemes that can be supposed to underlie the design of the mausoleum of Sheikh Zāhed-e Gīlāni, a monument dating back to fifteen century in northern Iran. The investigation shows that there are intricate geometrical relations among the elements composing the façade of the monument. An isosceles triangle and a regular octagon inscribed in a square, together with some other related lines, form the geometrical master diagram that determines the design of its façade. The findings of this research are compatible with the opinion that geometry played a decisive role in the Timurid/Turkmen style of architectural design.

Introduction

This paper undertakes a geometrical analysis of the main façade of the mausoleum of Sheikh Zāhed-e Gīlāni in northern Iran. This monument was built in the fifteenth century and contains the tomb of Sheikh Zāhed-e Gīlāni. The most significant component of this building is its pyramidal dome which can be considered a unique example of its type in traditional Iranian architecture. The beautiful proportions and pleasing composition of the elements composing this monument prompted the author to examine whether there might be some thoughtful geometrical relations behind its design. Therefore, through a process of trial and error, the façade drawing of the monument was studied and fortunately some geometrical and numerical patterns where discovered within it.

In this article, after describing and introducing the building being studied, some geometrical patterns that were found to govern the design of its front elevation are presented step by step through two-dimensional illustrations.

The monument introduced

The mausoleum of Sheikh Zāhed-e Gīlāni is located near the city of Lahijan in the province of Gīlān in northern Iran. Although Iran's climate is generally thought of as hot and arid, this region of Iran, which extends itself narrowly between the southern coasts of the Caspian Sea and the northern slopes of Alborz mountain range has a moderate, humid climate, which reflects itself clearly in the design of this monument (fig. 1).

This monument dates back to early Safavid dynasty in the fifteenth century and is believed to be dedicated to Sheikh Zāhed-e Gīlāni (ca. 1218-1300) the spiritual trainer of Sheikh Safi al-Din Ardabili (1252-1334) who is the great forefather of Safavid dynasty.

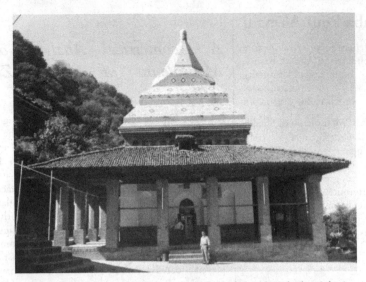

Fig. 1. The main façade of the mausoleum of Sheikh Zāhed-e Gīlāni

There is an interesting story about how this monument came to exist, according to which Sheikh Zāhed was initially buried in his birthplace, far from this current place. About two centuries after the Sheikh's death, Sheik Zāhed appeared to one of the rulers of the Safavids dynasty (Haidar) in a dream (892 Hijri/1487 A.D.), saying that in near future his tomb would go under water and ordering him to move his body from there and transfer it to a safe and secure place. The king obeyed the Sheikh's order and built this new mausoleum for him on the slopes of the mountain that was once the place of Sheikh's spiritual exercise [Sotoodeh 1995: 149].

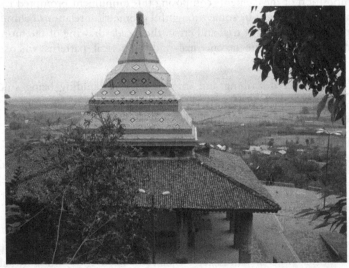

Fig. 2. According to a legend the construction of this mausoleum originated with a dream

The monument consists of a domed chamber and a surrounding columned veranda. There is another room which seems to have been added to the original building later (figs. 3 and 4). The most remarkable part of this monument is its pyramidal dome, which

is covered with colorful tiles. It starts with a square shape at the bottom and after some transformations turns into an octagonal pyramid, a form that usually indicates the mausoleum of Sufi spiritual leaders, at the top of the dome. Of note is that as far as the studies of the author indicate there is no other similar pyramidal dome in traditional Iranian architecture. Therefore, it seems strange that this uncommon dome enjoys a highly perfect design.

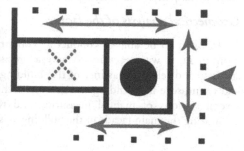

Figs. 3 and 4. The monument consists of a domed square chamber, a second room that seems to have been added to the original chamber later, and a columned veranda

One of the features that make this dome more impressive is that due to its relatively complicated design, its form cannot be easily grasped. When an observer moves around the monument and looks at the dome from different perspectives, he sees changing views of the dome which are hard to simplify and grasp mentally. This feature provides the dome with a quality of constant newness and strangeness while being pleasant; properties which correspond to the mystical qualities that are inherent in Sufism (fig. 5). The legend about the construction of this monument also underscores this mystical aspect of the design.

This monument belongs to the Timurid/Turkmen tradition of Islamic architecture which typically lays great emphasis on geometry. Golombek and Wilber believe that in this architecture geometry was not just a means to achieve a goal but it was a goal in itself [1988: 216]. Regarding the decisive role geometry played in Timurid/Turkmen architecture, Necipoğlu agrees with Golombek and restates her opinion:

Fig. 5. In contrast to other domes in Iranian architecture, this pyramidal dome is difficult to grasp and enjoys a special sense of novelty and strangeness

The obsessive preoccupation with geometry in the planning, construction, and decoration of Timurid/Turkmen architecture has contributed to the statement that it constituted "a form of design theory" in Iran and Turan between the fourteenth and sixteenth century [Necipoğlu 1992: 48].

Provided with this historical insight it seems reasonable to try to discover the geometrical patterns underlying this monument.

Geometrical analysis of the façade

In order to be able to conduct a geometrical analysis of the front elevation of this monument, it was necessary to have a precise plan of its façade. Since there were no accurate and reliable drawings of this building in relevant authorities in Iran, the author had to measure the building and draw its architectural plans himself. Therefore, through several sessions of manual measuring and re-measuring the monument the drawing illustrating the main façade of the building was produced (figs. 6-8).

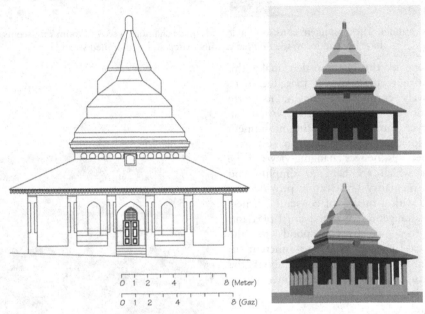

Fig. 6 (left). The main façade of the mausoleum of Sheikh Zāhed-e Gīlāni measured and drawn by the author. A scale in the traditional Iranian unit of measure, the gaz, is shown beneath the drawing
Figs. 7 and 8 (right). Three-dimensional illustrations of the main façade of the monument

Next, this drawing was analyzed in order to find geometrical patterns in its design. The analyses indicate that there are two main underlying geometrical schemes that govern the composition of the façade.

Scheme 1

The most fundamental geometrical order is illustrated in fig. 9. The whole façade is circumscribed by a square, ABCD. Considering the fact that the current stone paving around the building has been recently made over the ground, it is then possible that the original building was designed to sit on the original lower ground level of the line DC in

fig. 9. The lines GH and EF halve the sides of the square. GH lays over the widest lower step of the dome.

The boundaries of the dome are defined within the isosceles triangle a_1a_2E while the square a_1a_2IJ approximately describes the boundaries of the tomb chamber (fig. 9).

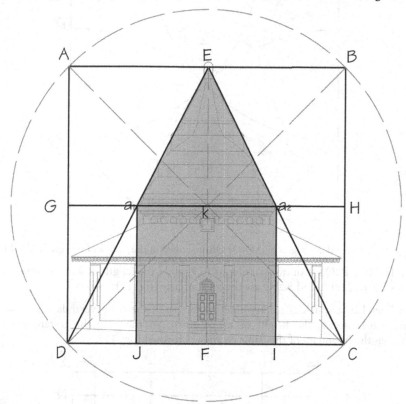

Fig. 9. An isosceles triangle inscribed in a square forms the composition of the main façade

Scheme 2

The second scheme that regulates the general disposition of the elements of the façade is a regular octagon inscribed in the same square. One method to construct this octagon is as follows: With A as center and Ak as radius an arc is described cutting AB at M and AD at R (fig. 10). Similar arcs are described with B, C, and D as centers, thus constructing the regular octagon KLMNOPQR (fig. 10).[1]

Later on we will see how these two schemes have been used in combination with each other to produce the composition of the main façade.

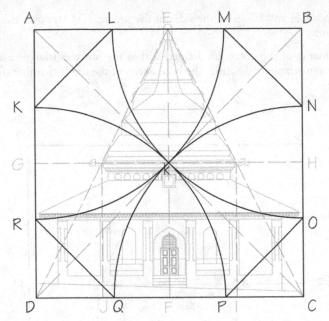

Fig. 10. The regular octagon KLMNOPQR inscribed in the square of scheme I, ABCD

Step 1. The line R2O2 is drawn parallel to RO while the length of RR2 is equal to GR. The lines L2Q2, M2P2, and K2N2 are drawn similarly (fig. 11).

The lines L2Q2 and M2P2 determine the length of the front veranda while the lines RO and R2O2 decide the height of its columns. In this way the rectangle J1J2J3J4 determining the boundary of the front veranda is formed (fig. 11).

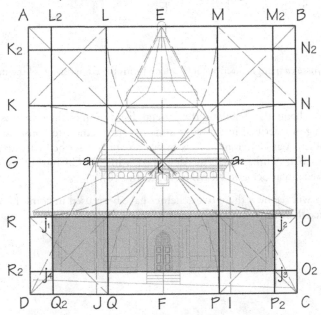

Fig. 11. The boundary of the front veranda is formed by the lines RO, R2O2, L2Q2, and M2P2

Step 2. Rectangle ABCD is further divided into smaller squares through drawing lines parallel to EF and GH. The line L_1Q_1 is drawn in the halfway between LQ and L_2Q_2 and in the same way the lines E_1F_1, E_2F_2, M_1P_1, K_1N_1, G_1H_1, G_2H_2, R_1O_1 are drawn in the halfway between each two adjacent parallel lines in fig. 11 (fig. 12).

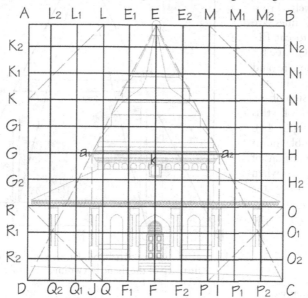

Fig. 12. The rectangular network in fig. 11 is further divided into smaller squares

Step 3. The distance between LQ and a_1J approximately suggests the width of the columns in the front veranda. So, the rectangle $h_1h_2h_3h_4$ is drawn as is shown in fig. 13.

If this rectangle is placed adjacent to the lines L_2Q_2, E_1F_1, E_2F_2, MP and M_2P_2, as is shown in fig. 13, an acceptable approximation of the location of columns in the front veranda is achieved (fig. 13).

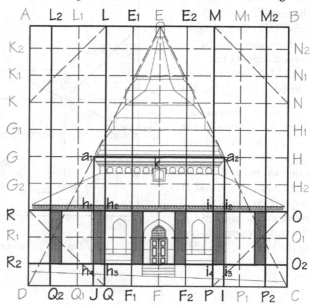

Fig. 13. The location of columns in the front veranda

Step 4. The lines EJ and EI are drawn. These lines intersect the R2O2 in b_1 and b_2 respectively. From b_1 and b_2 two lines are drawn upward to cut ED at b_4 and EC at b_3. $b_1b_2b_3b_4$ is a square and b_3b_4 determines the top end of the first step of the stepped dome of this mausoleum (fig. 14). Here a remarkable point is that the dimension of this square, when measured in the traditional Iranian unit, the *gaz*, is exactly eight units.[2]

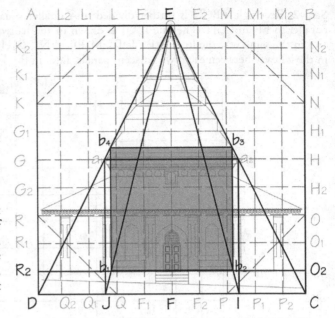

Fig. 14. The square b1b2b3b4 that determines the height of the first step of the dome has a dimension of eight gazes

Step 5. In this step we will draw the boundary of the tile roof of the building. First, using the vertexes of the octagon the lines KP and NQ are drawn. The intersections of these lines with the vertical edges of the square $b_1b_2b_3b_4$ are named g_1 and g_2 (fig. 15).

The midpoint of the line b_3b_4 is marked as the point g. the lines gg_1 and gg_2 are drawn and extended to cut the lines AD and BC at G4 and H4 respectively. Now the polygon RG4g1g2H4O finely determines the roof of the building (fig. 15).

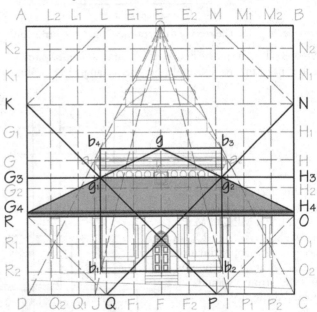

Fig. 15. The boundary of the roof

Step 6. In this step the current outline of the dome, as shown in fig. 9, is improved a bit in its lower part. This is done through drawing the lines AF and BF, then finding their intersection with b_1b_4 and b_2b_3 which are the points l_1 and l_2. Now the area which is confined by the points l_1, l_2, a_2, E, and a_1 illustrates more accurately the outline of the dome (fig. 16).

Fig. 16. Refining the outline of the lower part of the dome

Step 7. The next step of the dome is determined through drawing a square laid approximately on the line RO. The lower edge of this square, C_1C_2, is formed slightly over the intersection of EJ, EI, and RO. Two other vertexes of this square, C_3 and C_4, are located on EC and ED. The upper part of the square $c_1c_2c_3c_4$ finely superimposes on a step of the dome (fig. 17). Again it is noticeable that the size of this square is six gazes by six gazes.

Fig. 17. A square with a dimension of six gazes forms the next step of the dome

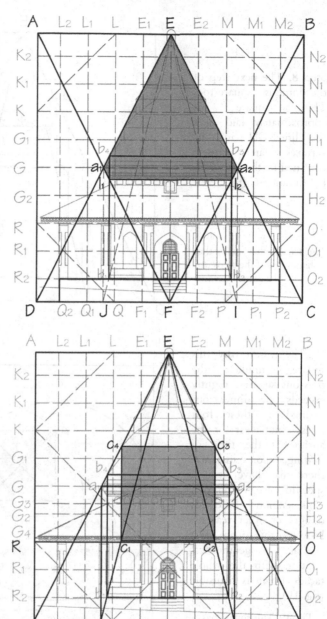

Step 8. The next step of the dome is a square too. This square is approximately laid over the line GH and its vertexes are closely confined by the lines ED, EJ, EI, and EC (fig. 18).

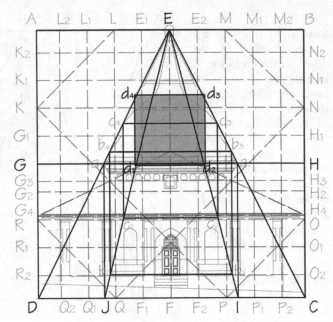

Fig. 18. Another square that shapes one of the steps of the dome

The reason why this square, unlike the previous squares, slightly exceeds the dimensions defined by these four lines is not clear for the author at the time of writing. For instance, there may have been a specific structural consideration behind this design, or other reasons. However this square has a special geometrical relation with the whole façade which is plausible (fig. 19).

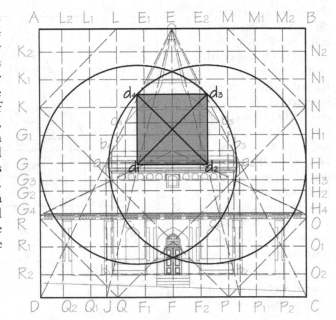

Fig. 19. This square has special geometrical relation with the whole facade

Step 9. This time the uppermost horizontal step of the dome has the form of an octagonal prism instead of a cube. The upper end of this prism is confined by the line K_1N_1, the lower part of it is set on the square $c_1c_2c_3c_4$ and its width is defined by the cut that EJ, EI, create on c_3c_4 (fig. 20).

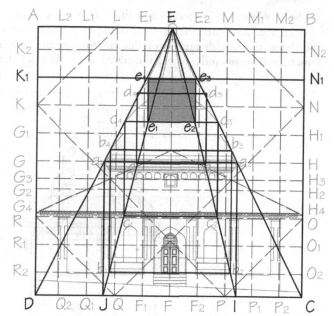

Fig. 20. The boundary of the octagonal prism of the dome

Step 10. Through previous steps we saw how the vertical segments of the dome's profile might be designed. Now the slanting surfaces of this profile are examined.

By drawing the lines Ef_1 and Ef_2 one may find an acceptable explanation for how the zigzagging outline of the dome is shaped (fig. 21): the lines Ef_1 and Ef_2 cut the vertical edges of the squares in f_3, f_4, f_5, f_6, f_7, f_8, f_9, and f_{10}. The lines f_3f_4, f_7f_8, and f_9f_{10} determine the location of corresponding lines on the dome with an acceptable amount of precision, but f_5f_6 just approximately defines the location of the horizontal line where the slanting lines from c_3 and c_4 meets the square $d_1d_2d_3d_4$.

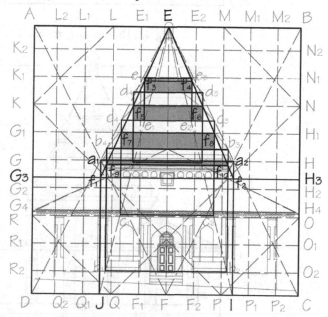

Fig. 21. Ef_1 and Ef_2 can be used to determine the slanting surfaces of the dome

The profile which is produced in this way is quite similar to the real dome's profile (fig. 22). Fig. 23 illustrates the final result of previous steps combined. Now we can hypothesize that the designer/s of this monument probably have used an underlying geometrical scheme similar to one illustrated in fig. 24 when designing this building.

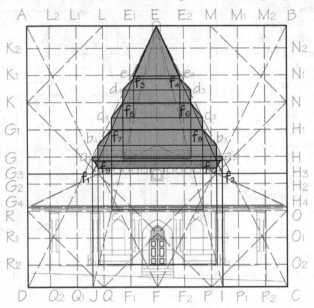

Fig. 22. The outline of the dome

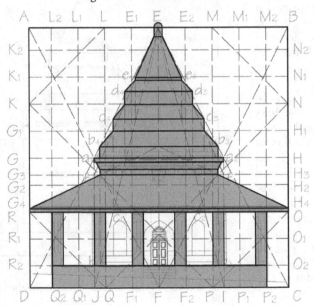

Fig. 23. The result of previous steps combined

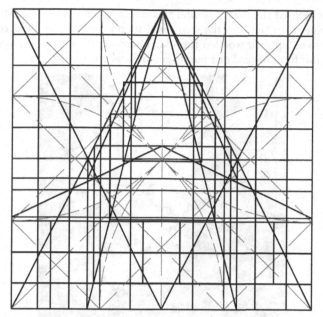

Fig. 24. The general underlying geometrical scheme that might be used to design this building

When attempting to analyze the form of this building geometrically, considering the practical issues that the designer/s of the dome had to consider in the fifteenth century is essential and helpful. For example, one of the questions that preoccupied the author for a long time was that one of the platforms of the dome sets back two gerehs (13.3 cm) from the top edge of the pyramidal platform beneath it. This setting back differentiates between the slope angle of the lines L_1 and L_2 in fig. 25. Was there a geometrical reason for it? Considering the humid climate of this region, with a great amount of annual precipitation, creating such a flat segment on the external surface of the dome does not seem a wise design decision. Why did they do it?

Fig. 25. Is there a geometrical logic behind this setting back?

The author realized the reason behind this design while trying to climb the dome as he was measuring it. In fact, this flat step could simply provide the builders with a place to stand on or to set up their wooden scaffold. Therefore, there may have been a practical reason behind this form instead of a purely geometrical one (fig. 26).

Fig. 26. The horizontal surfaces on the dome provided a base for traditional wooden scaffolds

Conclusion

The analysis presented in this article suggests the presence of thoughtful geometrical order within the design of the main façade of the mausoleum of sheikh Zāhed-e Gīlāni. Appertaining to the geometry of this design it was demonstrated that an isosceles and a regular octagon inscribed in a square formed the geometrical master diagram upon which the main components of the façade were to find their form and proportions.

Through this research we witnessed an example of how geometry may have been utilized by master designers of monumental buildings to create harmony and everlasting beauty in their designs. This monument testifies to a close relationship between architecture and geometry in Iranian architecture during and after Timurid period and reconfirms the opinion of Golombek and Wilber that in Timurid architecture the buildings were not just supposed to have a geometrical structure, but were rather supposed to look obviously geometrical [1988: 216]. Therefore, it is acceptable to describe this monument as a valuable example of a "geometry-based architecture"

Suggestions for further research

Further research is desired to explore other dimensions of geometrical design in this monument, that is, how the geometry of this building was integrated with other aspects of its design. One of the interesting issues that can be studied is that how the designers of

this building integrated its geometrical design with its structural design, especially in its dome.

Another interesting question is what the relation is between the decoration of the dome and the underlying geometrical scheme of the building. This question becomes more interesting when one considers the statement of Golombek regarding the relation of the geometry of whole plan and that of its surface decoration in Timurid architecture: "The primary grid, which assisted in the design and construction of the building, survived as an "after-image" and became the starting point of all decoration" [Golombek 1988: I, 44]. It would be interesting to investigate whether or not this building too obeys this rule.

Fig. 27. How the structural design and decoration of the dome is integrated with its underlying geometry?

Notes

1. Bernard Parzysz illustrates this and another "classical" geometrical method to construct a regular octagon within a given square that might have been used in Roman mosaic designs [Parzysz 2009: 280]. However, we know that the method described in fig. 10 was well-known to Iranian architects at the time; to cite as an example one can see Al-Buzjāni's book, which was addressed to architects and other craftsmen in the tenth century A.D. Problem no. 101 in this book describes this method exactly [Al-Buzjāni 1990: 43]. For a thorough examination of the role geometry used to play in traditional Islamic architecture and especially the role these kinds of books on applied geometry played in Islamic architecture, see [Necipoğlu 1995].
2. The traditional Iranian measuring unit was the *gaz* (pl. gazes), equal to 106.66 centimeters. A *gaz* was composed of sixteen segments called *gereh*, so each gereh was 6.66 cm in length [Abol Ghāsemi 2010: 380].

References

ABOL GHāSEmi, Latif. 2010. Hanjār-e Shekl Yābi-ye Me'māri-ye Eslāmi-ye Irān (*The Order of Creation of Form in Iranian Islamic Architecture*, in Persian). In: *Me'māri-ye Irān (Doure-ye Eslāmi)* (*The Architecture of Iran (Islamic period)*, Mohammad Yousof Kiāni, ed. Tehran: Samt.

AL-BUZJāNI, Abu Alvafā Muhammad. 1990. *Hendesse-ye Irāni: Karbord-e Hendese Dar Amal* (*Iranian Geometry: Application of Geometry in Practice*, in Persian). Edited and adapted into modern Persian by Alireza Jazbi. Tehran: Sorush.

GOLOMBEK, Lisa and Donald WILBER. 1988. *The Timurid Architecture of Iran and Turan*, 2 vols. New Haven: Princeton University Press.

GOLOMBEK, Lisa. 1988. The Function of Decoration in Islamic Architecture. Pp. 35-45 in *Theories and Principles of Design in the Architecture of Islamic Societies*, Margaret Bentley Sevcenko, ed. Cambridge, MA: The Aga Khan Program for Islamic Architecture.

NECIPOĞLU, Gülru. 1992. Geometric Design in Timurid/Turkmen Architectural Practice: Thoughts on a Recently Discovered Scroll and its Late Gothic Parallels. Pp. 48-66 in *Timurid Art and Culture: Iran and Central Asia in the Fifteenth Century*, Lisa Golombek and Maria Subtelny, eds. Leiden: E.J. Brill.

──────. 1995. *The Topkapı Scroll: Geometry and Ornament in Islamic Architecture*. With an essay on the geometry of the muqarnas by Mohammad al-Asad. Santa Monica, CA: The Getty Center for the History of Art and the Humanities.

PARZYSZ, Bernard. 2009. Using Key Diagrams To Design And Construct Roman Geometric Mosaics? *Nexus Network Journal* 11, 2: 273-288.

SOTOODEH, Manoochehr. 1995. *Az Āstārā Tā Estārbād* (*From Āstārā to Estārbād*, in Persian). Tehran: Anjoman-e Āsār Va Mafākher-e Melli.

About the Author

Mojtaba Pour Ahmadi is an architect and a lecturer at Islamic Azad University, the branch of Roudsar and Amlash, Roudsar, Iran. He took his M.Sc in architecture from the University of Tehran in 2006 and is the author of a book entitled *Me'māri va Akhlāgh* (Architecture and Ethics, in Persian) published by Islamic Azad University. He is interested in studying the role that geometry can play in architectural design to enhance the quality of the contemporary built environment and to facilitate a better life for people.

NEXUS NETWORK JOURNAL Architecture and Mathematics

Subscription information

ISSN print edition 1590-5896
ISSN electronic edition 1522-4600

Subscription rates

For information on subscription rates please contact:
Springer Customer Service Center GmbH
The Americas (North, South, Central America and the Caribbean)
journals-ny@springer.com
Outside the Americas: subscriptions@springer.com

Orders and inquiries

The Americas (North, South, Central America and the Caribbean)
Springer Journal Fulfillment
P.O. Box 2485, Secaucus
NJ 07096-2485, USA
Tel.: 800-SPRINGER (777-4643)
Tel.:+1-201-348-4033 (outside US and Canada)
Fax: +1-201-348-4505
e-mail: journals-ny@springer.com

Outside the Americas

via a bookseller or
Springer Customer Service Center GmbH
Haberstrasse 7, 69126 Heidelberg, Germany
Tel.: +49-6221-345-4304
Fax: +49-6221-345-4229
e-mail: subscriptions@springer.com
Business hours: Monday to Friday
8 a.m. to 6 p.m. local time and on German public holidays

Cancellations must be received by September 30 to take effect at the end of the same year.
Changes of address: Allow six weeks for all changes to become effective. All communications should include both old and new addresses (with postal codes) and should be accompanied by a mailing label from a recent issue.
According to § 4 Sect. 3 of the German Postal Services Data Protection Regulations, if a subscriber's address changes, the German Post Office can inform the publisher of the new address even if the subscriber has not submitted a formal application for mail to be forwarded. Subscribers not in agreement with this procedure may send a written complaint to Customer Service Journals,within 14 days of publication of this issue.
Back volumes: Prices are available on request.
Microform editions are available from ProQuest. Further information available at http://www.proquest.co.uk/en-UK/

Electronic edition

An electronic edition of this journal is available at springerlink.com

Advertising

Ms Raina Chandler
Springer, Tiergartenstraße 17
69121 Heidelberg, Germany
Tel.: +49-62 21-4 87 8443
Fax: +49-62 21-4 87 68443
springer.com/wikom
e-mail: raina.chandler@springer.com

Instructions for authors

Instructions for authors can now be found on the journal's website: birkhauser-science.com/NNJ

Production

Springer, Petra Meyer-vom Hagen
Journal Production, Postfach 105280,
69042 Heidelberg, Germany
Fax: +49-6221-487 68239
e-mail: petra.meyervomhagen@springer.com
Typesetter: Scientific Publishing Services (Pvt.) Limited, Chennai, India
Springer is a part of
Springer Science+Business Media
springer.com
Ownership and Copyright
© Kim Williams Books 2012